CF.

From a boy Sven Berlin intended to be a painter, yet also he loved the stage, music and beautiful women. This was the Age of the Dance – the Charleston and the Tango, Adagio and Ballet, Carioca and Bolero, and in the dance he found the essence of movement and colour and of form in space. His passions were fused together when he joined the Music Hall and became an Acrobatic Dancer – an Adagio Dancer – who practised his skills beside Henri the Clown; the Mystic Saxons; George Formby; Max Miller; or Alexander Zass, the Strongest Man on Earth. He rose to stardom with the Crazy Gang, then abandoned it abruptly to continue his odyssey as a painter. Penniless, he eked out a precarious living as a casual labourer, often starving, rejected by society, obstinately reserving all his energies for the art he believed important. And in the end he won through to a level of skill which was worthy of his dream.

This beautiful, vividly evocative story is not so much a chronicle of a drop-out before his time, as of a dedicated man, who as he himself says, never dropped in. No one can fail to be delighted by its humour, its vitality and its deep poetic insight into the growh of creative imagination.

D0931591

PRIDE OF THE PEACOCK

By the same author

ALFRED WALLIS

I AM LAZARUS

DARK MONARCH

JONAH'S DREAM

DROMENGRO

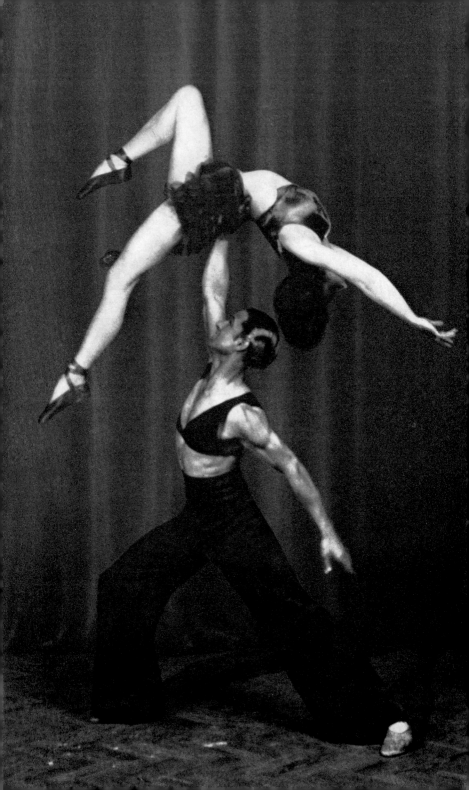

SVEN BERLIN

Pride of the Peacock

The Evolution of an Artist

COLLINS
ST JAMES'S PLACE, LONDON
1972

William Collins Sons & Co Ltd
London · Glasgow · Sydney · Auckland
Toronto · Johannesburg

First published 1972
© Sven Berlin 1972

ISBN 0 00 211675 8

Set in Monotype Garamond
Made and Printed in Great Britain by
William Collins Sons & Co Ltd Glasgow

TO MY FATHER
KARL BERLIN
WITH LOVE

The pride of the peacock is the glory of God.

<div align="right">BLAKE</div>

Contents

Dancing Man

Daedalus in Knossos once contrived
a dancing-floor for fair-hair'd Ariadne.
HOMER

I

Coming to Meet

ETHEL took each of my hands in her rough palms, holding me with her strong arms while I climbed up the great hill of her body, which was clad in a white apron almost to the ground. She was tall, she was only nineteen, she was placid and kind like a country girl, she was our domestic help. I loved her as much as anyone in the household because she made me feel safe and never seemed to be afraid and was patient when I climbed on her. I could feel my feet tread on her soft belly and breasts, her hard hip-bones, which were like the rungs of a ladder under my bare boyish soles. Her thighs were tall and strong as trees – trees I could climb. When I did this I was as much climbing into the future, plotting the expedition of life, as when I listened to my aunt who came with her dark hair and earrings and gold bangles, with presents and drawings for me; told me tales of Gypsies and artists living together in harmony by the sea.

All these people, these women, added to and slowly formed an image within me with its light and dark sides. Even Miss Avocet, who was my father's secretary: when she touched me with her black satin sleeve, looked with her blue eyes, turned her head of golden hair, surely she sent my love image moving down the years and was of the substance of goddesses I would meet later! At another time I was holding my mother's blue-veined hand – always a little cold – and looking at her, into her as the first person I ever knew, the first image ever recorded by my senses; this governed so much of my life. These were the images that were drawn to me and to some extent that I had made, and were the substance of my being and of my dreams for years to come. While this is going on one's own image grows out of such early adventure, begins to emerge, to be

made ready, to be gazed upon in the pool of youth. And then, later, there was my sister and my sister's beautiful friend, Greta, with whom I was in love.

Small wonder that when I had met the Gypsy girl, Liza, on the Forest road and had followed her into the trees to discover the city of Shave Green with its tents and fires and families of real Gypsies, I afterwards fell to thinking again of my aunt, wondering how she got on and was accepted by these people. Such musings set the whole of that rhythm of life going in the direction of the future and in many ways preordained my return to the Forest years later. But there were other forces at work; two lines of fate were drawing me at the same time, not simply one. I left the Forest in 1928 with a Gypsy named Parker in a Crossley motor car, and travelled with him as far as Romsey where I stayed with another Gypsy family till the next day. I intended to go on to London, but in my dream that night I saw and heard Greta so clearly, asking me to go to her in Lyme Regis, where I knew her to be staying with her brother, that I got up at dawn and started in that direction. The following day was hot and hard going on the road with no food save an apple stolen from an orchard here and there and a few black-berries. I slept in a haystack that night and lay for hours thinking of the past: so much of it seemed to be always in the present, growing in length every day and pointing perhaps even from the future, directing me on. The stars were cold and huge; I could see them spinning. When dawn came it was chilly and I was taken with a strong desire to move on. Slipping down the shiny hay I continued west towards Lyme. By the second sunset I was there. I slept under the cliffs of blue lias to dream again of Greta, whom I would dance with and lift into the hills of light; make her as tall and as strong, as white for me, as Ethel had been, and myself a hero and a child at one and the same time. I was beginning to look at myself as an inward image growing beside the image of a woman. Sometimes they seemed to merge and were indistinguishable; sometimes they were clear; sometimes there was only myself.

After the journey to Dorset I was tired. For all that, the sun, rising like an eagle over Portland, touched my hand with its

golden light, waking me where I lay curled up against a rock in a hollow of sand. I washed my face in the sea, treading now and again on a pebble that felt like Ethel's hip-bone under my foot, and stood for some time with the feathery waves trickling over my feet. Beneath the pane of clear water in the rock were ammonites and shells of thousands of years ago, set in a lias mud which hardened only when dry so that they had survived all this time in a state of semi-softness, which, under the incessant action of water seems almost inconceivable, like the drawings of early man in the mud walls of Les Comberelles. I searched among the stones and rocks for other fossils. My excitement grew. This was a form of casting by natural processes: nature's way of preserving extinct forms. It recalled for me the tombs in the Valley of Kings and the weird feelings they gave me – the first premonitions of the powers of art. I thought of the lost cities discovered by Sven Hedin; the men and women of Pompeii fossilised in the volcanic dust of Vesuvius. All things to do with man's deep past. This was the awakening of the idea of sculpture. To open a rock and find a fossil, a rock already formed by sea and wind, was as exciting as opening a cave in France and finding a Cromagnon painting: one made by the hand of God, the other made by the hand of man.

The cliffs of blue lias, laminated and strangely insecure against the sky, hung like libraries of great books whose countless pages held the secrets of time far beyond the wonderings of a young man whose mind was in no way trained.

'Fancy if I found a complete fish!' I exclaimed, as I broke a rock. 'Like Mary Anning, the countrywoman who found the first ichthyosaurus! And what if I found a portrait of myself,' I shouted, wild at the idea that came to me for no reason at all. A thought that seemed so natural in this place that I realised I had begun not only an outward adventure, but also an adventure of the mind which was to last all my life into the first bright embankments of old age: perhaps longer, to all eternity. At that moment anything could happen – and it did.

'What then?' I heard a voice say. Looking up I saw Greta.

Before her I felt shabby, worthless. I could not speak. She stood beautifully on the rock because of her dancer's figure

and highly arched foot. This made her blue dress fall away into her in a marvellous manner. Her mouth was full, her eyes were blue under strong, dark, stormy brows like the sea. This surely was the true goddess carried in the heart of northern man! The Gypsies were the dark side of the moon.

'It is an eternal sort of place!' I said, by way of apology almost. 'You see, I love places like this. I don't like cities and the machines that are coming into them, spoiling everything. I want all the time to feel things going back for centuries. The feelings themselves are old too: just as old I suppose – if one thinks about it.'

'Have you found any fossils?' she asked.

'No,' I exclaimed, looking at her. It was as though I had opened the morning and she had fallen out. 'No – nothing perfect, that is. Nothing worth keeping.'

'Does an artist make his own perfection?' she queried, out of the blue, and for some reason I was embarrassed.

'Yes – I suppose he does. Standards anyway. It is questionable whether he ever reaches them because the whole thing is moving all the time. As I see it he is making something new: that is quite difficult. But he has to learn how things are created first, before he can do that. I'm not an artist; not yet. I can't draw. I know nothing about paint; it won't do what I want it to. Nor will life for that matter.'

'Why don't you learn then, instead of complaining?' she said off-handedly.

'I'm trying to. I'm going to ask my father if I can learn. He's not in sympathy. He might agree to six months at a school of art. It's difficult at the moment. I've been chucked out, or rather I cleared off after a row because of all this. Now I don't know if I can do it alone. I've been in factories and all that. It doesn't work, though. That's prison, not life.'

I did not know that I was what people forty years later were to call a Drop Out. What I was doing was quite an original thing in those days – I had never dropped in.

Although Greta was giving the right answers to what I said, she did not seem to be listening. She looked anxious and preoccupied as if something was forming in her mind. It did

not matter. What was a woman's purpose other than awakening her image in a man's heart? Thus she was the image within and the image outside me at one and the same time. For the first time I understood the inner and outer relationship and how it could be dissolved into one when the exact image was found, bringing about a perfect marriage of opposites, and a state of love. No, it did not matter what I was saying. I had a strangely beautiful sensation for a moment and wanted to dissolve into her.

'Won't you join my brother and me at our hotel?' she asked.

'No, no, no! I couldn't do that. I've no money. I'm shabby. Dirty, even!' My shirt was torn over my sunburnt arms and chest. Her brother held a commission in the Air Force. I could not join them. No, I would be the clown. She was too lovely for me.

'No!' I said, almost in panic. 'I must go to London. I must see my father. I must ask my father to help me. Good-bye Greta. I can't stay. It's quite impossible!'

'But Karin is here. You know that?' said Greta as a last try. But it was not a strong enough motive to alter my mind, to produce my sister from nowhere. I knew she was coming but had forgotten. She had told me about Greta being there.

'No. I mean I know but it's still no,' I said, stumbling over the rocks and pebbles. I ran for quite a while until the magnetic force of the moment was broken, little knowing that in doing so I was running into my destiny and not away from it. Then I turned and watched Greta's slight figure in blue standing against sea and sky in the thin bright morning air. Slowly she lifted her hand and, a little sadly it seemed, she waved, then turned away.

I made my way back to London very hungry, buying myself a pint of beer and a hunk of cheese and bread with some money I got from the Gypsies, sleeping in haystacks and again with the few Gypsy families I began to know: the Wells and the Smiths who lived in benders by the upper reaches of the Avon and in the Forest. Feeling the warmth of the open fire on my face, the cold night air on my back and the sweet smell of wood smoke in my nostrils, I wondered why men had ever lived

differently. In shutting off the sky, as one day they would shut off the land and perhaps the sea, they were shutting off the sources from which all life comes. That night the sky was like it was in the beginning and I vowed I would not lose sight of it for long.

Then once more, I was under the pale green sodium lights of Trafalgar Square. The regiments of London's underworld slept on the pavements, rank upon rank, the rancid outlaws of the earth who stank to high heaven, yet in whom were incarcerated our lost dreams and the visionary future, like prisms imprisoned in the drifting spray from the fountains. The National Gallery stood staring silently, darkly down at us, hiding many another and more immortal face.

Quite unexpectedly, standing at my side, was my friend Horseface: he who would always be safe, always with enough tobacco, enough food, enough ability to make money, which I have envied, but with never a touch of that sacred spark that had lit the eye of some of these fallen men. There had been talk weeks before of our going on that journey together. Now he seemed aloof and angry.

'Christ!' he exclaimed. 'What happened to you? I searched the plains for you.'

'I didn't think you would go,' I said. 'In any case I wanted to travel alone. There was something I wanted to find out. I went to the Forest first and then on to Dorset!'

I felt quiet. I did not want to talk and stood staring into the square, thinking of those hot Dorset roads, the broken landscape, the weird atmosphere which is the ghost of the place, and exists nowhere except in the novels of Thomas Hardy. I wondered if the nihilism of the great man had had anything to do with the spectral atmosphere amid plenty and fruitfulness which he created with such quiet force. Had he lived in Hampshire or Kent would Jude have been so cursed or even possible? Or was it a deeper root than landscape and place; death of God perhaps?

I did not care about Horseface. I knew his genial nature would forgive me and that his bone was too thick for him to worry about me really.

'I've been home,' he said.

'Home?' I remarked incredulously.

'Yes, I didn't want to tramp on my own. I thought you had gone after a Gypsy girl.'

'I had,' I answered. 'She was marvellous. Black and strong with eyes of onyx and a golden body like a puma. You can't imagine how marvellous she was, moving under the trees in that strange green light. It was enough to be in her shadow.'

'You want to be careful, boy,' said Horseface, a little shocked at my sudden expression of manhood. 'I bet she had the pox!'

This remark made me feel sick and go pale under the green lights. Its brutal realism shattered me. It seemed that she was a sacred image which he had defiled. She belonged to my deep secret life which was peopled by ancient queens and pharaohs with golden faces; whereas Greta was the Snow Queen, *La Belle Dame*, the White Goddess: each was half of the other in some way. I understood for the first time that it was not everybody who led a secret life; a life that was so deep, so tender, so delicate that men hid it lest the first falcon should rip it open and leave it to bleed upon the ground after the heart had been torn out. I had known the claw and was defended, letting life grow rich with each day and night. I found I came upon parallel things – parts of a process, a voice, a face, a scent – things that harmonised with feelings and images already known to me inside and somehow explained them, making me feel larger, more touched with the magic of life. What I hadn't learned was how to incorporate the horror as well as the beauty of experience. For Horseface a spade was never a warrior's shield dropped on the field of battle, a queen's face or a rare flower – it was a spade; not always a clean one. If one painted in both worlds – painted the real and imaginative images as one new image – surely life would be larger and more complete! If it were done well.

'Pox?' I said at last. 'Do you really think so?'

Horseface looked guilty and puffed at his pipe.

'Shouldn't be surprised,' he mumbled, then changed the subject. 'By the way, I met your father. He wants you to go back!'

At first I was angry. This sudden news had broken my sense

of drama: however ridiculous this might have seemed, or indeed, *I* might have seemed from outside, to me inwardly it was of the utmost importance. What may seem to be the poses of youth are sometimes the expression of a deeper fantasy that protects and adds strength to the emerging soul in the so often brutal dream of day to day reality: like stage properties that have since lost their use these poses may become the eccentricities of age. I had planned to go on the Embankment and draw on the pavement with coloured chalks and, if that didn't work, go back into the country and find a free way of life. This sudden offer to go home had taken my stability and my freedom. But had I not said to Greta that I must go and see my father and ask his help? Now he had come halfway to me it was wrong to reject the offer. Whatever happened I would not now become one of the chain-gang in the great penitentiary of London, or one of its fallen statues. My mother would have been very much behind everything I was doing. They were both anxious for me. Their real strength would have been in not sending for me, my strength in continuing to stay away. Yet I needed help. My destiny seemed to hang in this chance meeting with my friend Horseface.

I watched a couple making their way across the square; a man and a girl. It was the same couple I had seen here on the night before I went on my journey: the man was wanted for murdering a cuckolder; his woman held to him; and now they could only emerge from the underworld at night and disappear again into the fountains like ghosts at dawn. To my young mind they were somehow immortal: an event in history.

The painters crowded silently together behind the dark stone walls of the National Gallery. They understood the excitement of the sodium drama and that I too must be a painter. It seemed to me they nodded as the young man and woman passed through the fountains into the unknown. These events which were directing my life had repeated themselves before.

'Oh, come on,' I said to Horseface. 'Let's go home. I must talk to my father.'

'But I thought you were staying *out*?' he said, dismayed at my change of mind.

'Yes, I was. But I need help. I must go to school and learn my trade.' Horseface had to pay the fare back to the Crystal Palace. I had no money.

When I got home, having climbed the long stairs to the top of the tenement flats that overlooked the North Downs and the Weald of Kent, I found the front door open. Sitting at breakfast with my mother and father was my aunt, dressed in her Gypsy-like clothes but now, to my new eyes who had known real Gypsies, not like those who live in England and have lost their elegance and colour they once brought into the land from India. She was a symbol of something working strongly to form my destiny: a forerunner and a comforter, although that wheel was not to turn till much later. It was the snow goose that now called in my ears.

My mother offered me breakfast. She was a little, small-boned woman with a high colour and blue eyes and looked nervously upset on this morning. Whereas my father was a huge dark virile man who ate quickly and gave out everywhere his masculine strength. The little kitchen in which they were eating was full of tension and nobody referred to the fact that I had been out on the roads for some time, which made me angry. My aunt should know anyway, so I rather pompously told her in front of the others and there was the sort of silence in which people are embarrassed by real situations and do not talk unless angry or distraught. I went into the other room.

A shaft of sunlight jewelled the carpet, falling through the flowered curtains, across the shabby chairs, the bookcase with its coloured spines of books each containing a life. There was a box gramophone with a horn and a few records my friend Bamburger had bought: Listz, Beethoven, Rosa Ponsell, Elizabeth Schumann. A painting of mine of an avenue of trees in sunlight hung on the wall; also an interior of a room – this room. Both works were without luminosity, which I searched for, and without structure, which I craved to master, and without growth or rhythm, but with an indefinable personal passion that marked, even shouted, possible future glories, ever evading the grasp.

Out of the window I could see over the houses of Anerley

and Penge to the North Downs, which were quite blue in the heat. The funnels of ships on the Thames could just be seen to the south-east berthed at Gravesend and Deptford. Immediately to the north was the south end of the Crystal Palace with its two Towers which was the house of my childhood.

I fell to contemplating the extraordinary condition of inside and outsideness, wondering exactly where one began through the open window and one ended in the bright air, so that as I started to climb out on to the little verandah I also hesitated and climbed back in again, going into and out of the outside, inside to the out: in this way I was gathering the sensation of two experiences of opposite nature by making them one. It seemed to me that if I could find a certain hairsbreadth interval which was neither one nor the other I might arrive at simply a moment of experience in the sunlight which streamed down at an angle and was common to both conditions.

While this was going on I was aware of something changing on the inside and, looking up, saw my father standing in the doorway filling the room to the ceiling. He was in his middle forties, going grey at the sides and far more lined with worry than he should have been. He had had a very hard time. There was little hope of improvement. It was the end of the twenties.

'Hallo, Dad,' I said, feeling foolish, and climbing back into the room, which he seemed to wear like a box coat.

'You had better go to art school,' he said, scratching the back of his head. 'I don't know how I shall do it and I can't do it for any more than six months – unless you earn some money from somewhere, of course; it would be different then.'

I could not believe his words. In those days there were no grants. For a man who had looked through the eyes of a businessman in the toughest period of national depression, this was a noble act of fatherhood. Starvation was rife. It was a time when Londoners were killing cats and eating them to survive: not us so far, but we were still short of food and clothes, and debts piled up no matter how hard my father worked to lessen them. It was a time of nervous anxiety and fear of social collapse; these feelings ran through us all – all ordinary people – not just ourselves. In making this offer he

released the flood of creative vitality that was to flow all the days of my life – even in the face of death.

I flung my arms round him and felt his rough beard scratch my face, smelt the tobacco in his jacket collar, felt the great love and strength that was my father. The terrible resistance to life and to authority, which is so often the stone that makes a tomb of adolescence, was suddenly rolled away; the light flooded in.

During the previous winter I had been to a school of art in Beckenham, drawing plaster casts. The master was sympathetic and now, when I came with my plight and asked if I could cram for a scholarship to the Royal College in six months, he told me that, although he had never heard of it being done in under two years, he did not see why I should not. If I worked hard, with no moment wasted in the evenings or at weekends, with my kind of enthusiasm it should be possible. Although I had already tackled a life-sized *Discobolos* – that miraculous spiral in stone – I saw my way ahead as a formidable journey, until an unexpected twist of fate became apparent.

It is difficult to tell if the inner law of a man, or indeed of a boy, governs his life by his deep needs, or whether an unknown law from outside sweeps him forward, whatever plan he may have set – in all probability set too late or too early. The Fates tugged the other cord to which I was attached like a marionette.

The weekend before I was to enter the school of art a telegram came, it seemed out of nowhere, and caught me completely by surprise. It ran:

> PLEASE CALL AT MY HOUSE STOP URGENTLY
> NEED TO SEE YOU RIGHT AWAY STOP
> CARLOTTI.

Carlotti was a dancing mistress with whom my sister had worked for some years, starting as a young pupil in her school and later working as one of her dancing team. The team made up a stage act, headed by Carlotti and her partner, Tiopolo, who did ballet and slow acrobatic numbers, called at that time Adagio Dances – they were Adagio Dancers.

My sister was home. Tall, slender, beautiful Karin with her

long black straight hair cut like an Oriental Princess: her dark eyes, her humorous mouth!

'I wonder what *she* wants!' I said, bewildered.

'I expect she wants you to become her dancing partner,' Karin answered off-handedly, knowing perhaps better than anyone else the depths to which it would penetrate, for she knew how I loved the stage – the romantic image of the Apache Dancer, the coloured lights, the music and the girls – in particular Greta, who was Carlotti's understudy. I used to go to see them work whenever they danced at a theatre I could get to. But although I was a first class dancer in the ballroom I had never thought of becoming a dancer, as I had of becoming a painter: this was something that was new. With its first impact I felt a new, emotional and physical excitement which I had not known before, giving me life. I could not believe that here, by some unknown set of events, I should be approached by this woman to go with her and share in her work on the stage. In some way it all fitted in and seemed to be the true piece to make up the puzzle rather than the one I had almost shaped for myself. At least I must try: see what she says.

'What of Tiopolo?' I said suddenly, remembering her partner who had been with her for years.

'Tiopolo is no longer with her,' said Karin, with an inward smile and looking out of the window. 'They had a row over that bird he used to cart round on tour with him. He's walked out!'

'What – left her flat?'

'Exactly,' said Karin. 'Rotten of him really. But she was as jealous as hell. They were always rowing and it would only have led to some terrible accident on stage. I think she wants to train you in his place. Why don't you go and see her? It can't do any harm.'

I was too naïve to realise that Karin and even Greta might be party to a plot. They might even have suggested to Carlotti that I would be exactly the person to replace Tiopolo. I never found out. Whatever it was, the incident awakened a passion in me I never knew existed, as if all my dreams of great painting and sculpture had taken on a sudden concrete reality: dreams

also of life. Once more my own image came before me – being only eighteen this was inevitable – but the two halves of the image had grown together: face and reflection were one. Always near to it was the face of a woman – Greta. I was being drawn towards her by anonymous forces. It was more than I could unravel.

'Yes, I will. I'll go and see her this evening, Karin,' I said at last. 'Can you lend me three pennies for the bus fare?' As she dropped the three coins into my hand I knew they were reading out my fate as surely as when, years later, I cast my destiny in the I CHING – a Chinese Book of Changes – and the hexagram for the Summer Solstice came up. It read: 'Coming to meet. The maiden is powerful.'

2

Carlotti

CARLOTTI lived on a hill over which, I had always thought as a child, the sea must exist. I would hurry to meet it, watching the bright sky full of luminous light, eager to the point of exultation, always on reaching the top to be left staring down the tramway to Dulwich and Victoria, wondering at this kind of dream and what it meant. Opposite Carlotti's house there was a museum, called Horniman's Museum, where I had first seen human bones and the bones of animals: the drawings I made from these were used to construct a human skeleton of my own, which was a unique addition to anthropology.

Inside the museum there was a great clock out of which twelve Apostles moved in slow procession at four in the afternoon, in silence save for the music it played and the bells, watched by a pterodactyl and a human skull, a stuffed gorilla and a beautiful turquoise mosaic mask from Mexico. I wondered also if it did this in the cold stillness of four o'clock in the morning.

The Victorian house where Carlotti lived had an overgrown garden and pathway. There was a pair of huge cement Grecian vases turning green at the foot of the front steps. There was a rotten wooden gate and the smell of rotting walnuts. As with all entrances that are seldom used there was a feeling of trespassing. Finding the bell out of order I knocked at the big oak door. After a long wait a tiny old woman with a black dress and jet necklace, reminding me of my headmaster's mother at Kenley who used to teach me to read the Bible, opened the door and gave me the sweetest smile, asking me to come in. She belonged to a world that was then fast vanishing and is entirely gone to-day. I followed her down the dark hall into the well of a built-in staircase to the basement. This was the

only place where there was life. Other rooms I passed with half-open doors were huge and silent and empty, like rooms I have seen in the great houses of Spain. But in the basement, in spite of the fine day, the fire was burning in the hearth, and with the electric light, which was always on, reflected in the heavy furniture and brass and silver ornaments. Beside the fire, curled up in a chintz-covered arm-chair, nursing a Pekinese called Confucius, was Carlotti; that ugly little woman who had been one of the best dancers on the English stage. She was now between forty-five and fifty. Her dog growled and snapped for her. She held out a limp hand to be shaken. When this was over I was told to sit down.

For my eighteen years I was tall and slim, highly developed in the arms and stomach and very gauche. Carlotti looked me over like a thoroughbred colt and hissed quietly in approval to herself. I felt a little nervous.

'I hear you are interested in dancing,' she flung out suddenly. I was taken by surprise.

'Why, yes. Is that why you sent for me? Do you want me to be your partner?'

She paused as if not quite sure of herself – or me. Perhaps I was not what she expected, although we had met before.

'You are a very forward young man,' she remarked. 'I like your directness. But make no mistake, you could not do this in five minutes. I thought you might like to *begin* training. Being my partner would take a long time.'

'How long?'

'Three months. In three months you could do exhibition dances with me – the Waltz and so on – because you are already an accomplished dancer in the ballroom, or so your sister says. But the range of expression and gesture on the stage is quite another thing – broader, larger in every way. The Adagio – that also is another matter. I see you are strong, but strength is not everything. You are lithe and graceful, but there is more than grace. I could probably teach you the lifts and swings in six months, or perhaps a year. The rest would take years: the ballet, the stage presence, the timing, the ease of personality; but this would come.'

Six months? That was just the amount of time I had gained
for art school. This was one of those strange moments in life
when I had to know intuitively what was right.

'Do you mean that by then – after six months – I could go
on; appear on the stage and earn my living?' I asked eagerly.

'I don't see why not,' she answered. 'You would have to
treat it very seriously and work hard.' She lit a cigarette, then
offered me one, which was a godsend, smiled to herself. Her
rather prominent eyes went heavy.

'Of course. It is an art: all art should be taken seriously. I have
six months to spare. I know my father will agree with that. This
will be my life.'

'What about painting?' she asked. 'I have heard you want to
be a painter.'

'That's what I mean. My father has just agreed to me going
to a school of art for six months to study. But that will come
in time. If I am in the world of art everything will add to what
I most want to do – that is to paint. But without real experience
the academic study is useless. It will be far better for me to
dance because I will be involved with life. I can think of nothing
so exciting.'

This was a big decision to have made. It now seems to me
to have been right, but at that time what vision gave me such
certainty I can't tell.

'Will I get any money at first?' I asked, almost as an after-
thought.

Carlotti offered me fifteen shillings a week retaining fee while
I trained and three pounds a week when I was ready to go on.
I was greatly relieved. This would solve the endless worry of
money at home, or help to. There would still be plenty of time
to draw and paint.

Another woman came into the room. She had a friendly,
girlish face but was about fifty. She was self-conscious in my
presence. This was Flavia. Amelia was the older sister who had
led me in – a dear fussy old thing who lived, as Flavia did, under
the thumb of Carlotti, the breadwinner. Without Carlotti
everything would collapse – or so they thought.

'Flavia, Flavia, dear Flavia,' said Amelia in her fretting

voice and trying to fix her bun with a hairpin. 'Isn't it exciting. This lovely young man is going to train with Carlotti to take Tiopolo's place. I do hope he does well. Oh, that awful Tiopolo going off like that without telling us.'

'I am sure I will,' I said, shaking Flavia's soft hand. She blushed to the roots of her hair, rocking her head slowly from side to side, like a ventriloquial doll.

The door opened again and slipping through it into the shadows wearing that same blue dress I had seen her in at Lyme, was Greta.

'And Greta will be your understudy, won't she, darling Carlotti?' Amelia's quavering voice fussed on and poor Flavia wagged her head with excitement.

'Of course,' said Carlotti, looking a little skinned at the eye with jealousy. 'Hasn't she always been? At least, that was the general idea.' While she was speaking Carlotti gave me a direct sexual look, but I was interested only in Greta. I watched her long hands, her strangely beautiful feet and her eyes as blue as ever, sitting in the shadows, as I always seem to remember her; passive, remote, silent.

It was arranged that I should go over for a trial practice on the morning of the next day, which was Sunday.

My father did not quite understand this sudden change of direction and at first was not particularly keen for me to take up with what might be considered 'something cissy', although he was relieved about the money, such as it was. At that time the music hall still had its bad name from Edwardian days as being rather corrupt. On the other hand artists such as painters were thought to be of no social value by the ordinary person. It was a difficult choice for him to make.

My mother was neutral. All she said was: 'You know best, dear!' and left it at that. It was part of her gift that she always believed in what I was doing. If things took an unexpected course that she did not understand she would await the outcome. She was not reasonable, but accurate in her assessments.

Karin of course was delighted. In some ways it forged a link that was to last all through life: our friendship – brother and sister. All this first grew out of my seeing Greta at one of

Karin's dancing classes when we were about fourteen. She walked across the floor dressed in a blue Russian coat trimmed with fur, grey Russian boots and an astrakhan hat. Her eyes were more blue than anything I had ever seen. They seemed actually to smile at me. I had never seen anyone walk like that; it was gliding rather than walking, like a swan. Ever since then we had sent messages to each other through Karin, who was her best friend.

My brother, Leopold, was strangely reticent. I had the feeling, but never quite knew, that he loved Greta and had told no one. Sometimes things explain themselves in the depths of the soul in this way but are never confirmed. Our friendship went on, sometimes to be obscured but never lost. We continued our long walks over Sydenham Hill and Dulwich Golf Links discussing Bishop Berkely and Kant; or Nietzsche and his effect upon Hardy; Hardy's impact on D. H. Lawrence. All were lasting influences, especially the philosopher Henri Bergson, whose concept of *Élan Vital* and the process of creative evolution seemed to be the most fluid way of explaining the universe – anyway in the Western World.

Then came crashing through the centuries Van Gogh, Gauguin, Epstein. Our minds awakened like sleeping princes to marvel at the fierce beauty of the world projected and completed through the imagination of man; to wonder at its great tragedy and whence came suffering. I began to understand the creative act as distinct from intellection. It was to this miracle, to perform perfectly in one form or another, that I would give my life, and so expand in each direction of which I was capable. William Blake became more important than Emmanuel Kant and Nietzsche, and through him the mystics of east and west: Jacob Boehme Miester Eckhardt, Lao Tzu, Buddha, Christ, Jal'lu'din Rumi. This was an intuitive course, opposite to the way civilisation was progressing, save with its greatest thinkers like Jung and Wilhelm, with whom I was not well acquainted at the time.

These researches were helped by, and sometimes directed by, Claudius Lantern who visited us with our friend Bamburger in our tiny attic room high over Kent and London. Here was

the trained mind, the computer of all knowledge, the embryonic philosopher and teacher, the priest of consciousness; here was the now almost obsolete creature, the scholar with the multi-sided mind in search of enlightenment – a far cry from the sabre-toothed mice of to-day. Here also was the mystic to guide us on the perilous path of self-knowledge and awareness to life which all artists must have. To direct us also to poetry, the true source of the spirit of man. When Bamburger had directed me to the untold glories of painting by showing me Turner, it was as though a great gong had been struck, the vibrations of which are still resounding almost fifty years later, for the overtones of a great man sound forever, and Turner's bell was of solid gold. Thus the friendship of these two young men, each a genius in his own right, was a benediction.

I had left school at the age of twelve when I started to receive evening tuition to pass the entrance exam to Public School. This I succeeded in doing from a gifted little Scots tutor who patiently taught me Logarithms, Algebra and French by the light of an oil lamp which I can still smell whenever I think of him. But the family fortunes, such as they were, went aground and I never started my first term. My university became the streets of London and the tiny cell of learning at the top of St Christopher's Mansions, where my masters, Bamburger and Claudius Lantern came to visit.

These activities were linked with my most secret inner life and were concerned with a search for understanding: an under-standing of myself, my own processes and of the world of which I became increasingly aware, for in as much as art interprets the past and foreshadows the future, so experience belongs to the present. It was by an act of chance and of cir-cumstance that my life started to grow into the physical world of dancing in which my body was more involved than the intellect in giving a direct link with the spirit and rhythms of the universe. Here also I began to understand music. So back to Carlotti.

The training to be a dancer was by no means effeminate or soft. It was one of the hardest and most exacting processes I have ever tried to master. For him who would doubt it, let him

try. Especially under a woman; a woman as fanatical as Carlotti. She had little idea of the limitations of a young man and forced me to push my body too far in ways that were dangerous and harmful. With someone as eager as myself this was not difficult – perhaps she did not know, or just enjoyed it. At this distance I cannot tell.

Carlotti had the insistence, the toughness, the maddening patience and ceaseless application of the masters and mistresses by whom she was raised in the old ballet schools such as those described by Karsavina. This heritage was invaluable and served me in my own self-teaching later. In the short time I was training she instilled in me the knowledge and power of physical control and self-discipline. Although I knew I could never become a great dancer I was fast becoming a good one in the bastard world in which I found myself. The Adagio Dancer was a creation of the late twenties and early thirties: a spectacular and illegitimate child of the ballet. Its sensational acrobatics were laced with ballet and exhibition dancing, touched with sex, imbued with vanity, dowered with grace and pride. That it was an exhibition rather than an expression, a music hall rather than an art form, can be said quite honestly by the true ballet dancers. From my point of view it was a way of touching the basic rhythms of life and projecting them among people: sometimes it was beautiful, at others brutal. It was always tough and dangerous. The standards were high.

By this kind of application and with the particular mania that has always characterised me in anything I do seriously, I learned my steps and positions, pirouettes, entrechats, lunges, spins, and finally danced well enough to make continuous sequences of movement in relation to music and to the movement of another person, which was a reward for the intensely hard physical work. The mind became a directive force; it had to make the feet and arms and torso do what it wanted, to create certain patterns corresponding to music and space – until the *duende* broke through and took charge of everything. This was greatly inspiring and helped me later to draw and carve stone without academic training – I could visualise the image in space.

I learned day after day in one of the big rooms at the back of the Victorian house. The spins came soon when I had found my centre in motion, followed by the swings which were made sometimes by holding two ankles, sometimes by holding one ankle only with one hand and finally, with one ankle and no hands, the foot jammed between the lifted deltoid muscle of the shoulder and the back of the neck, snatched and placed there while the dancing partner was in mid-air. All these were learned and performed every day in a space which gave only six inches to spare on each wall, Carlotti's hair flicking the practice bar as we went round. Old Amelia jangled away at the piano, whimpering and calling out:

'Do be careful, Carlotti, dear. Do be careful. You'll kill your-self one of these days and then what will poor Flavia and I do!'

Carlotti, with extraordinary nerve, continued to make me spin her at higher and higher speeds: the faster the safer, she used to say. I ached in every part of my body. The tiny deep-set muscles as well as the major ones were used. My lungs were already stretched from over-breathing, my stomach bruised, my back torn. No part of my body was left unarticulated; even to learning to smile while lifting Carlotti above my head and walking round with her on one hand – often after she had kicked me in the balls on the way up – then dropping her in a dive to be caught just before her face hit the ground. When I consider that I worked in this way for weeks without any form of support, not knowing about the professional jock-strap, I wonder I was not injured. Why Carlotti, who weighed one hundred and twelve pounds exactly, told me nothing of these trade secrets I cannot think: only propriety, perhaps. Some-times I was in dreadful pain. I took it all as part of my training which should have taken three to five years, not months.

I was proud of my growing physical prowess and skill which directed my natural gift of strength into becoming something more than brute force. I enjoyed what I was doing, especially on the two evenings when Greta practised with me instead of Carlotti. Being young and much lighter she was full of spring and much more resilient. I was able to do lifts and swings with

her long before I could do them with Carlotti. This we kept to ourselves to avoid wakening Carlotti's jealousy. We also kept to ourselves our growing regard for one another and the simple love-making that expressed it while we danced. With Greta I began to know the real meaning of the dance: that it was an expression of the human spirit through the body in which love and sex and the movements of the universe were understood as in the sculptures on the temples of Kharjuraho. For her also this was made true, for her long years of teaching and working for Carlotti had made her grow to hate the dance until we worked together.

These disciplines were, in a way, parallel to my interest in philosophy and comparative religion. I was also interested in the good life, and the good life seemed to me to exist in the complete development of all one's powers – body, mind and spirit – to the full extent. In this way the whole person was possible. I had to adjust my habits to a new way of life; not for moral reasons but because it simply would not work otherwise. Where I smoked as many as eighty cigarettes a day when I was in an engineers' office, I now smoked two, at most four. I never drank when I was working and never got drunk when I was not, whereas, previously, when I was sixteen, I was drunk every night if possible. Excess with a woman was only occasional, with a woman older than myself who worked in the local cinema. She had great limpid eyes and a full mouth and a body that opened like a flower. I went with her on a park seat or on a sloping gravestone in the cemetery where we made our love over the sleeping dead and under the indifferent stars, disturbing neither, for each was spinning in his own universe as we were at the fountain of life pouring ourselves into one another.

Gradually the dancing became a centre of devotion to which all other activities were modified. Even my all-night vigils by candlelight trying to understand the philosophers were cut down so as not to disseminate my energies. Greta, because she was a woman, and a special kind of person, grew close to this centre of devotion and needed a special kind of faithfulness and

I gave up my woman at the cinema, never to forget her dark and enclosing beauty.

In this way I began to realise that I became dedicated: dedicated to art and to love. *Vissi d'arte, Vissi d'amore*: although it did seem I had given up one kind of love to preserve another. Perhaps all this began when I first saw Turner's 'Ulysses Deriding Polyphemus' at the age of fifteen; Van Gogh's haunting symbol of fierce beauty and lunacy 'Self Portrait without an Ear' when I was sixteen; Matthew Smith's 'Coleur de Rose' at seventeen, and at eighteen the Ken Wood 'Self Portrait' by Rembrandt. To say nothing of meeting Greta across the practice room floor when I was fourteen. To dance with her was to draw in space with the image of one's love. And although the dedication was to dance it was still a painter I wanted to be.

As the months went on, the need to get bookings grew more urgent and Carlotti started to drive me. We practised eight hours a day, including Sundays.

'You must keep at it!' she said over and over again in her squeaky nagging voice. 'Come on now. One two three – ONE Two Three – One two three. . . . Back lift. . . . Hold. Walk round the stage. Drop to dive. UP. Arabesque. Pirouette on the finger. HOLD. Now again. One two three – ONE TWO THREE. . . .' I did not flinch, but in the end was transported like a Spinning Dervish and fell unconscious. I came round with the women fussing about, pushing pillows under my head, brandy down my throat, burning my lips.

After this she brought in a fully trained man to fill the first booking, which I was supposed to have taken. This was a great shock to me and my romantic image of myself was shattered at a single blow. I hated him for his rather brutal realism; I was jealous of his effortless lifting; I loathed his stocky figure and plain looks, not realising women fell not for the incredible beauty at which I aimed, but that the more your face was like an artichoke and your eyes lecherous the more they went. The entrance of this man was exactly the right remedy in every possible way. It slowed me down, I was forced to take stock and also I had to bite the dust when he started to teach me what to do. Thanks to that man, whose name was

Jack, I was saved from failure. Another week and I would either have been dead or injured for life; literally so.

Jack's horror at finding me straining without any support went almost to the point of rage, both with Carlotti and myself. He could not believe it when I told him I didn't even know. Instead of going mean because I was still to take over the act finally, he was helpful and I hope Carlotti paid him well for being so, though she was a mean bitch over money as I was to find out.

He showed me how to take a lift and to time the tiny unseen spring of my partner exactly with the upward thrust so that she almost shot into the air of her own volition; how to lock my arm at the elbow when I got her there; how to arrange her weight through my frame so that by standing properly – beautifully therefore – the forces were distributed. He was not a good dancer himself and I was better at the swings because I had learnt them in such a confined space, which he could hardly believe, but he was master at the laws of lifting. Even with Carlotti's great weight I was soon throwing her about like a stuffed doll. We started composing dances and building them into music. I encouraged Carlotti to hire a hall where I could spread my steps and gestures and learn to throw her from a swing at high speed so that she glided down on her back and slithered along the boards unharmed, except for an occasional splinter in the arse.

Quite suddenly I hardened off and became an immeasurably strong, supple man, instead of an anxious, physically inarticulate youth: with this a new confidence came.

Carlotti's troglodyte life was centred in her dark basement room always lit by the electric light. From here she controlled the lives of Amelia and Flavia, of myself to some extent, and partly of Greta. But Greta returned to her home on the other side of London quite frequently, thus keeping her secret life, as we all must who would become individual.

She had been with Carlotti since the age of four and still did a lot of teaching at which, in her quiet unassuming way, she was expert. But Oh, how she hated it! Her mother, who was a kind person, preferred that she lived with Carlotti, mainly

because her father – a failed artist – was uncommonly addicted to drink and women and was not particular where he did either, which was fun for him but made it difficult to bring up a girl of unusually fine looks and talent with any degree of safety. Apart from this the financial arrangements of the family forced them to live in a slum area where the mother used to collect the rents. She wanted to do better than this for Greta, whose brother had been to the same public school as I would have gone to had not my fortunes been reversed. Greta always seemed slightly ashamed of the warm-hearted rough people who lived in the street; Londoners, whom I had already learned to love in the streets of my own childhood. Her father had an office in the City and was a warden at a city church; this made it more difficult for Greta to assess his behaviour at home, which had its effect on her much later. But she was an unique creature. I loved to meet her on the street corner in her three-cornered black hat and long scarlet coat. She made the world shine. So she made the best of both worlds as young people always do, getting even greater freedom when she was on tour with Carlotti and her troupe, of which she was head girl. But I think it was on those long bus rides across London, from Kilburn to Forest Hill, that she worked out her life.

Meanwhile I returned to my home and my chaotic attempts to paint, making copies of Blomaert, de Hooch, Murillo, Hokusai and Rembrandt: weeping with despair at the intractable nature of paint and the evasive structure of form. I did not know I must build these within myself and fire them with the holy torch – only then would the angel appear in the flames.

I continued to take those long walks with Leopold, mostly at night under a cold moon. Sometimes we sat in the garden of a deserted Victorian house, where the last roses were shining and the midnight primroses stood with their pale faces in the long grass. There was a lonely marble Apollo who had no one with whom to share his beauty. The tall black penis of the Crystal Palace Tower was stuck in the sky where the stars mingled with the twinkling lights of Penge. We spoke of poems, of love, of painting and the whole miracle of creation

which men sometimes made more beautiful by what they created – sometimes more terrifying. Although we knew nothing then I am happy to say there is no more worth while thing I know now.

On Sundays I did not find it easy to escape from Carlotti. After morning practice of some four hours she would get Flavia to come to me, blushing and rocking her head, to invite me to lunch. If I tried to refuse, Amelia would come fussing out of the steam of the dark kitchen with her hair half down, complaining that I was an ungrateful boy and that I must stay. So stay I did. Besides which, my not being there helped out at home and I was sure of a real English roast cut from a huge juicy almost Victorian joint. The work demanded good food. It was not part of my austerity to refuse, only to get away. Once I accepted, the trap was sprung and I had to stay till at least five in the afternoon, which was spent in the basement smoking Carlotti's cigarettes, which she handed grudgingly with her podgy little hands, and talking of the future. I could not get away because she kept my fifteen shillings retaining fee till tea-time, and I had to have it to pay in at home. This became a source of torture, unless Greta was there: then we would go upstairs and work all afternoon, sometimes till late evening, at the dances. This I enjoyed.

I began to realise my first booking must surely be near when Carlotti had me taught to drive by a cold clear-eyed Cockney chauffeur who had a diabolical sense of humour as well as a unique way of instructing. Once he had told me what to do I was expected to do it and he distracted me all he could by telling me stories of the demobilisation days at the Crystal Palace after the First World War.

'Many of the poor bastards were ill,' he said. 'Bleed'n shame really when they 'ad passed froo the war. Some of it was wounds, of course, and some of it was disease – pox an' all 'at! Dysentery, jaundice, trench fever. Silly fuckers used to kick the bucket one after the ovver. Then, you see, their women used to come an' collect 'em. Well, like this. If a mate a' mine snuffed it there was a big circular 'fridge see, an I used to put 'im in it. Much easier, see, than 'avin 'im stinkin' ararnd in bed. Simply

tie their feet togevver, label the body and chuck 'im in 'ead first. Then when the ol' woman comes along an arsts for 'er man, you just goes froo the labels on their feet like, until you comes to the right man. Whips 'im art and 'ands 'im over!'

This apron of humour was the perfect driving aid, because I was laughing so much that I had to get on with the gears automatically. The final test was crossing Tower Bridge on a Monday morning when all the great dray horses were pulling their loads into Shoreditch and the East End, the river traffic sliding by, pedestrians swarming, and the dung-collecting boys darting in and out of the traffic with fantastic skill, while my instructor had me laughing with a new story so much that I thought it would drop me and my 1926 Citroën between the great cantilevers if they rose too early, into the Thames. I did not mind running into another car, of which there were not so many, but hitting that great machinery of living flesh, a horse, would have been sacrifice. That I succeeded in this venture in the particular way it was presented is perhaps the reason why I so enjoy driving.

Then came the first booking: East Anglia.

3

Stage

IT was winter. The dykes and waterways of East Anglia looked lonely and deserted with the sedge broken and the cold sunlight flashing on the still water. Just the weather for pike. The live-bait would work well and there would be little weed to get caught up in after the hard frosts. Rime was still on the grass, the autumn sourness had gone from the water and the great prehistoric predators would be on the feed in pairs, or, in the case of the old ones, quite alone. I think it was these thoughts more than anything that gave me the sense of being caught in something inescapable as I drove through the morning over the flat country. When one is fishing one is a complete part of the law of life and not simply engaged in an objective adventure – anyway not so me. Thus with life also.

Carlotti sitting at my side in the car did not seem to see the landscape when I pointed it out; she could not understand my excitement when I saw a heron take flight and remarked that it was like a pterodactyl. In some ways this place was like the Rhône Delta, especially where there were cattle.

Greta and Karin sat in the back seats making faces at me through the driving mirror. The rest of the girls, some of whom I quite fancied, had gone on by train. Carlotti was fretting over the band parts and props that had gone with them. I was thinking of Bergholt and Flatford where Constable had painted, wondering if I should have time to visit them; and the early English water colour painters at Norwich.

Always, behind everything, was the unavoidable truth that I had got to appear on the stage for the first time before an audience and perform three difficult and dangerous dances. There was no way out, no chance of reprieve, the firing squad must be faced at sunset on the next day. There are times at

certain intervals in life when all one's courage is called upon
to do a certain thing for a certain purpose because it is the
channel through which your life is being expressed. Not to
flinch. Who in his soul does not flinch? Who in his soul does
not run away? Who is not afraid? Yet you must stay.

I found myself in clean theatrical digs at Lowestoft by
lunchtime and ate a hot Sunday dinner which had been ordered
by Carlotti in advance. The girls were spread in houses around
the other streets and although I was in the same house as
Carlotti I had a separate room where I could shut myself in
with my most secret thoughts. The room was bare and cold,
but it was mine – the cell for which I have looked all my life,
where I could be myself – a place to pray and to find courage.

In the afternoon I walked by the sea and watched the fishing
boats at their Sabbath rest; nets hung out to dry, silent, sombre
like the sea; the strange sea with which I could always identify
myself – something so necessary in a strange place. Later we
went to the theatre, as was often the custom of actors on a
Sunday afternoon – to see what it was like. Otherwise only the
boredom of empty streets in a strange town could drive one
into an empty theatre.

It was a small theatre like any variety hall built at the end of
the last century or the beginning of the twentieth, which
functioned now as a cinema part of the time to save the expense
of a full live bill. Not only did I see my name billed for the first
time but saw it, most unfairly I thought, at the top of the bill,
simply because Carlotti's act was the largest and most expen-
sive. She had insisted on calling me Carl. So there it was in
large red letters for all to see:

CARLOTTI AND CARL
The Whirlwind Dancers
with their

BEAUTIFUL GIRLS

So the public could not tell if we were from Italy or Sweden
and I am sure would have been horrified to know that it was
Upper Norwood and Forest Hill that had bred our talent.

This was the beginning of the image the world projects upon an artist and the artist in turn projects back upon the world. For some reason it is this image the world loves before the work and before the actual person. It does save the real person the pain of being seen; it is his legend, his suit of armour; but it can also destroy; the great danger is in getting caught so that you don't any longer know the true image because it has become dissolved into the false one; that is, if you are weak. This is the piss and wind of the ego. Cocteau says the legend is woven with falsehood that becomes truth in the end, but it means nothing if done for its own sake. Only the evolution of the soul should matter. So it is on the stage: each town you visit as a lonely traveller you enter invisible and make your way to its heart, always wondering – as I wondered on this winter's Sunday for the first time – how it should be that people living in strange houses down strange streets should come and see one perform, save that by the time you reach that heart, which is the stage, you may be a clown or a brilliant dancer, an acrobat, a juggler or a comic. The curious magnetism of the theatre and of the individual artist, in whichever sphere he works, is an ancient, a magical and a potent thing.

We entered by the stage door. I walked past the doorman's office, past some firebuckets and sprinklers, some stacked scenery, straight on to a stage for the first time in my life, not even realising that I was on one until I heard Carlotti say, with her hands on her hips under her open fur coat, that she could not remember what it was like to step on to a stage for the first time and wondered what it *was* like to do so.

'*This* is the stage?' I exclaimed. 'Well – I don't know. I can't say. It's queer. I never thought it would be like this. It's so small and rough and seems to slope. No feeling.'

'How did you think it would be?' she asked, smiling. 'Glamorous?'

'No. Different to this though. Quite different.'

I felt horrified and wished I had not gone in for it. I could never dance in such a place under such conditions. Where were all the people – it was so empty. I stood looking into the empty auditorium, which is about the most frightening thing in any

actor's life. Yet the fascination of the empty theatre has always been the same. A cold blue shaft of daylight shot down from the flys, cutting across the Orchestra Pit and part of the dusty plush red of the Stalls. Cymbals hung in silence. Tympanies had short spindly legs like modern sculptures by Armitage and Chadwick; figures carrying bellyfuls of sound. In a theatre at this time everything is potential: the seats with people; limes with amber, green, magenta, blue; the ornate brackets with yellow electric light; the stage with drama, excitement, comedy. It was like entering a reconstructed room in a museum or in memory, that was independent of the machinery of time; still, silent, peopled with the past or the future but not depending on to-day's happenings or to-morrow's destiny.

A theatre isolates a sequence of events, like the Death of Socrates, and goes on enacting it as though in eternity where all events are perpetual. Although it was only the variety theatre, it was the natural home of the great clowns whose genius is equal to Irving or Olivier; of acrobats who have delighted kings and queens down the centuries, ever since lovely girls beguiled the bulls of Knossos by somersaulting between their horns; of jugglers of the fairgrounds and of the circuses; of dancers at ancient rituals. All this was inherent in the empty theatre which smelt of dust as old theatres do, and the sweet stench of make-up.

The boards under my feet were rough and splintery.

'And quite a ramp on it!' said Carlotti, smoothing the stage with the toe of her shoe. 'You'll have to be careful on the swings.'

'What is the ramp?' I asked her innocently.

'Haven't I told you? Goodness, I must have forgotten. The ramp is the slope of the stage that corresponds with the slope of the auditorium. If a stage hadn't got a ramp – or the auditorium – you would only see the actors from above the knees, because they are higher up. But it can be difficult. You will have to adjust your spins. Look – try now!'

Without any warning she leapt on my hip. I caught her automatically and started to spin. But it was quite different from the flat floor and close walls where I had learnt, and I

knew nothing else. As we turned, the smooth backcloth of a woodland scene gave way to the slots of the wings and then to the black abyss of the empty auditorium, wing slots again, woodland and so on increasingly fast. But every second step my feet moved down one so that the centre was lost and I lurched across stage crashing into a piece of scenery as though I had never spun before. What's more, feeling giddy.

'Goodness, how different,' I said in bewilderment. 'I wish I had been able to rehearse on a stage before I came here. I had no idea.'

'You'll be all right!' said Carlotti reassuringly, looking at me with her grasshopper eyes, a little guilty. 'It always seems strange at first. After the first night you won't know yourself. It's only a matter of correcting your feet as you spin to counter-act the ramp. You'll soon get used to it.'

What she had said was true but the environment gave me vertigo: the heights above me seemed immeasurable, the stage floated, the auditorium was far away. I was sick with nerves, my tongue was cork, my mouth full of alum.

There was an evening house of cinema to which the manager allowed us in free. We saw a love film in the desert. With Greta sitting at my side and my hand on her lap I was able to forget my apprehensions, watching the tiny silver screen, no bigger than a postage stamp it seemed.

Morning brought my first band rehearsal at which the other acts turned up. There was a juggler, a trapeze artist, a magician and a comic. Carlotti and I went through our dances by miming and marking out on the stage, giving cues to the musical director for drum roll and fortissimo and the curious cadenza in the second dance; it was all silent, nervous, unreal.

I had not been among pros before. The first thing I noticed was their well-cut clothes: they were all well-dressed; none was shabby. The comic had a long camel-hair coat almost to his feet with a wide collar and belt; with this he wore a bowler hat. One woman had a fur coat with white shoes, a tight costume under-neath and a pile of peroxide hair under a tiny hat. Each had that curiously smooth skin-texture – the men as well as the women – that make-up gives; and the dark around the eyes

which is the unremoved black from the last show. I was impressed by how friendly they were; how they kissed one another and said 'DARLING!'

'Daaaarling! I've not seen you for ages. We've not been on the same bill since we worked Derby with Tommy Lorne. How ARE you. Plenty of work?'

'You've got it all wrong, darling. It was Pontefract. And what a dump *that* was. Do you remember? Lousy digs into the bargain. No one came in all week, except Mr Wood and his family and *they* were sitting on their hands. Then the ghost was about to walk and the manager scarpered with all the money – the whole week's takings. I'll never forget it as long as I live. Let me see now: there was Marie Kendall singing "Just Like the Ivy", 'Arry Tate and old De Groot with his fiddle – or was that at the Shoreditch last year? I know we died a death.'

'Not on your Nelly,' chimed in someone else. 'Harry Tate was dead and gone by then. You're thinkin' of Harry Lauder, darlin' . . .' in that hoarse pro's voice that only the microphone was later to make extinct.

I was in a new and exciting world of people who were unique because they were initiated into the secret of life: all other human beings seemed like amateurs.

While the chatter was going on the girls lined up under Carlotti's direction to mark out their numbers. I found it fascinating to watch them swing gently to the rhythm with Greta at the centre and Karin next to her and Daphne, and fair-haired soft-mouthed Yvonne, immaculate Margaret, Mary Rose, Janie and Jackie and Jill, all moving with their long winter coats open, and tailored skirts and clean legs showing boots or high-heeled shoes. Tiny hats on their heads and splendid hair-do's; instead of the full punch and precision of their dance when the show was going, this lazy rhythm was like a wave of the sea: made me want them all.

The actors stood and watched us: our entrances and exits.

'Remember, girls, you all shriek as my partner comes on,' shouted Carlotti in her loud voice.

'Yes, Carlotti!' they said in unison, smiling at me.

'Drum roll from the band! Got that, conductor?' Carlotti

went on. 'Cymbal crash! I am snatched from among you. OK? Four bar da de da da de dada da de da . . . ! Get that time right. Quicker.' She hummed part of the Hungarian Dance No. 5 by Brahms. 'Right!' The band, conducted by a small grey-haired little man of about fifty, took up the music from the orchestra pit, while I walked through my second dance trying to look as though it was old hat, but feeling terrified even of my sympathetic but perceptive professional audience. The girls, particularly the girls, who knew the dangers.

In the late afternoon I was at the theatre long before anyone else had arrived. It was still and empty as on the previous day. I spent some time alone marking out the dances step by step, swing by swing, lift by lift, until I could visualise the sequence objectively. I did several spins alone, correcting my feet to the ramp, but more to avoid giddiness, which I had overcome at home, than to keep centre: without the weight of Carlotti it was fairly easy not to wander. Ever since a bullying by a singing master I had never been able to remember or hum a tune correctly, for he made me stand in front of the school and sing a song I did not know: it finished among jeers and laughter. Perhaps some of the terror of that day came back as I leaped around the darkened stage like an idiot boy without an audience unable to hum, though able to keep time: my love of the dance halls had stood by me in that.

During my teens the Crystal Palace Dance Hall had been a place of attraction. In the underground halls, where as a boy I had swung the great circus stallions, Night and Day, down the stairs to the stables, where I had talked to the old Don Cossack about the Russian plains and to the German Stey Family about the perils of tightrope-walking, and teased the pet mongoose into rage, I came on Saturdays in my fifty shilling suit with winkle-pickers and a pork-pie hat to kill the girls in their black satin dresses, gold high-heeled shoes, long earrings, their trout-hooking eyes. I would fight a whole gang of boys, from the leader downward if necessary. It was perhaps a virtue of those days that, however tough a situation, a man fought one man at a time; only in feuds were knives and guns used, or in the case of stealing another man's girl. The girls loved a strong

man. It had not yet occurred to them to scream for insects. They loved a good dancer who was not afraid. These qualities often outweighed money – or the lack of it. I swirled to the alto-saxophones that haunted those distant halls of glass, with a golden goddess in my arms and not enough in my pocket to buy her a coffee; instead she would buy me coffee.

The Charleston, the Waltz, the Foxtrot, the Ragtime, the Black Bottom, the Tango: at all these I was expert; prided myself. They went with a streak of violence I seemed to have and a good deal of swashbuckling of the Douglas Fairbanks senior kind: even to having a gun stuck in my ribs one rainy night trying to save a dame – I beat the assassin unarmed and threw him in the gutter. However absurd this was, the perils of life and death were not isolated and the fullness of the heart not yet lost – not until the devices for safe living had finally been perfected and its warmth slowly etiolated, its courage entombed. There was also something of Victorian melodrama still in existence, catching in the weave of one's days like smoke. Of course physical prowess was of great importance, both to impress the girls and to deal with difficult situations: it was also becoming to the figure, a prerequisite to good dancing. With almost ridiculous bravado I challenged my friends to hit me in the stomach as hard as they could without making me flinch. I punched through wooden fences and plate glass windows with my naked fists. I cycled twenty-six miles with my brother on the carrier at the back. I swung in the highest tree.

It was a natural sequence of events to hero-worship Tiopolo later on; also to learn the uni-cycle from the clown Jacques, melodrama from Susan Jean the circus girl, a love of spectacle and daring and bright clothes from the circus itself. All this fitted together. I almost think I drew these ghosts from the past towards me and through me as De Quincey did in his opium dream, until I reached the point where I found myself sitting in an empty theatre on a cold winter afternoon, painting my face as though I were painting a portrait in a mirror, past and future floating through me; a self-portrait. My hand was shaking a little with nervous tension, my hair shining like polished black

marble, my long sideburns acting as portals to my pale face. I had begun my career as an artist. I was also learning to draw.

I was sharing my dressing room with a Belgian acrobat who was old; how old no one can now know, but he looked like a Neanderthal man with his low skull and heavy jaw, his nose that had been flattened by a fall. One felt that he might have given up such a hard life years before, yet he gave out great vigour and love of life – *his* life which was his work. Part of the nobility of these people was that they toured the halls year after year, spending months between bookings, destitute on Charing Cross Road, where the agents had their offices, dressed up to the nines, never losing faith in the act, until the day came when work was less and less, their skill failed under the advance of age and hardship, often to be ended by a fatal crash or entry into one of the actors' homes to which all members of the profession give their services to raise money during their careers. Many are victims of drink but not markedly more than in other professions, I think.

Henri came into the dressing room puffing a cigarette.

'*Gofurdummer!* I'm late. Who's on first, Carl?'

'You are, I think,' said I, using the eyebrow pencil.

'Me!' he shouted, dancing at the news, flinging his clothes to left and right, baring his body down to the angular white naked structure of bone and muscle that had known for years the hard discipline of an acrobat's life in the circus and on the halls. Even when he was not working he had to practise several hours a day or his body would refuse to meet the challenge when the time came. Never could he afford to falter when he balanced his daughter on a pole while she played a piano, the pole resting on his shallow, bony forehead, and flicked the pole away at the last moment to catch her before she hit the stage. This was his big trick – ugly and pointless as it was his whole life revolved round it. A split second too late and her skull would be cracked.

I watched him pack his jock-strap and vest with hunks of foam rubber like spare muscles, which stank of last night's sweat, and put on a huge comedy evening dress; make his face up white with a red nose and black eyebrows, his straw-

coloured hair combed out from a centre parting. He put on a huge collar and tie. Out of nothing was created a fantastic being – projected into the room like a dream. The room came to life. Everything was altered by his being there, and I understood how actors are apart from the drab everyday world because they are more complete people. Henri was anyway, even when he remonstrated because I was wrong about him going first.

'Girls fust. Girls fust. Girls fust. Oh, yes, Mister Carl, you are quite wrong. It eez ze girls fust – *then* me! Can't you hear them?'

The band struck up. A call boy was shouting: 'Overture and Beginners, please! Overture and Beginners!'

Girls clattered down the corridor for the curtain raiser.

Tension grew within me. I was possessed by the quiet dry fear a performer takes on as part of the wages of his art. It is a fear which, if controlled, leads to integration and mastery of what he is doing: this must be faultless, a thousand pairs of eyes shall judge it. Fear that never quite goes.

I dressed in full tails with high stiff collar and a stiff shirt-front, feeling like a wooden soldier and looking as elegant as Henri had looked ridiculous. I took my quick change to set on a packing case backstage and left the dressing room, went downstairs and watched the girls working from the wings. I noticed there was a carpet on stage which billowed a little as they danced, belting it out with sharp, scintillating, peerless precision, coming off with a series of high kicks to be swallowed up in the velvet jaws of the wings, while the tabs went up on Henri doing leaps and levitations and falls from a tiny trampoline.

For me it was like being in the kitchen while the guests were having dinner in the main hall. I was seeing life from the inside again, as I had when I was a scavenger at an engineering college trying to earn a training. This was my unique viewpoint and was to remain mine for several years. Once I lost it and was blind during that time to the secret of life.

A huge beautiful girl stood near me. I drew comfort from her warmth and started to vibrate, almost purr with pleasure:

we were both aware of one another. And then Carlotti – tiny, stringy, looking rather worried and doll-like in her make-up and evening dress – snatched at my arm, looking anxiously to see how I was.

'You look all right,' she said, straightening my tie by reaching up against me. I distinctly got sexual vibrations from her.

'Yes, I'm all right!' I said nonchalantly. I had almost forgotten my ordeal ahead save for an occasional yawn, my consciousness being swallowed up in the beautiful girl. Under greater stress I have seen men go to sleep; before battle for instance. Fear triggers off sleep!

Henri did some flip-flaps with that kind of Continental humour which is so naïve when somehow one expects it to be sophisticated. As he tumbled from point to point I began to see why he needed his extra muscles. Out beyond was that multi-eyed creature, the audience, watching from the darkness behind the light, as I have so often watched from a side street the glare and bustle of a main shopping centre. So many things link back to little-remembered incidents and events. Because we have experienced them we have stained the soul a little with a new or different colour, which, when related to other things at some later time, give to experience a new and wider meaning. It is the mosaic of man's life seen from within. I felt this strongly as Henri was preparing for his great trick.

We watched with awe and in silence as he got the pole set firmly between his eyes, with his daughter sitting comfortably at a harmonium twenty feet above in a sequin dress. It was incongruous when the drum roll stopped and in the silence that followed she started playing 'Home Sweet Home'. When she stopped, the drum started to roll again. Henri threw his two hands out wide. Suddenly the prop was knocked away and he caught his daughter as she was about to hit stage. There was great applause.

This was followed by the comic, immaculate in a grey dog-tooth suit with velvet collar but, like everyone else to my eyes, he looked strange in full make-up; especially as he was wearing a gladiator's helmet; his grey bowler he left with the stage manager as he went on. He ran through a patter of gags with

extraordinary speed and exact timing. Here again there was tremendous vitality. I am sure stage artists release energy from the unconscious when they are working well, like sculptors and poets. The girls were on again. I felt Carlotti pull my sleeve.

'This is us,' she said. 'We're on.'

We walked on stage to a long chord in G. My nerves had reached such a high pitch that, instead of shaking, my mind became quite paralysed: absolutely blank. All I was aware of was the blinding glare of the limelights meeting with the foot-lights, forming a screen that shut out the audience. Instead of the darkness I had expected I was looking into an abyss of light that seemed to go on forever. The first dance was an exhibition waltz; quite simple in its way. I heard Carlotti chanting: 'ONE two three ONE two three . . . !' as I fell into the right timing, but I could not remember the routine at all – what spins what steps came next – it was blank. Carlotti seemed to realise this and told me each step as it came. The carpet – which I am sure should have been tacked down or not there at all – made smooth dancing difficult.

'ONE two three – TURN. ONE two three – TURN. PIROU . . . ETTE. Link fingers – SPIN. . . . Pause. Back lift.' She was above my head spinning round on one hand, but still giving directions. Her full organdie skirt was over my face so that I could not see.

'DROP! UP to the fifth position – right. FLYING ANGEL!' And she was in the air flying round at tremendous speed. I could not believe I was holding her. I followed her as if in a dream, somnambulistic, until I found myself bowing with a noise like the sea in my ears and my tongue like wood. The curtain fell.

'Quick change! Quick change!' shouted Carlotti, half out of her dress. I was pouring with sweat, my hands trembled as I tore my evening dress from me and put on velvet trousers and checked shirt for the Apache Dance. When one does something very fast for the first time it seems to take an age; a week later it is so simple. In the meantime the comic had gone on to tell a few gags in the front cloth while the scene was set. The stage

manager was shouting to the electrician that number five batten was wrongly lit. The girls and Carlotti were sitting round the stage at tables looking very exciting in short slit skirts and low shirts, pretending to drink wine. Karin was at the bar. There was an apprehensive pause before the curtain rose and everything started to come alive with chatter and music. There were some pistol shots and feeling ridiculous I ran on, dragged Carlotti from her table, flung her down. Girls screamed, glasses crashed on the floor, tables were overturned. At least the carpet was comfortable for Carlotti to fall on instead of the splintery stage. At this point the girls left the stage and we faced one another.

When the strain of a situation is abnormal everything is foreshortened, telescoped into a shorter space so that the senses can deal with it. My memory was clearer but I was so slippery with perspiration that I could not hold Carlotti safely. I had forgotten the meths containing dissolved resin my trainer Jack had told me to use. It was a good idea; you simply rinsed your hands in meths, let it evaporate and the hands were left tacky with resin. Too late, Carlotti was already giving me the cues in rehearsal room jargon. Throttles, spins, lifts, were executed quite expertly, but a split second after the exact time because of my blank mind.

'THIGH lift – DIVE! . . . TUMMY LIFT – ROLL AND CATCH. ROUND-THE-WAIST-AND-ARM-SPIN . . . STOP. ARMCHAIR – TWICE. PAUSE . . . LUNGE.'

What I had not foreseen was the strain two consecutive dances – let alone three which I was to do later – could put on one. My breathing was at twice the normal pitch, giving me emphysema, making each lung feel twice the actual size. There was weakness at the thighs from swinging one hundredweight of bone and flesh at high speed over the footlights; dizziness from the unequal stage, and unfamiliar surroundings; sickness from nerves and blinding lights, eccentric swings from the acute ramp; aching hands and tired back. What sort of confidence or madness had made Carlotti go on with someone so inexperienced as me can only be guessed at. I don't think she understood or remembered the dangers; it was so long since

she and Tiopolo had trained together. Before that she had been a straight ballet dancer – and a very good one. Even now she wore wooden toe blocks, as I was later to find out. Partly it was a curious mixture of courage and vanity that drove some of the old-time artists on; that and the fear of their performing days ending. As far as I was concerned there had to be a first time. God knows it was a firework show of emotion and fear.

The Achilles' heel in our arrangement to work by spontaneous cues was to be found in the finale swing we called the DRUM ROLL. To do this Carlotti had to go to the other side of the stage; too far away for me to hear what she said. I watched her. The girls were in the wings, crowded together. I could see Karin and Greta standing side by side with arms linked, symbols of my future life, half-lit as people off-stage so often are. Strange how the senses had started to train themselves so early; as time went on nothing was lost; each fragment of experience was a glass fragment in the huge remote dome that has become my life. Henri and his family were there, the comic in his gladiator's hat, the tall thin family of jugglers, still to go on. The audience sat tense as the drum roll began. I moved towards centre stage but could not remember what came next; my mind was once more utterly blank. I was the only one that knew this. For the first time I stood completely alone with someone's life depending on my right action. Yet the machinery to give me right action had stopped working, just as years later my rifle jammed in a street fight in France. Life has such an amazing way of proving us, no matter how evasive we may be; sooner or later we are caught in the cage which can only be unlocked by a secret which we do not know till the moment comes. In the end it seems to be a matter of truth. It is these situations that reveal a deep morality in a way of life, which many would brush away as the performance of mountebanks and tinkers.

The drum roll had started quietly in a tense silent theatre gradually increasing to a crescendo. Carlotti cowed back and I instinctively made a dramatic gesture towards her. Thinking this was a sign that I knew what to do she started to run at me; when only a few feet away she took an enormous leap as though

to deliver a drop kick feet first. My mind remained blank but the sight of her feet near my face triggered off something else: some other mechanism it seemed than ordinary consciousness. My hand went out involuntarily and snatched at the left ankle, rammed it behind the neck. I lifted my right arm rigid above my head and the foot was jammed safely by the huge shoulder muscle – the deltoid. I let go the other ankle and we started to spin at high speed with no hands at all. To do this I had to get near the footlights and spin my partner over the musical director because the stage was half-covered with chairs and tables.

This was going well but for one thing. The carpet had worked loose and it was twisting round my feet. I tried to work between the footlights and the carpet edge on the bare boards, but the correction for the ramp made it impossible; I hadn't the experience. Meanwhile the sweat on my neck was mixing with the grease in my hair; Carlotti's foot was slipping. I kept speed but knew I could not hold her. I felt the foot come away. As it did so I caught the foot in mid-air, with hands that, thank goodness, had gathered enormous strength during the last months and grown broad by so much gripping. I had to increase speed as she flew farther away and the conductor ducked as she came round over his head. The next thing was to choose the turn, the exact moment at which to throw her. I had come round to this with great accuracy when the carpet folded completely round my feet, locking them together. I fell headlong. Carlotti crashed into the footlights, smashing several bulbs with her face. A shriek went up from the audience. When I got up I took her by the foot and dragged her from the stage, feeling relaxed and at ease. The curtain fell amid tumultuous applause. The show was a success.

4

Strongest Man on Earth

THE creation of the dancing man was no doubt a result of conspiracy among the gods. I could not now turn back. One thing was made clear by the accident; Carlotti had no intention of putting Greta in as her understudy. This realisation set the course of my stage career. Both Greta and I had resolved to be together, though this decision had come about separately. Carlotti's behaviour had made us conscious of our feelings and messages started again to pass between us by way of Karin.

By the fortune of high places there had been both a doctor and a dentist in the audience on that first night; they were able to patch Carlotti up enough to go on for the second house. She flatly refused to go to hospital or to rest: indeed to admit that Greta knew enough to take over. She sat in the dressing room amid sympathy and anger, tears and dissension, argument and acrimony. It was as though she were an old vixen with no cubs to defend, cornered by hounds. She had to go or fight – fight she did. I suddenly realised how alone and lonely this little woman was; how she feared losing her work, which was not only the means of her livelihood but her life. I never felt that she needed to express herself as much as she needed to dance and to be looked at, ludicrous as she was. Had she not gone on she would have lost her nerve; at her age it would have been fatal. To give way to Greta now would also be fatal; she knew I would never be satisfied to dance with her again. Her best tactic would have been to train us together – let us be the act and she the manager. Then we would have stayed as a point of honour. But actresses and dancers seem unable to take such a step in their work of being the *grande dame* even though this would be to preserve their genius. There is a hidden pocket of the Narcissus pool into which they still gaze and cannot get away. Finally it must swallow them.

'You are only a boy, Carl. You don't know anything about it. You have only been in the business five minutes. That was your first time on. Take *over* indeed!' I conceded everything. She was right. Her eyes were red with crying, the teeth in the side of her face were gone. I could not see how she could go on like that. While she was talking she made up again and put on a white wig, powdered her face. Greta shrugged her shoulders with her palms upturned and left the room.

'I didn't really mean that, Carlotti,' I said, standing among the clothes and props. 'Of course I know nothing. I've only just started as you say. I only meant that Greta should go on for the second house while you rest. It would be a great chance to try out the dances.'

'Too true it would,' she muttered to herself as she hooked her dress up the side. Then out loud: 'I'm all right. *Quite* all right! And I *am* going on. That's final!'

For that moment I hated her. I stopped myself telling her how bloody awful she looked and went to my dressing room to get ready for the show. Poor Carlotti. What else subscribed to her courage but pride and vanity I could not see. Even her jealousy was a protection. I could not help respecting her, angry as I was.

She went on in the second house smiling out of one side of her face, keeping the right side away from the audience. Only we could see how comical she looked. She could not laugh at herself.

The carpet was removed. From then on all was well save for a few splinters in Carlotti's bottom when she was thrown across the rough boards. These were taken out with a needle between shows. When I left East Anglia that weekend I was no longer green. With violent and intense experience initiation comes quickly although one is not nearly expert or mature; the *duende* starts to break through. This was so later, on the battlefield in France. So when we left we at least had an act – that most valuable of all things to a music hall artist. Not only myself and Carlotti, but also the girls had become one with it – my beautiful Maidens of Crete as I called them, doing their labyrinthine dances, awakened my golden sword.

Henri waved a friendly good-bye at train call on Sunday morning – we were heading north, he south, to follow his destiny by sacrificing his daughter to the gods twice nightly. The others were gathered in groups as always on the platform, laughing and gagging to each other, enclosed by their profession, their strange clothes, their way of life. The comic with his long overcoat but not his gladiator's helmet, the tall family of jugglers, the girls in a small herd for warmth and a young Jewish tap-dancer who liked Karin. His name was Lew Grade. Other people – the rest of the world – were different; they were always the audience. I had stepped outside the chain gang forever. I would be privileged to see the world from back-stage, whatever I did. The outsiders were the amateurs. It is the basic man who is of most importance – the man who writes his symphony because he has to, the huntsman who hunts hounds because that is his life, the painter who paints while the bailiff sits in the house. We danced and juggled and sang, even though we had been hungry, and were enough in love with our work to risk being hungry again. Among these was Carlotti, tiny in her fur coat on the cold platform; she also must be counted.

I toured with Carlotti for two years, working mostly number two, and sometimes number three theatres such as the Star, Bermondsey; the Hippodrome, Hulme; Barnards, Chatham; and the Canterbury, Waterloo Road. It was a gruelling life with little to commend it in winter, working at draughty theatres with damp dressing rooms and arriving at mingy digs, sometimes bug-ridden, on a Sunday afternoon in the Industrial North. Somehow we could not leave it, though I was sure it could be better than this. One thing was certain; if you could quell these audiences you could work anywhere. I hoped we would soon go south – south of London – until when I would not be happy. We did late cabaret at hotels and summer shows by the sea. I never felt quite content with Carlotti as a partner: it was incongruous and was probably the reason she no longer got good bookings as in her earlier days; yet she knew I would not leave while Greta was there. She was so heavy I often fainted when the tabs fell. If she was angry she would tap me below the belt in the testicles with the wooden blocks in her

ballet shoes as she went up in a lift. Being strapped tightly forward the pain was terrible; I had to hold her above my head in front of a full house without flinching.

I began to notice that this happened when Greta and I were taking too much notice of each other. We would have to return to the underground messages through Karin. But Karin, after all, had her own life to work out and wanted all the freedom she could get while on tour. Sometimes Carlotti would stand dead weight on stage, not giving her timing leap – the little leap from which the next lift was timed and gained its velocity. I had to lift her as she was. Although I had become much stronger, this needed endurance because I was not schooled in lifting dead weights. Before an audience one always smiled – never showing exhaustion, fear, anger or hatred. Often I was full of each emotion, with tears of pain running down my make-up and perspiration on my face. Although I was young I thought that I was being killed, slowly sacrificed to some great monster that lived in the labyrinths of life, for whom Carlotti was a ridiculous priestess. Until the Fates arranged that I should meet Alexander Zass, the Strongest Man on Earth – or so said his billing.

My wish that we should go south had been granted and we found ourselves booked for the theatre at Guildford. It was summer and the fields and river seemed particularly green and lovable because they were of southern grass and southern water. Greta used to slip away with me in a boat, as we did at Tempsford a little later, and spend hours of unimaginable happiness rowing through the lock gates and down to wherever it went and back.

I did some small paintings. I found this adventure excruciatingly beautiful and exciting; violet punching into ochre and blue shrived into gold; pregnant green bursting the fertility of trees; columns of oak bending to support forest majesty; coaches of clouds; processions of buttermilk fields; all interpenetrating lust and love and the magnificent tower of hope that was my life. The miracle of the vibrations of these ends of experience making patterns of existence, translated somewhere between paint and emotion, leaving one breathless and

inarticulate, were the eternal thing of living beyond the body's bone frontier.

The theatre was small, as I suppose all those music halls were, but for that week anyway it had a special significance because of Zass. He was not in any way a beautiful person nor had any special qualities of appearance that I remember. He was short, stocky, very broad, with good muscles not over-developed. He was losing his hair. He was over-grown at rehearsals and wore a shabby blue serge suit. But he gave out an impulse like a strong dynamo which was quite silent. When he shook my hand it was like bonded steel.

'*Russe*,' he said, when I said Russian. '*Russe*.'

'*Russe*,' I repeated.

'That is good! You will lift anything in time. I am the strongest man on earth. That is why I am call Samson; because I really am strong.'

Carlotti was standing nearby, fully clothed. Without any warning he took her by the back of the neck with one hand and the ankles with the other. Being a professional she immediately went rigid and he picked her up completely dead weight as though she were a plank of wood, twisting her this way and that, then without any apology put her down and went on talking to me as though she were not there. Then he did the same to Greta, but after setting her down he smiled with his hard blue eyes a smile of approval.

'I do the same for you, Carl. Carl, you call? Yes, Carl. But you know I not shoke. You work all ze time and you be as strong as Alexander Zass.'

'Yes, I'm sure I will,' I said, feeling awkward at being so much taller.

'You grip wiz ze mind!' he said, pointing to his brain, 'and 'ere – ze 'art! – then wiz ze 'ands. Leeft.'

At this point his wife shouted to him and he went to the far corner front stage by the footlights and she to the far opposite corner back stage only much higher on a pedestal. They faced from opposite corners on the diagonal. She had a large monkey in her hand – it was probably a capuchin. He shouted and the creature leaped through the air in one enormous leap and

landed on Samson's shoulder with tremendous force. This was followed by another and another. I marvelled how he took the impact with only a slight lurch backward.

'I train them like zees every morning,' he said. 'Nosterova, Mister Carl. Your health. I drink your health my good friend, when we go out.'

The monkey act was his wife's who worked it separately. She was a dark, fierce person who was in her thirties. Samson's act was quite different and a source of great interest to me; so much so that I watched it every night, to see how he did things. He started by picking up a 650 lb girder, and there was no kidding about its weight. The local boys came out to try it on stage but were not able to out-do this proud little Russian in his leopard skin and black straps on his wrists. He performed neatly, succinctly, with steel cannon balls, catching them on his neck with a thud, and then turned to a trick which was something like the one Henri the Acrobat had done – only in reverse. Instead of balancing his daughter on his forehead, he suspended her by his teeth, playing the piano, while he hung upside-down from the flies by one foot. It was a sensational performance and as he slid down the rope afterwards, he leapt forward, took a bow with his daughter and the tabs back-stage opened revealing a white pony from the Russian plains of about ten hands. Samson walked straight up to this and as a final announcement of his strength took it from its pedestal on his shoulders and walked round the stage with it, to wild applause. He, in turn, watched my act and gave me all manner of tips afterwards.

During the day Samson arranged a picnic in which we all joined, travelling to the Hog's Back in a circus van which even contained the horse and had scrolls and horses painted on the outside. When we got to the field where we spent the day we rode the horse, whose name was Vladimir, while Zass rested in the grass drinking beer and eating apples and ordering everyone about. I believe we took the monkeys also, but I have always disliked these animals, deeming them too near in evolution to be loyal, having both the secrets of animals and men, without the refinements of either. There was something

marvellous about these days of thick treacly sunshine with the girls slithering about in the dry grass and myself showing off on horseback till I was thrown headlong over Vladimir's head into a bush, one leg of my trousers torn right off and my naked torso scratched. Some wildness Zass carried perhaps; some love of natural places and things; some vitality which men are fast losing and women have forgotten they had. Whatever it was we loved being with him because then we were all fully alive. And I enjoyed walking back to the theatre with one leg of my trousers missing because the people in the streets of Guildford stared at me and laughed and I was the centre of attraction and did not care about the dangers of the evening performance any more, felt bigger and better because I could face them and knew the perils of an artist's life; just as when I strutted among the boys in the rear after my first street fight in France. It is because, in some way, the gaps in the soul are filled, the *duende* is awakened and ready at any moment to leap forth. I did not even care about Carlotti and her mean tricks.

Zass disliked Carlotti as much as I did although I said nothing to him out of loyalty. He picked up the vibrations and also saw what happened on stage. I had been dancing with her for two years and was no longer the greenhorn that had crashed into the footlights. I knew what I was doing and what she was doing. Also I was still being paid only £3 a week.

'You must get someone younger,' he said one morning on the empty stage when he was trying to teach me to flip-flap from one end to the other. I found it difficult to throw the body over and forward by casting the limbs in front of myself and allowing them to pull me. Greta came down and we did a few lifts.

'Beautiful, Carl. Beautiful! Why are you not togezzer, my friends? She is a lovely girl. But Carlotti – huh – my monkeys are better. You see, Carl, zee man ee can go on till feefty or an 'undred years old. Ze voman – dirty an' she is kaput. Zee man can keep strong,' he went on, tapping his shoulders, 'but zee vizage crinkle, that is all. Always the vizage crinkle. Zee woman can only be good a little while – till she dirty. Keep always young, *Mesieur*. Work always with ze young woman –

never ze old. She have young body, she give her strength to you. Carlotti *kaput* – donfor. But you, Carl, you are very fine artist: you need zee *belle fille* to explain you.' His wide generous smile spread across his face and he knew his meanings had gone over for he had spoken our own thoughts. 'It's ze Beeznis, Carl! Ze Beeznis.'

Then a sad thing happened that evening in the first house, when Zass was lowering his daughter and the piano to the ground. The weight of the load had just been taken by the stage and Zass turned to slip his foot from the loop that held him. As he did this the rope broke and he fell twenty feet from the flies, hitting his shoulder first on the piano and then on the boards. The audience drew its breath. I stepped forward from the wings to help him but someone stopped me. I think it was his wife. For a moment he lay there like a wounded animal and the audience sat in hushed silence. I thought I heard him groan, but if I did it was drowned by the drum that started its fast beat at that point. Samson started very slowly to get to his feet with one arm hanging at his side. The tabs at the back parted slowly revealing the white pony and, as if he went to gather his own soul about him, he walked slowly up to it, lifted it on to his shoulders and stood in the centre of the stage amid a deafening roar, for even we were shouting with wild excitement. Then the curtain fell – and he with it. The remarkable thing is that he repeated this in the second house without flinching and with a face as white and transparent as alabaster.

When I went to see him he told me to go away. He went mean and stayed that way until every show for the week had been performed. Only his wife and the monkeys were allowed in. It may have been the beginning of his own defeat, I never really knew. I only know that at train-call that weekend we saw his circus waggon pass down the road and head in another direction never to cross our path again. He had opened up a great deal and given me for the first time the power of decision. There was now a hard centre. It was a privilege to know him; to work with him even more so – this man who had entertained Tzars. The Strongest Man on Earth, Alexander Zass. May that be his epitaph, wherever he is.

Icarus

As the weeks went on, growing into months through the long winter, we moved from town to town, north again of London which I always looked upon as the perimeter of my soul. The squalor, the black skies, the brass attitude to life in the north did not appeal to me, despite the glimpses of symphonic landscape.

> 'O, for a beaker full of the warm South
> Full of the true, the blushful Hippocrene,
> With beaded bubbles winking at the brim
> And purple-stainéd mouth;
> That I may drink and leave the world unseen
> And with thee fade away into the forest dim.

So I read Keats on the long train journeys, to look out of the window at the rooftops of Wigan in the drifting rain and smoke when my eyes were tired.

Late one night after the show we took ship at Bootle for Ireland and steamed down the Mersey in thick fog. Sirens and hooters were blowing mournfully. Standing in the stern with Greta another ship loomed up and passed so close that we reached out and touched it as one would do in a dream. We had almost been run down. Only being together seemed to save us. We remained at anchor two days. There was no food on the boat after the first day and nowhere to sleep because to save money Carlotti had booked us steerage. There was a gang of Irish workmen there who sang hymns all night while we tried to sleep among packing cases and ropes. During the second day the fog cleared and we crossed the Irish Sea at night in the moonlight, watching the Isle of Man jagged against the sky, the water encrusted with silver light, the sea

in quite a deep swell, till we watched the dawn break over Ireland.

Then we were in Dublin land-sick. Dublin, the city of Yeats, James Joyce, James Stevens, with its cabs and brakes, its trams and government buildings, its Post Office and its Abbey Theatre. There were Irish soldiers in deep green uniforms outside a barracks, girls with luminous eyes inside the trams, bare-footed urchins begging in Grafton Street and horses clattering among the traffic. Ireland not long after the uprising, a decade or so, but I could not comprehend what had happened there. I loved it for its poets and I searched for them in the streets. Our digs were at Rathmines where swans worked the territory between the canal and the road we were in, rooting in the dustbins and among the garbage along the banks. No 'wild swans of Coole' here, I thought. The terrible realism of life began to break in on me. In a shop near the theatre there was a Chinese carpet displayed on its own. It was a quiet pool of amber to the mind in the moonlight late at night, after the last show when we walked back tired to our lodgings. Tired from the dances, tired from the critics, tired from the priests who filled the front row of the stalls to vet our show and the girls who were in a scene called *Joie de Nuit*, which was daring in those times and may well have foreshadowed *Oh, Calcutta!* Who can tell? We were attacked bitterly in the *Catholic Times* for 'obscene and disgusting gyrations'. We felt sick. At the weekend there was a quarrel with the landlady who tried to over-charge us at Rathmines. We were glad to leave the green shores of that floating isle, which I have always thought of since as the image of a man with a broken thigh and more than a touch of genius.

Whenever it was possible Greta appeared at my side in the wings, like a shadow, always gentle, recessive in her black satin evening dress or her Japanese silk kimono. Sometimes we slipped away to the cinema in the afternoon. We spoke little; it did not seem necessary. I was nervous and full of *angst*. In Scotland, one happy sunlit day, we climbed to Arthur's Seat above Edinburgh and I did another of my early paintings, of Inchkeith Island. The wind blew through our hair, the blue

mountains in the distance seemed to guard our horizons. Karin was out most of the time with her Jewish tap dancer who later became a millionaire. We saw her only at work; always she was full of the love of life and of enjoyment.

All that went between Greta and me linked our lives in a marvellous way, coupled by chance meetings in the corridor of a train or the deck of a ship at night, understanding through poetry and painting and sometimes music. So when Carlotti suddenly announced one day that we would be out of work for a couple of weeks I was taken aback. The homeless travelling life had established me in a way of living to which I was suited. What on earth would I do? Besides, I would not see Greta.

In the dressing rooms I spent all the time between shows trying to write a book and to learn to draw; to paint even. Always hankering after these things but knowing I could not get near them or master either one till the focus, indeed the centre of life was shifted. The dancing was a visual art where one was *oneself* the image created. It was hard; it taught the discipline the artist must have and only he can assert. It made me tough, gave me stamina and developed that progressive obstinacy I needed to go through the privations of later years. Beside this it gave me awareness of the human form in space, of velocity, of harmony, articulation of forces, rhythm and growth. Things which belong to a set of natural phenomena that govern the universe, and with which every good artist must be in touch. In later years when I found myself among self-styled artists – painters and sculptors – I was amazed how ignorant of these things they were, and of the work of the great artists going back to the dawn of time: as ignorant as were many of the poets I met of the sources of poetry. I wondered at their lack of experience in these fields and how their intellects compensated so poorly for what their hearts did not know.

I did not want to go home, to be involved in difficulties besetting my parents. I was away now, a man. Let it be that way.

Standing on the deck of the boat with Greta, her hair

blowing against the sky, her eyes like the night sky, I asked her what she was going to do.

'I'm going to stay with my brother again,' she said, smiling, as she always did, a little quizzically. 'You must join us. He has moved from Lyme. Since his prang he has had to live in the country and be quiet.'

'What was his prang?' I asked, feeling a little jealous.

'Didn't Karin tell you? He dropped from a great height and his parachute didn't open until it was almost too late. Then he got dragged along head down over some very rough country. It sent him a bit potty for a time I think, poor boy. But he is all right now as long as he is not emotionally upset by anything. He is writing books.'

'What sort of books?' I asked aggressively.

'Air thrillers, I think you would call them. They are rather good really.'

'Oh,' I remarked with some trace of snobbishness. 'Really!'

'Oh, he is not a great writer or anything like that but he is dying to meet you. Do come. They have a spare room and specially asked me to invite you.'

I was withdrawn, guarding my secret life as the sacred cats of Egypt guarded the Temple of Baster. How would I find this flying officer and author of books? I was afraid really. Yet I wanted to be with Greta so much that I accepted, knowing the money I had saved on tour was now bespoke.

'Don't tell Carlotti, for Heaven's sake,' she whispered as she touched me gently on the cheek with her lips and vanished below.

'Of course not!' I replied to myself when the surprise was over and I was feeling that lovely thrill of giving way to one's destiny. 'I would love to, darling,' and settled to watch landfall in first light; however hideous in the industrial north, always beloved when it is England.

This moment was important to my whole life, not only because I realised my love for Greta but because I was going to stay in the country with an author; because it was to be by a river; because it was to be a time of quiet and beautiful experience. I had only stayed in the country once before, when

I was a boy at a place called Apple Tree Cottage in Suffolk. It was a very old place with ladders taking you to the top rooms, so different from anything I had known. The experience was always with me and was connected with some fairies we saw there. I never understood why my aunt who had the cottage should later have killed herself. This new visit to the country was to be a setting of the parts of the future.

When I arrived at Tempsford station I walked along the small platform on to a gravel road between fields thick with the yellow of buttercups, the green of leathery grass under tall poplars that waved gently, and cattle that moved in a curious somnambulistic fashion. The call of the late cuckoo. Little parts of Beethoven's Sixth Symphony travelled through me and although I could not whistle them right, sounds came. It did not matter. It only happened when I was happy and to-day I was very happy, happy as the brimstone tumbling over the hedgerow, foxglove, campion, meadowsweet, valerian and cow's parsley.

The world of the theatre in which I had lived for over two years fell away like a skin. I emerged, a dragonfly with burning wings, on my quest for life. It seemed that the nymph that had been living out its dark life at the bottom of a lake over which winds were turbulent, had suffered a metamorphosis. Now all was quiet and the waters clear.

Then came the gate with a winding track across a field to the cottage by the river. Greta came out of the door in a dress of red and white striped poplin, her eyes the more blue for her being sunburnt and her arched feet like curiously beautiful sculptures in open sandals. Our groping toward one another all those years at this moment became alive and real. We ran until we met and kissed, becoming one hermaphrodite form, which is man and woman.

'You *gem*!' she said breathlessly. 'I'm so glad you came.' I wondered how anyone could count me as a gem, not realising that the magic of harmony which is love was working in her as well as in me. When that happens there is no dichotomy and no devaluation.

Her brother, whom I call Icarus, was not tall or particularly

impressive, but he was a man of great vitality with the external personal charm that often goes with an Air Force commission and the understatement of achievement. He had a brooding melancholy in his stormy eyes that can go with the man behind the person who becomes the officer. This made him a little self-conscious at becoming a writer, because the problem for a writer – or one of them and they are many – is to be able fully to expose and at the same time to find a suitable armour for his secret life. The failure to do this so often brings superficial books out of a man who is capable of writing deeply. It has always seemed to me that poets have wings. Perhaps only those who fly near the sun and those who fail to fly speak with the tongues of angels. Yet this man, as I knew him, had flown near the sun and spoke only with the tongues of men; but he was not inarticulate and was without the high-mindedness that emerged rather pompously from Leopold and me, under the guidance of our philosopher friend Claudius Lantern: our searching into the work and lives of the great men. I never wanted to alter the world because it seemed to me that it could only alter itself by growth and that could only be from within each person. No amount of building by incompetent and immature people could bring about a better place. I was in this sense a non-political animal. The better artist I became the more it would illuminate those about me. So it seemed right that Icarus should write his books in the country and say what he liked if he wanted to say it. And if he didn't say anything profound, his books were exciting and entertaining and not badly written; he made me feel what it was like to fly.

After hours of his reading aloud I began to realise the energy needed to extract the nerve from experience and transplant it into a book. It is the level of the experience and the way it is handled that gives quality to the book, made moving by depth of feeling and sincerity with which it is written: without sincerity a great book was never written. While he read I sat by Greta, so anyway the hours did not matter. Icarus's wife, a tall good-looking woman, handed him pages and chipped him about his embarrassment when he came to the love scenes. When you read the books of Icarus, however violent they are,

remember he is gentle at heart and that once he flew near the sun; too near perhaps.

> He felt his wings singe
> The wax melt
> With fire,
> The sun impinge,
> Fountains of light,
> The cool rains
> Incisions of prisms,
> Spectrums of desire:
> From this great height he fell
> To the dark earth.

The days were not separate but glided like the river through dark and light of continuous experience, a process of being alive, with sudden flashes of understanding, of sunlight on the water, a rainbow crashing into a tree, an orgasm of thunder, a child drowned by the lock; then the sun again. We slid on the slippery surface of the river for several miles as we had done at Guildford that week with Samson and re-gathered something of the same delight. Swans were with us and a great pike watched my hand trailing in the water; the musk rat gnawed at the root of a tree; a heron speared a frog. Only by the emergence of ourselves from our own horizons of experience was the limit of our awareness governed. When the great sunset wrecked the trees we submerged again.

As the week went on there were talks about Carlotti. It was clear that we must break away or we could not realise our love or our art – not grow therefore. It would take time; a little money. Icarus was in sympathy. He would help. He wanted to see us dance together and together be. We all agreed it was impossible to tell Carlotti because of her jealousy and because she would naturally fight with everything to save her act and keep me. She would bring the whole family down on Greta and try to crush her. It must be done secretly; the underhand way, the way of cunning and clandestine planning, of lies and intrigue. The women were less kind. When I remarked about this and said I felt sorry for Carlotti, they flew at me.

'Well I don't,' snapped Greta vehemently, which was unusual for her. 'I've been with her, teaching her bloody kids, since I was four and a half and not a word of thanks ever, and not a penny extra. She won't even allow me to understudy her which is the reason I've stayed so long. You know that. She's a greedy jealous old bitch!'

'Take it from me. I can see from *outside* remember,' said Icarus's wife.

'Yes, but it is a bit underhand,' put in Icarus. 'Can't we be more open about it. Tell the old bitch she's done and you're not staying, so that's that!'

'Oh, don't be so naïve, darling – it's the business. You know very well what would happen. The bottom would fall out of the whole bloody thing. She's as crafty as a monkey. Take my word.' This was Greta and her brother replied right away, realising she was right.

'That settles it. I gather you've had enough. I don't blame you really, knowing what I do. Anyway I'll keep mum in case she comes down and does me for letting you hatch your plot in my cottage.'

I tried to remain neutral. All I could do was to think how to arrange new dances, set them to music, get them properly orchestrated, master new lifts and swings, get to know the business and meet some of the agents without Carlotti getting to know. I must design our own dresses myself and somehow get them made. In all this I would need help, but the extraordinary thing about starting on a new venture is that the people and the money needed to make it work appear from nowhere.

I lay under a lime tree by the river talking all this out with Greta. Neither one was innocent of the other when we had finished.

As we drove to London next day in a coach she held my hand with her long fingers.

'What a wide hand you have,' she said. Then added, as if she could see into the future. 'One day we will live in the country in a cottage like Icarus has, and you will paint and carve stone.

It will be like that later. First we must fight it out on the stage.'

'That will be fun,' I said. 'Now I've got you. When we work together. When we are free from Carlotti. Yes, it will be fun. Shall we get married?'

'Yes, later. Later on.'

6

Splitting Apart

WHEN we arrived in London I took Greta to the National Gallery to see the 'Self-Portrait' of Rembrandt that was so like her mother: or so I thought. He smiled gently upon us. It was as though, out of his great passion, out of his disillusion and out of the tranquillity and pride of old age he felt compassion and spoke.

'Do not be deceived. To do this thing you must be inspired, but also you must be tough, you must be unrelenting, must have stamina, must not falter or be dishonest with yourself, must endure poverty and know those that lack charity – the husk-hearts, the dissenters, the disbelievers: know the sting of their mercy, the sourness of their gratuity. Learn to be alone, to work across the empty fields of hunger, to contend with evil and bear with traitors, ignore those who pretend: never to deviate, to stop only to rest and not to despair. The mission of the artist is to bring God to the eyes of Man and Man to the eyes of God, so that they see each other in the same mirror and there is unity and something of mystery is revealed.'

He spoke in silence and in silence I listened with my inner ear, for I felt I was an inspired man.

Greta was dressed in a red cord suit and a black hat. She clung to my side and smelled the tweed, the tobacco smoke and the personal smells in my jacket that delighted women before we learnt to deodorise ourselves. She was pressing my hard arm. Her breast was burning.

Proudly the 'Fighting Temeraire' was towed to its last berth; proud too was Goya's 'Donna Isabel Cobos de Porcel'; cool among the rocks was Da Vinci's 'Virgin'. From these was shed an everlasting light that had come from the painters' brushes: or was it that they awakened the soul? I think both.

When we came out through the tall hall of Madonnas dreaming their tranquillity upon us, we stood for a long time on the porch watching the fountains of Trafalgar Square in the sunlight and the vista of Whitehall with its traffic beyond the square. There were still horses, their hooves clattering, brasses flashing, but it was becoming more and more a slow procession to the show ring as the motor cars progressed. I told Greta about the night I had returned from Lyme after seeing her and had spent the next night watching the tramps asleep – of the young man and woman and how they came out at three in the morning alone in the face of the world because they loved one another.

'For life or death,' said Greta, 'that is how it should be. That is how it must be with us.' She spoke out of herself as if she did not quite realise what she was saying.

'I believe you,' I replied. 'When a direction is taken there must be no turning back.'

We descended the steps and passed the pavement artist, Rem, by St Martin's-in-The-Fields, who was at work copying a Vermeer direct on to canvas with oil paints, and a convincing amount of skill. We passed the Irving Memorial where there was an escapologist at work in some chains, on Charing Cross Road, the home of the theatrical agents, a rendezvous of all actors therefore, from Shakespearian to music hall and from acrobat to juvenile lead and principal boy.

The Express Café opposite the Alhambra was full of professional people talking business, looking always unique in their long overcoats and wide-brimmed hats; the women made up to the nines in fur coats. We had got a table and a waitress to serve us and were talking over the problems of rehearsals when who should come and sit next to us but Karin with our childhood friend, Maryrose Mackilligan, now an attractive slightly Jewish blonde chorus girl of my own age, beautifully dressed in a grey tailored suit and a teddy bear coat swung open.

'Christ! Fancy seeing you two,' they cried. 'Have you been to the agents yet?' Karin, who was wearing a close helmet hat fitting her long black hair and loose tweed coat, had a penetrating voice. I was worried she would let out my secret.

'Don't be silly, darling!' she shouted when I checked her. 'Mac knows it *all*. Everyone knows. They are all tickled to death; think it's marvellous you two going together like this. It'll be a marvellous act; just like brother and sister. Won't it, Mac? I mean don't they? Bloody marvellous. That's what I think!'

'Yes, I know dear,' I interjected, 'but I don't want Carlotti to find out. That's all.'

'Oh, nonsense,' said Karin in a loud whisper. 'That silly old bitch. I've left her anyway. I shouldn't worry about her. She's finished. And anyway, my dear, you two will be an absolute riot. Mark my words. You'll bring the bloody house down. Won't they, Mac?'

'Yes,' said Mac in a slightly affected voice. 'They'll stop the shew!'

Greta, who was usually quiet when there were a lot of people about put in a word now. 'Where can we rehearse? That's our problem at present.'

'What, near here?' asked Karin. 'Dean Street; anywhere like that. It's not a problem, the place is honeycombed with rehearsal rooms.'

'No, dear. Nearer home. You see, if we work our act up here in the West End it will leak out before we are ready. Near home, even near Carlotti's home, anyway in the suburbs, we are more likely to go unnoticed.'

'I see what you mean,' said Karin, puckering her mouth and pushing up her chin like the toe of a boot. 'I know. I'll ask Daphne in the troupe. She might get you in at the Gymnasium down Lower Sydenham. Her Dad has something to do with it. Anyway I'm off. There's a new production at the Coliseum called *White Horse Inn* with George Robey. Mac and I are going to try and get in that. Come on Mac. Better than messing about with old Cardboard Botty. She wants a good man, my dear. Something really strong that makes her teeth curl.'

'You are awful,' drawled Mac as she followed her, laughing. 'Cheerio each!'

Karin got up. 'That's right, kid. Come on. I tell you what,

you two go and see Daphne yourself. Her Dad keeps a shop in
Lower Sydenham just by the Thingumabobs.'

'Yes, I know,' I said, kissing her good-bye. 'Be good.
Cheerio Mac. Good luck at the Coliseum. I saw Grock there
once; he was fantastic. Did Pat Aza book you?'

They were soon lost among the other pros and we sat talking
longer under the hum of voices and the drone of the traffic
outside.

This was the last day of our holiday really but we had
wanted to stay together; that is why we had come to the
West End. The day wore on and it started to rain a little; we
knew our holiday was over. So also for a time was our being
together. The awakening to new experience often happens at a
time when the daily rhythms of life are broken up in freedom
and one is able to see their meaning. It is difficult afterwards to
fit them in to old disciplines: they simply won't go. In our case
it was going to be a major change so it would be quite a
problem. On the other hand there was not the constriction of
an office or a factory to contend with. Nevertheless we felt sad.
Greta had to go north to Hampstead, I south to Norwood. We
parted in the Underground. She slid away down an escalator
into the roaring caverns below, while others standing bolt
upright like corpses, levitated towards and past me on their way
to Heaven. Greta was gone. She had made me feel like a royal
person, but alone I felt shabby with only the modest things I
kept alive inside myself. She was like Cinderella when she was
swept back to her kitchen after meeting her fine prince. I had
met my princess and, indeed, the ugly sisters.

I went back to Trafalgar Square and caught a bus directly to
Sydenham, sitting on the open top with the seat cover up to my
chin and the rain trickling mournfully down my face. Clapham
and Peckham seemed more beautiful in the rain and it did not
seem so tragic that everything was built of stone, though the
roads were mostly still wood and gravel, except where there
were granite cobbles between the tram lines. The great trams
were always dramatic: they roared down between the brightly
lit buildings like yellow dragons. The lights made long streaks
of colour in the wet road. The newsboys were shouting and the

barrow boys were lining the curb with their naphtha flares burning like catalysts and their brightly coloured fruit and vegetables in wild display.

Later on the journey I passed a Catholic Seminary on a hill. Along by the road there was an opening which was the entrance to their place of worship. I remembered being here when I was quite young with some other boys older than myself, who dared me to go into the place and blow out the light that was burning there. This did not seem to me a very daring thing to do; I was not a Catholic although I had an innate respect for any place of worship. I entered quietly into the cold stone building, golden with the single light that burned there and, moving towards it, blew it out. When I came into the night again my friends had run away, laughing and shouting: 'He has blown out the eternal light!' I felt terrible. I had a feeling of great emptiness which for years always returned to me whenever I thought of this incident. The act had a deep impression on my young soul and as I thought of it on that night passing in the rain on the top of the bus I resolved that my life be dedicated to rekindling the light, illuminating, however faintly, all that which should go on around me. This I have never forgotten.

When I got to Sydenham I had to get off the bus at what we called Cobbs Corner, because it went on from there to Forest Hill where Carlotti lived. I walked over the railway and passed the road where the Mackilligans lived, and where I had once seen a huge drunken doctor recite Blake on his front steps on my way home from school, down the main High Street where memories crowded in on me, right down to the lower parts of the town where I was born. There on a bend I found the shop I was looking for and Daphne with her marvellous huge eyes and inviting mouth serving the last of the cakes, dressed in a white overall and chef's hat.

'Yes, of course I will help,' she said joyfully, showing her white teeth. 'I wondered when this was going to happen. I'd find Dad now but I'm afraid he's baking. But don't worry. I'll tell him later on. I'm sure it will be all right.' And all right it was. In time of change everything happens of its own. You find

the links instinctively because you are timing your life with others and with the universe. It is a matter of faith.

Two days later I met Greta in Lower Sydenham and we made our way to a big gymnasium in a field by arrangement with Daphne's father. It was a beautifully equipped place with all the things necessary to get myself into tip-top shape, but no atmosphere for the dance. Going into so huge a place and trying to find life and rhythms was difficult. A portable wind-up gramophone was all the music we had; it sounded thin and tinny. I had not reckoned with the kind of difficulties I was to meet by being on our own, without experience of how to form and weld dances together. Not having worked for two or three weeks I felt every muscle in me aching and I had to set myself a tough schedule of exercises and rope-climbing to get fit. The lack of place-feeling was the worst; we could not get any continuity into what we intended to do: this factor is of great importance. Often since, when I have been working continuously and well, I have gone to a new theatre that has no ghost of its own, and one's own *duende* cannot be awakened: the dances have been disconnected and unreal until about the middle of the week. So starting in a strange gymnasium was like starting at the foot of a mountain – on ice. Worst of all, being used to Carlotti's weight and shape and timing, length of arm and leg, I had to adjust all my own judgements to Greta's way and dimensions. Moreover, Carlotti's will, Carlotti's integrity, Carlotti's courage and presence of mind, Carlotti's experience: all these were gone. So she was right after all. I had to find it in me to take their place. It was good that it was so, that Greta was passive and only wanted to follow. I had to find the will for us both, to master myself and her, and to impose myself in an overwhelmingly difficult situation. Bit by bit, stage by stage, step by step, we worked together over and over again, until after a period it got a little easier, then worse, then easier again, and one day we suddenly found ourselves in each other and started to move in harmony: the dances formed themselves. In other words we were being created by them.

Meanwhile I had to go to Carlotti every day, after a week or

so, or she would have wondered at my taking so much time off. After practising with her in Forest Hill I had to go to Lower Sydenham and practise with Greta. Sometimes Greta was also at Carlotti's and I had to practise with them both. If it happened we were asked to do a particular lift for Carlotti to see – for I think she was now sensing danger and beginning to think about us working together for her – if this happened we feigned incompetence, struggled desperately and fell. This made Carlotti crow a little and she never failed to remind us how long it would be before we were good enough to be anywhere near appearing on the stage together. Sometimes I was worked particularly hard at Carlotti's and because I had no money had to walk to the gymnasium to work with Greta, often not eating. How I had the staying power through this period I don't know: nor how I made the gymnasium come to life, to achieve something of a *satori* in the dance with only a scratched record gurgling in the background.

It was a nervous strain also; especially the deception, which was done with consummate skill. Carlotti never realised what was going on till the time came.

Carlotti and I did another string of dates with Greta as head girl. Out of this I saved to buy my own props. This was not easy since I sent a pound home to my mother after paying for my digs each week. It was never cheap to have theatrical costumes made to measure but always worth while.

When we were away, practising was not so easy. We dared not let rehearsals go or we would have to start all over again. One was a highly trained animal and this one had to carry with one as though one were a fine greyhound needing the most sensitive attention. Sometimes, when we were working a seaside date, I would pick Greta up in a lift on the sands and throw her into the waves as if for fun. But this usually ended in Carlotti showing off and she and I giving an exhibition from one of the small bathing rafts, for all to see that she, Carlotti, and not Greta, was the person billed at the theatre. I always contrived to finish these sessions with a swing and by getting up enormous speed, throw her as far as I could out to sea, leaving her to swim back.

So Greta and I had to slip away to the theatre in the late afternoon and practise together when there was no one about. We made love in the dressing-room, leaving me weak for the evening show, but I no longer was able to hold the flood of life locked back for so long. Usually I stayed in the theatre after this and made-up for the first show – always a lesson in portrait painting: face in the mirror. At last I began to see myself for I was no longer angry. I often got in an hour's drawing or writing at a huge romantic novel I was working on. At least by meeting in secret we got in some stage experience before our debut, which I did not have with Carlotti.

We met also to plan the new act. This was the first serious attempt at creation I had ever made. I could draw well enough by now to work out the dresses and some of the dance positions and lifts. We both had our own ideas about costume, lighting, music, choreography, decor, and the meaning of our work, but did not come into conflict over these things: I think because when they were welded together into an art-form the whole thing mattered in terms of movement and sound with qualities of emotion that could not be defined.

Being inexperienced the ideas sometimes broke bounds, such as that of entering on an elephant to dance in the precincts of a temple or tomb where in the end we would be embalmed for eternal life and mourned by the whole company. This was left over from an early obsession with Tutankhamen and his Girl-Queen. It might well have touched the treasures the race of man has left buried in each of us, had it been done well – or done at all. These ideas were too grandiose and expensive to materialise on stage; at best they signified our desire to advance away from Carlotti's stale ideas. We had no experience but hers and after that our own imaginations to go on.

When possible I took Greta to see the leading adagio dancers of the time – Balliol and Merton, Gaston and Andrée – to gain new ideas and see the way they did things – even to use anything of theirs we had nerve enough to do. Neither of us had the courage to undertake the big dive from a sixty-foot pedestal, the girl being caught by the man at the last second. I am glad now that we had not.

For my new dances I exchanged my full evening dress with tails for a tailored black satin suit of my own design which had shape and elegance and was easy to work in, with wide Russian sleeves. Greta had a white satin dress with a long waist. I had suggested a red lining which showed when she pirouetted but it came out black and completely unadorned, as if to foretell her early death: who can tell now? She wore black earrings – I wore white.

Our theatrical tailor was a feminine gentleman who lived in a Georgian house filled with Louis Quatorze furniture and tasselled cushions. For some reason he insisted that Greta should wear cockerel's feathers, perhaps because he wanted her to be the man ('Cokes Feathers' as he called them). They looked beautiful but were torn off in the first dance. That was no good. The cost for all these things and for a costume for my Dance of the Storm God – a number created entirely by ourselves – was very high. I could not pay. But instead of telling the queer this I asked Greta what on earth we were going to do. 'Don't worry so much!' was all she said. I have always believed the anonymous donor was Greta's brother, Icarus, but was never quite certain, nor have I ever tried to find out; for the anonymity of the giving blesses the giver twice, and I would not want to spoil that.

I got the orchestration done by a musical director I knew and everything was finally gathered together – band parts, props, dances, make-up and finally our first date, booked through an agent in Charing Cross Road. It was the Shoreditch Music Hall.

The masterly way in which this was done precluded Carlotti knowing anything about it. I always had the feeling that Flavia knew and that poor lovable Amelia suspected what she hardly dared to think was true. I did not feel sorry for them because it would force Carlotti to give up the stage once for all and teach all the time, which was more profitable and offered greater security to the old sisters. The only thing they would lose was their freedom when Carlotti was on tour. Strangely enough it was only Carlotti for whom I felt sorry.

Finally came the last night at Cricklewood Palais de Danse; our last show together.

There had been a wrangle all week because the band parts had been twice lost: once at the beginning on the way to band rehearsal, when they had been found at the last moment, and once on Friday night when we had done a late cabaret in the West End. Nothing could upset Carlotti more. I had been driving round in the Citroën trying to find them. The brunt of the blame fell on me, even when they had been found again. Carlotti nagged and fumed all Saturday evening until it was time to go on.

The dance floor at that time was of sprung maple and covered with French chalk to make it more slippery. Having worked it all the week I knew it well: my feet were intelligent. There was no rake, no footlights, plenty of room: so much so that I could spin round the floor while I was doing one of my big swings, like the earth orbiting the sun, which caused a tremendous sensation with the audience. The unchoking of my youth by recent developments had brought a new audacity to the dance. I was looking forward to this last show with someone whom, although I still respected, I had also grown to hate. I think my hate crystalised when I surprised her rolling naked on her money – a bed covered with pound notes – and smoothing fivers over her body with her white podgy little hands; it seemed that all love had turned to avarice and lust. Perhaps, like the bitch rolling in offal, she was able to trigger off a sexual ecstasy. The effect on me was freezing, although it was a private affair.

The exhibition waltz went smoothly and without any hitch. To dance on such a floor in the open manner of the exhibition dancer, with wide gestures and perfect timing, was a reward which well paid for the terrors and strains of the past two years or so; and to have the girls in tall elegant hats and long silk dresses of the Victorian era, gliding round me, made me feel a prince among men. For the first time I was complete master of myself and of my job. After the waltz came the slow Adagio Dance, started by the girls again: a *corps de ballet* to introduce Carlotti, who did a solo before my entrance, then I walked up silently behind her and took her by the waist when she was still on the point. She turned towards me and from this I took her

by the outside of each thigh and went into a lift. As she ascended she did her old trick of tapping me in the balls with the wooden blocks in her points. The pain was so bad that everything went black. I gave out an agonising scream of silence, which is worst of all. I knew I had to hold on and not flinch while the pain was making a slow and terrible exit. No one knew about this except Greta who knew the dances and was watching closely. Because of the slow elegance and dignity of this dance I could find no way of relief until it was over. Towering with rage I danced the next dance with a real and consuming hatred.

It was the melodramatic Apache Dance. I throttled her in earnest, so much so that she shouted for me to stop. I flung her with all my force from one point to another, caught her from each dive and drop just as her nose hit the ground and grazed her chin on the floor in the swings, until the greatest chance really to terrify her came round. It was the double-ankle swing in which, with arched back and rigid body, she was heaved up toward the ceiling and down toward the floor at great speed. I was in perfect control. The floor was obedient to my feet. I was able to go faster than ever before, bringing her down the azimuth at sensational speed. A few bars before the throw I sent her as high as I could, turned her as she swooped downward by crossing my arms and, just before the throw, flicked my wrists sharply. This slight movement went through her rigid body like a message and cracked the back of her head on the floor with a sharp splintering sound like breaking ice, before I sent her slithering to the other end of the floor, be-lieving I had killed her, which was my intention. Everyone caught their breath. I walked over and dragged her off by one foot, amid roaring of the applause. By the time she had reached the side she had become conscious again. She stood up and looked at me in bewilderment; I looked at her without flinching. She walked away rubbing her head but saying noth-ing. I left the hall. I never danced with her and never saw her again. Many years later I heard she had died.

The Dance

'. . . there is only the dance.'
ELIOT (Quartets)

'How can we know the dancer from the dance?'
YEATS

7

Hall of Mirrors

EVERYONE gives you something in this life. Many years ago I was taken by a friend of the family to the Coliseum to see Grock. This was Uncle Willie's contribution to me. For the first time I saw a great clown. 'No one like him since Grimaldi,' said Uncle Willie. 'In the great tradition.' And although we went afterwards to a little restaurant in Compton Street, the D'Itali, and drank Lacrima Christi with our meal, it was Grock who made the whole evening. At first I was disturbed by that ridiculous image, not of a man but of some being from the world of fantasy, performing everything in reverse with deliberate artistry, obstinately proving the world wrong and himself right. His presence was powerful. I was spellbound.

It is said that the clown originally represented the devil in medieval mystery plays and was later developed through the fools and jesters of Elizabethan times. This is probably right. But it does not seem to be until Watteau's day that we see the lonely figure of the clown as he painted him; Grimaldi, Pagliacci, Grock, later Coco, Corelli and Popov. That a man who weeps or makes you weep should be so funny! No doubt he once knew evil. The clown is destructive, frustrates schemes, brings down the important person, jibes at the serious. In being originally the devil who destroyed, laughing, he learned later to imitate the devil and grow into a clown who made us laugh by upsetting situations; at whom *we* laughed and so protected ourselves from evil. He was the hunter who imitated the animal he wanted to kill, and that in turn we wanted him to kill. In this way humour has become much more than an attitude of amusement. It is a weapon with which we can slit open the pomegranates and pumpkins of pomposity, of

pedantry and indeed of persecution and the order of peckability, which are the modern forms of evil, sending their pips everywhere. Humour is a blade, which, recognising only itself, like a Samurai sword, slashes across the face of life, reducing it to an immediate answer. Heals dichotomies.

This miraculous old man named Grock, with his huge clothes, his vast boots, his absurd gloves and painted face, insisting the grand piano should be moved to the stool, gave us, with quiet methodical genius, an insight into life and into quite ordinary situations, which was touched with wisdom.

I had met Jacques in his spangled suit and clown's tall hat at the Crystal Palace Circus – he had taught me to ride the uni-cycle and was no doubt a direct descendant of Jack-in-the-Green: possibly an image of fertility as well as of fun. And later I had met poor Henri who never attained the attention of the highest circle or could be called clown but was a more humble kind of August or clown's Caliban who probably threw dung at the devil. Later I worked with Charlie Naughton, who was funny even getting off a bus in Whitehall dressed immaculately in a tailored lounge suit and a bowler hat; Nervo and Knox, both of circus families; and Bud Flanagan. Flanagan had something of the tragic loneliness of Watteau's 'Clown.' These people gave out funniness and sadness as part of their being, just as Ted Ray gives out comedy by his lightning flashes of intuitive invention. Chaplin was the greatest by presence as well as by situation. All these men have one thing in common: to make this strange and valuable comment on the human scene. To please and to make laughter is their great humanity, at best their gentle handling of tragedy. Men who learned to laugh at the devil and protect us from evil by themselves being fools. They only fail when they start to become philosophers.

I considered it a seal of fortune when I found that Harry Tate was on the bill at the Shoreditch Music Hall. For Greta and me it was our first show together: for him, it may well have been his last. I was enthralled with this thin man with his trailing moustaches and his peculiar alchemy of fun performing the earliest, the funniest and most disheartening automobile act on record, making the acid face of the deposed groom

stretch in laughter: an act that was father to the mad garage scene of Nervo and Knox in which Jack Train was stooge, all of whom we were destined to work with later. This experience with comics opened my life no end and added to what was a deadly introversion a touch of healing lunacy.

All dancers and acrobats who worked at the Shoreditch knew it was a dangerous stage, one of the trickiest in the business, and warned new acts of the snags: a narrow proscenium, a steep rake and a brick wall directly behind the backcloth, so that the woodland scene against which we danced held death in its sloping lawns. In our case the musical director, an enormous jovial man of twenty stone, named Percy Lewis, who had done the orchestration for us, gave us this information at band call on Monday morning and I was able to adjust my movements accordingly. I was thankful to know but there was no need to worry: we were young, we were beautiful, we were strong – everyone wanted us to win, and I had a good experience of rough theatres. In spite of the familiar tensions before a show, especially with a new act, I knew it would go well from the moment the overture began with a resounding march by Sousa. When our cue came we walked on to applause and whistles. The stage was rough and the space more limited than I had expected and I had to swing Greta out over the footlights and over Percy Lewis's head, but now with complete confidence; this gave the extra room I needed away from the brick wall. By the end of our last dance every hand in the theatre was clapping and the gods whistling through their teeth. We had faced an East End Cockney audience: from then on all would be well, for if they didn't know, then nobody else did. It was the acid test. Tomatoes and bad eggs otherwise. Lewis introduced me to Lilian Bayliss at the Old Vic.

At that time the variety theatres still had something of Sickert's world about them. I have often thought how much his glowing colour and tonal coherence emerged from the interiors of such places as the Shoreditch. The rococo plasterwork and gilt and blue and cream paint, the red plush chairs, the boxes and the railings across the gods were the same. The slow-moving safety curtain of solid steel lowered at every

interval during the adverts. Then the great red velvet swing of the main curtain like the swish of a woman's skirt. The brassy music of the band. The cigarette smoke and smell of beer. None of this had really changed. One could still feel the Master of Ceremonies and the chucker-out and see the true coster of Edwardian and Victorian days. Sometimes a Pearly King appeared in the box with his queen and her great feathered hat for some charity or other; a dark Gypsy face was seen to watch in the shadows; and once Harry Champion was called out of retirement to sing 'Any Old Iron' for the Artists Benevolent Fund, the powerful limelight transfixing him like a man seen in a dream – never to be seen again.

People were still hanging on to this reality, this breath of humanity and of humanism which was soon to die, to give place to the artificial, the plastic phoenix of hygiene and untruth which would rise out of the next war when the Shoreditch was completely destroyed and what was left of a robust age etiolated by fear of a hierarchy of midgets that was to rule the Atomic Era. The time was running to seed and had to be cut back. I only desired to know that the growing need to pretend to be real had not replaced the warm incongruity of being real, for this was our great heritage. It seems to me that the clowns carried the flame through a perceptive audience who would not see the extermination of full-bellied laughter and were not afraid. He who laughs has no fear of the devil or of the gods.

After our two evening shows we came out into Shoreditch High Street to buy hot roast potatoes from a barrow with a brazier glowing red outside the theatre, cutting into their floury insides with a penknife; even the earthy jackets were enjoyable. There was poverty, there was strength and danger, and a fierce beauty, none of which things were able to live in the sterile safety of a deodorised future after the corpses had been put away. So our laughter then can be counted of high order: also the hot earth that burned the inside of our bellies.

After our meal in the street we drank stout in a bar across the road from the theatre where a lot of comics and jugglers and singers and dancers were also drinking. Any night they

were there because of the theatre even if they were not working that week: it became a meeting-place in the profession. Never with Carlotti did I get this warmth, this feeling of being accepted into one of the oldest professions in the world, as old as human civilisation and nearly as old as prostitution, but always closed to amateur and idiot alike; the only idiot we allowed in was the clown. We worked and kept our high standards because it was a matter of love and of life and of death. Whether it was Bud Flanagan singing 'Underneath the Arches' with Chesney Allen, still touring with Florrie Ford, or Max Miller cutting us down with laughter, or Nellie Wallace with her skunk oppossum, it was done well because it was part of the psychic life of the people, by whom we were created and sometimes made immortal.

No wonder Sickert painted it. Sickert, like myself, was a stage artist, but at that time I was not yet able to paint. When my skill reached that point the variety theatre was gone. That, along with the gas-lit streets of London, along with the curious vitality of the people, must remain fôrever with Sickert's brush: as with Toulouse-Lautrec in Paris. There is no doubt that because of the closely knit community of the East End a great deal of its truth has remained and shown itself in the emergence of so many good comics and actors during these later years; Peter Sellers, Warren Mitchell, Frankie Howerd, Arthur Askey and Ted Ray all have the rich music hall blood coursing in their veins. But the atmosphere of which I speak was gassed out by the saxophones of the twenties, the poverty and unrest of the thirties, and finally the war. And surely the dances Greta and I were doing were more emblems of the next two decades and carried something of the future rather than the incongruity and raggedness of the past. In our precision we pointed ourselves forward to an atomic age.

Following the first booking at the Shoreditch London we had a rough time for a while. At the Star, Bermondsey, with its balcony right round the theatre as at the City of Varieties at Leeds, Marie Lloyd Junior was on the bill with Irene Kendall also, singing 'Just Like the Ivy': it was very rough here and an old-fashioned juggler nearly got slaughtered, but we won through the week. The warmth and glamour and friendliness,

indeed the success of Shoreditch, did not follow us to Chatham, where we worked at Barnard's Music Hall the week after. Here it was cold: the audience was thin and unresponsive.

We had joined a small group of artists, under a manager, who were to tour for a few weeks together. The group was headed by a trick act called Yedo and Fuji, in which a man – a tall Japanese – fired a rifle at point blank range through his wife. Also a mind-reading act called the Mystic Saxons, a couple who sang ballads in the manner of the old school. Ourselves of course.

Friday came. We were standing about on an empty stage in outdoor clothes waiting to be paid, asking one another when is the ghost going to walk. There was often anxiety in the music hall artist's life at this hour: he never knew what would happen. For my part I could never quite imagine money coming out of the dark shadows back-stage, even on the occasions when it did. Perhaps the saying: 'When does the ghost walk?' was from the ghost of Hamlet's father – a spectral uncertain thing.

> Angels and ministers of Grace defend us!
> Be thou a spirit of health or goblin damn'd
> Bring with thee airs from heaven or blasts from hell,
> Be thy intents wicked or charitable,
> Thou comest in such questionable shape
> That I will speak with thee:

Everyone moved in the grey shadows smoking cigarettes, as though they were themselves ghosts. A cleaner moved about in the stalls like a fly on a ceiling.

In a little while Yedo came out of the No. 1 dressing room on the back of the stage and stood before us, his oriental face looking like a *No* mask as the electric light from his door cut across it.

'Ladies and gentlemen,' he said, addressing us in perfect English. 'Mr Seahorse, our manager, has absconded with the week's takings. I have no money for you.'

For a moment there was complete silence and then muttering and complaining began. A comic started to shout that he had been top of the bill since he was sixteen and refused to be

treated like this or stay a moment longer and stormed out of the theatre. But I was surprised how quietly the company took the news. 'What do we do?' I asked.

'I can suggest,' said the Japanese, 'that you come with me. I have wired my agent in London and he can fix me in a summer show at Great Yarmouth if I can bring at least two other acts with me.'

The Ballad Singers said they were leaving anyway, and walked off the stage in their fur coats with that curious dignity that comes to music hall artists who have been through better times and know when worse are coming. The Mystic Saxons and ourselves agreed to go with the Japanese. It was arranged that Saturday night's takings which were still to come would be used to provide a coach and to pay our digs at Chatham. We had no money at all so this was quite a closely cut garment to fit to the figure of the week ahead. For a moment I wanted to punch Mr Seahorse on the head, for there seemed nothing worse than to live parasite on one's fellow travellers. The feeling passed off. We would not see him again; that was a good thing. It was as well I could not hit him. My anger died on the coach journey when the Mystic Saxons, seeing we had nothing to eat, shared their stale sandwiches and flask of almost cold tea. This little old man who must have been seventy and his huge wife were touchingly friendly and gave us all sorts of advice about what to expect ahead.

Yarmouth was clean and huge with that bright hard light east coast towns seem to have. But we had a shock when we saw where we had got to work. After searching the town and going in different directions we found it to be a fairground, with switchbacks, roundabouts, side shows and stalls – The Great Wheel, The Wall of Death, The Bearded Lady, The Hall of Mirrors – and of course, once more ourselves. I was bewildered and out of depth.

'Talk about a dump!' exclaimed Greta. 'We are in for it this time all right!' and I rather thought she was right. The next shock was the size of the stage we were to work on: as she said 'No bigger than a bloody postage stamp!' Third shock: there was no band at all, and only wooden forms to sit on. I had to

realise that this was the pattern set for us. I think we would have left if the Saxons had not been so patient and kind. They were obviously used to working this kind of place and persuaded us that it would probably be all right if we gave it a try. And realising that, if we went, they also would have to go we stuck it out. I am glad we did because of all things this was a vivid experience. Huge Mrs Saxon looked disgruntled and we in our turn tried to pacify her. Yedo and Fuji were not to be seen. As always with a tight situation there was really no choice because we had no money and could not go back anyway. So we went off into town to look for digs with faithful but heavy hearts. After all, Yedo had not bamboozled us: he had a summer show to offer – but only if we stayed together. The point was, could we stand it for long? Would it bring in enough money for us all? If we did stand it, how long before we had an accident on the tiny platform for a stage – and no insurance for life or death? The Wall of Death was not in it. But to be positive: if it did work out, what a fine way to spend the summer, lying on the beach all day doing two or three shows at the most. I could draw and paint and write my book.

We found nice digs three miles away. Early next day we were at the fairground clearing up the rubbish the last people had left in the shed, sweeping the stage down, arranging the forms for the audience. Just afterwards, ten people started to walk through the side shows and the man next door at the Hall of Mirrors started to shout through a tin megaphone – for the microphone had not been invented. In consequence his voice was powerful with an Italian accent.

'Come alonga! Come alonga, ladiss. Come to see how beatifico you are in ze 'all of mirros. Taker your bambino and ee will die laughing. Taker your man and ee will never get away. Come and increez your natural beauty a tousan time for only sixpence. Be ze girl with a tousand eyes who has but two. The lady with ze extra fanny. Come alonga! Come alonga!'

This seemed to affect the people like a drug and they stopped to listen to him.

On the other side the Wall of Death was starting and

opposite there were gigantic wrestlers moving awkwardly about on a platform making me feel like a matchstick. The switchbacks, looking like prehistoric insects, and the Great Wheel started slowly to move, music was pounding from the roundabouts and dodgems.

Outside our own shack there was a platform upon which I stood, with Greta beside me, feeling self-conscious in a way I had not felt since I had first been on the stage. We were both fully made-up for a theatre show, both fully dressed. Old Saxon, who was so sweet and gentle despite his long years on the halls, smiled at me and suggested I should do some speeling. Yedo gave me a megaphone. I held it to my mouth but there was silence. Yet this very gesture I noticed made people stop to see what was going to be said. Then I thought of something I had heard at Bromley Fair as a boy and shouted it as loud as I could.

'Roll up, roll up, ladies! Come and see our spotted leopard. Ninety-nine spots on its belly and one on its cock yer leg over the fence there, lady!' People started to gather to listen, smiling, laughing a little, anxious for more. I continued.

'Don't miss this loverley show straight from the West End of London. The Mystic Saxons will tell you what you are thinking.' Little Mr Saxon and his huge wife, both in full evening dress, got up and bowed. 'The miraculous act from Japan – Yedo and Fuji – in their magic feat of Shooting Through a Woman.' Yedo in Japanese kimono bowed impassively, and his wife – a gorgeous little yellow creature in full Japanese dress – bowed also. 'Finally Carl and Greta, the Whirlwind Dancers from Sweden to delight your eyes. Come on. Come on now. All this for threepence. You don't know when you're well off. Solomon in all his glory was not arrayed like one of these!'

To my astonishment the people started to file in while Yedo politely took their money.

The Mystic Saxons were on first. The old man in evening dress stood by his statuesque wife (who looked strangely like the Statue of Liberty when she held up her hand). He set her in the middle of the tiny stage and himself went among the

audience taking articles from them and holding each one up to the blindfolded lady, arranging his questions each time in simple code.

'And *this*?'

'Yoh hev spetikals!' she announced after a moment of silence.

'This?'

'Yoh hev ar cigaritt case!'

'Now this one?'

'Yoh hev ar wallet!'

And so on. It was amazingly effective and the little group of people, whose thruppences we thought we had, clapped with timid but willing gullibility. So in need is the ordinary human consciousness of the mystery of the world of dream that it is willing to believe anything: it pays to be deceived. The Saxons supplied something valid to help this need and were agents for good in doing so: behind it all was the terrifying thought that, at any moment, any one of us could disappear without trace for all time. I was fascinated by the expert way this act was conducted, and with what old-world politeness.

Yedo's daughter, with long black hair, sat at the piano and played them off while I lowered the curtain. She then played the opening bars of the same music while I opened the curtains again for our own entrance. It was quite ridiculous and because of that we were laughing instead of being afraid. They said we looked enormous on the small stage in the little hut. We went through all our dances with the same seriousness as we would have at the Palladium. The trouble was space: our steps were shortened, our lifts lowered by taking them in a lunge: even then Greta disappeared in the flies, and what swings were possible we contracted by bending the arms. But we completed fast pirouettes and high leaps to make up for lost positions. So instead of sticking to a rigid set pattern of steps we invented things by flashes of intuition passing between us, which was great fun and strangely thrilling. The piano was not much good and missed the beat of our steps most of the time but in some way with all these obstacles, even to nearly hitting Greta's head on the corner of the piano which was on stage,

we managed an act; abbreviated, but skilful and exciting to the audience.

After we had taken our call I ran off and lowered the curtain and then raised it again on Yedo and Fuji, leaving him to shoot through his wife with a .22 rifle. With her almond eyes and yellow skin I found Fuji attractive and would have liked to know her better, especially as I had just been introduced to the Japanese colour print artists by my friend Claudius Lantern before leaving London. She gave out that curious sexual attraction that tiny Japanese women have; something to do with dolls. I then remembered that my first girl friend at the age of seven was a Japanese princess, since when I have loved all eastern culture. But it would not do. I watched her act from the wings but the audience could see me and Greta got jealous. I got angry and jealous too every time Yedo pointed the gun at Fuji. In stage life this is going on all the time; a continual weaving of emotional and physical patterns. I suppose our reluctance to go with this – or to go too far – was the thing that impeded our progress later. It is a matter of choice in the end: if you hold on to the rice hidden in the coconut, like the monkey, you cannot get away. The trap was always open: it was tempting to get caught. But then I had my work cut out to keep the Cockney-Italian, who ran the Hall of Mirrors, away from Greta. Further to deter me, the wrestlers, like great Yeti, glowered over her from the side show opposite and I could do nothing about that: I was more than just afraid. I think this tickled Greta. She knew I dared not try to get Fuji. So the game of life went on.

In the tiny space at the side of the stage which was wings and dressing room all in one I brushed near and passed a word with my yellow idol when I paused to mark up with lipstick on the lid of my trunk every dance we did. On our first day between morning and midnight we did twelve shows – about one every hour – which meant thirty-six dances. At the end of this, in the hot summer night, we walked three miles to the digs. On the way we almost crawled to the sea our muscles ached so much, stripped off our clothes and under a great moon lay naked in the gently rolling waves, bathing our weary bodies

but too tired to swim. The salt burned into the wound in my shoulder made by Greta's shoe from doing the same shoulder-and-ankle-swing so continuously.

There seem to be times when nothing matters other than keeping with life and trying to deal with physical discomforts and strains so that life may remain. I lay naked on my belly running my hand over the slippery moonlit pebbles and sand, smelling the salt in a moment of identification which made it possible to continue, drawing energy from natural sources. I realised it was not a matter of money. Beyond that there was the deep persistent power of endurance that reached into the remote areas of life and forced it to go on, not just in the individual but in the whole universal process. To become detached from this was death. I watched Greta who was another entity, another source of energy and pain: and then I realised she was watching me. We stayed like this for a time and then started to slither towards each other like great fish – seals perhaps, till with a sudden bite in the shoulders we came together and were locked in our evolution from the beginning of time, the salt now burning our lips and faces. When we fell apart we lay for a long while with the sea running over us. This was the centre of the dance – the dance of creation.

We walked slowly back to the digs where a kindly landlady had stayed up to give us a hot meal, for which we were grateful beyond telling. When I went to bed I was too tired to sleep and read *David Copperfield* half the night. I had set myself to read one novel from every important author since Samuel Richardson's *Clarissa* and in this way to learn something of our literature. *Copperfield* was as far as I had got. The programme was the same with the Russians and with the French; followed by the English essayists and poets, whom I read anyway because I loved them. My inward obsessions went on even while I was otherwise exhausted.

In the morning I left Greta to sleep: as long as she was at the fairground by ten it did not matter. I was always an early riser. Everywhere was empty. I walked in the cool air just being brightened by sunlight and thought of the day I had walked to Lyme Regis after I had first found the Gypsies in the

New Forest when I was in search of the woman who was the shadow side of my life. How nearly I might have found her and gone with her! And yet, by a trick of destiny, an impulse, I had turned from the Dark People at that time and gone to look for Greta, not knowing it was she who was to be mistress of the dance, goddess of the moment of dawn. In spite of the tough reality of show business I was not fool enough to expel the possibility of poetry which would add up later to some kind of spiritual aggregate.

I watched the air being coloured by the sun: a moment always when space is of more importance than form; brightened and coloured and shaped but not polluted by smoke or breath. The sea dazzled, was calm, smashed the beach pebbles with long, narrow and very gentle waves, was silent, rolled, sparkled, swelled, was eternal.

At the fairground there was no one. The noise of the day – the energy, danger, death – were not awakened. The silent side shows with their badly painted nudes – Cleopatra the Great Lover Girl, Messalina the Maneater (of whom Juvenal wrote: *Et lassata viris necdum satiata recessit*), Nikolo the Siberian Bear fighting with Tiger Tankerton of Tonypandy – all stood in suspended animation waiting for peoples' eyes to bring them to life again, as a patient may wait for a doctor to end a hypnotic trance. The Wall of Death was a silent spiral; the spiral that was my whole life's theme. I walked through the fair like a lonely clown.

I came to the Hall of Mirrors that so many faces saw, past the empty booking office, through the curtain. At first it was dark and difficult to see after the bright sunlight. I could not tell if I was in a corridor or in a room full of people. Shadowy forms were moving everywhere and as I wove my way through them I was saying: 'Pardon! So sorry! Do you mind? Thank you!' No one answered. There is no illusion in life so complete or so strange as being eluded by something that isn't there. My companions were doing this to me, or so it seemed until my hand slipped on the wall and there was a blaze of light. To my dismay I found that all the images were myself, seen from every possible angle – even from above and below. I was bewildered.

At first I was familiar – at the moment of recognition – and then seemed to be a complete stranger; it was rather like meeting a man with his wife when you have only known him with his mistress. It was a shock as well to find one carried all these dimensions and probably many more than are visible at any one time; that man is also the total of his invisibility. Perhaps this was the multiple image that can only be resolved by art; by sculpture especially.

I spoke but there was only one voice. When I moved on I spoke again: by some echo device each image answered. This was very frightening. Could it be that they were real after all? What was real? Imagination as well as these? And what of those great backrooms of the mind cluttered with images of thousands of years? I moved again. The faces and the bodies of the crowd that was me moved also, slowly became distorted into wild shapes as though seen through water: the eyebrows arched, the faces stretched, the clothes became baggy. Art in its presentation distorts the normal object in the same way, insofar as it is distant from the archetypal image for which the artist is searching; the no-man's-land between frontiers of reality which only he knows. Something like that! . . . Or like this! I thought, as I walked slowly in comic procession through the remaining corridors, the mirrors diminishing until I was left standing in front of one – a huge solemn single image like Watteau's 'Clown'.

Greta was standing outside in the sunlight wondering where I had got to. I was relieved to be identified by her eyes and her graceful body again as she stood there in a thin summer dress. The little Italian with whom she was talking gave me a friendly 'Good morning, Signor!' I ignored him and turned to Greta. 'You!' I said simply. 'Thank God for that!' Then muttered; 'What does that bastard want?'

'Really, darling,' said Greta taking my arm, 'you are so jealous. What about that little Japanese bit? Don't you go having it off with her.' I smiled.

Once we were schooled to the toughness of the situation we began to enjoy it and to get terrific fun from making up new things to say when I was speeling. But the whole thing started

to deteriorate when the end of the first week came and nothing was said about money. I asked Saxon and his wife what was going on. They thought Yedo was waiting to get enough in to make a proper first share and I decided to wait, since they also said that in this kind of show they often paid out at varying intervals. I mentioned this to the landlady who did not seem to mind and carried on for another week. I then asked Yedo what was happening and he turned quite nasty; something I did not expect at all. He said he had not worked out the shares yet, after the agent and pitch were paid for: the return also of the money advanced at Chatham. This seemed unfair and with no experience I blundered in rough-shod over his plans, with the result that he offered me my share and said we could go. I accepted. We were both horrified when he gave us 28/– between us for ten full days work at twelve hours a day – 360 dances. We could not pay the digs, nor buy our tickets home. As a last resort Greta wired to her mother and she sent £5 by return, which enabled us to pay the landlady and get back to London without a penny.

I smiled sadly out of the coach window thinking of the little Japanese lady, and waving to the Saxons who stood isolated against the sea, seeing us off.

8

Mrs Terminus

WE managed to book one or two late night cabaret dates right away and a suburban cinema appearance to tide over. We found the agents usually had something like this to offer if one cared to take it. But instead of going to our homes, as we had always done before, we found digs south of the Thames, feeling now we had made a start together, the fight in the world was ours and not that of our parents: it would have complicated matters to be with them. They in their turn, like honest parents, were only too glad to be rid of us, though my mother fretted because money was short and she was not happy. We did sometimes return for a day. It was quite a different feeling to stand on the parapet of that great block of flats and look out over the Kentish hills as a young man instead of as a boy.

We went also to see Greta's mother, who looked so like Rembrandt, and tried to pay back the £5 she had sent to get us out of the fairground: she would not hear of it. I walked with my brother, Leo, round the old roads that had listened to the searchings of our young minds, but found now, that although things of the heart were still there, I talked more of life and experience and less of learning; he had become more of a scholar since I had been away. I had started to learn how to apply my little learning to interpret experience and visually I was preoccupied with the enormous difficulties of painting without knowing where I was going: only a certain instinct told me I was on the right track. These changes and the fact that I was living with a woman we had both known for many years must have made a difference to the ease with which we exchanged ideas. The intuitive experience of life which belongs to the artist was growing up in me like a kind of personal ghost with whom I was always becoming better acquainted; the

objective relationship with other people, save Greta, was less real. Greta and I knew we were alone in what we were going to do; this had come to us quietly when we had left Yarmouth and stood by the sea waiting for the coach, watching the endless remote light sparkling like wine and disappearing into the sky.

The Saxons stayed on, knowing that at their age they would be unlikely to get another summer booking and that this was better than Charing Cross Road. Acts of this kind lived always in digs, having no home of their own to go to. There had never been one because there had never been a family; they felt perhaps that to leave the baby in the top drawer of the dressing room clothes chest or the wardrobe basket while they went on to do their act was not good enough, although many did this thing as a matter of course – thought nothing of it. We ourselves had decided it should never happen to us, and we wanted a family very much. The time would come when we would have to choose. Somehow money must be saved for us eventually to give up the profession: that would be the time when I started to paint. Was this ever going to be possible, I wondered? Would the gods give me the flash of vision that would make me strong enough to start and not turn back? Dylan Thomas said, years later: 'To turn back now is to pay the expensive ogre twice!' I had not yet felt more than the ogre's hot breath.

The digs were at a large Victorian house in Penge, backing on to the railway in a road away from the shops. It had little plane trees along each side with sooty leaves and peeling trunks. Cast-iron gates and railings in front of the houses recalled Porcupine Hill of my childhood, with the same silence the roads in London suburbs used to have (and probably still do): sometimes a village quietness though with more tension and less ghostliness than in the country, a quietness broken by the roaring of the trains every now and then, and the screech of their vanishing whistles.

There were chalk marks on the flagstones of the pavement: several were filled in with different colours like the representations of prehistoric traps in the paintings at Lascaux. This is where the kids played hop-scotch, just as I had played, and

here, at the turning point, had not yet finished my game. There was always Rosie or Judith or Jill or Jackie to bring me down, matching my skill with theirs, tingeing the game with anxiety and laughter as it leads on to failure or success.

So we stayed at the great house called Karachi: named by some army officer serving in India at the turn of the century, when this would have been a rich residential area, built near the new railway to the city. Hence the wide drive up to the huge oak front door and the remainder of a once opulent front garden; now a dump for old bikes, clothes, tins, sinks and hard core, which made it look dishevelled and untidy.

The landlady was gigantic, like the fat woman at the fair in Yarmouth, but with big eyes and a wide engaging smile which betokened a warm heart. Her hands were red and scaly with scrubbing in soda, her breasts like those of Pantagruel's mother, her thighs like the columns of Karnak, her head as large as Ozymandias's and her arse the dark side of the moon. She smelt blue and greasy from the air in her underground kitchen, where she cooked the meals for her large family and for ourselves. A Londoner in heart and flesh and bone, exploding with humour, expansive with kindness, dominating and dutiful, sharp as a razor, quick as lightning, strong as a dray horse, a voice like a macaw. This was Mrs Terminus of Wednesday Green and a job you'd have to stop a blow from her: they say it was like the kick of a zebra. Every now and then she roared through our lives like a train.

Mrs Terminus had many daughters and a few sons. Of the girls, a tall ginger one had been set back by losing her man. There were several younger ones, out of reach by reason of their age but still attractive, and a fair one named Rosie who at once took my eye when she came in with the meal dressed in a neat blue skirt and jumper, and a beguiling apron.

The father, a builder, was a rough apologetic man, weak when sober; when drunk, which was at least twice a week, he was loquacious, and tedious or funny and very noisy, because he was deaf. I preferred him when he was funny. He was a man not unlike the crocodile gardener who used to work for an aunt of mine and caught my imagination as a boy. The

marvellous thing about people is that even though they turn up in each century as basic expressions of a race, they are each time cast in a different pattern of behaviour, as though a great composer were handling a continually recurrent theme in all its possible forms.

The room we rented was large, such as only Victorians could afford to build. There were ornate plaster mouldings round the ceiling and round the intricate brass gas-bracket hanging from its centre. The walls were of pale green flowered wallpaper, there were lace curtains that had gone brittle to the touch with dust. A carved marble mantelpiece from the quarries of Carrara in the Etruscan Mountains: that stood for something to a young mind and was not just mindful of the cemetery round the corner where the trains tried to wake the dead as they roared by; it was the quarry Michelangelo used. The bedstead was also of brass with a large crochet spread in white, and an old-fashioned feather bed of the sort that was like a great swallowing belly when you got into it and smelt faintly of urine. On the large table there was a red velvet cover with tassels. Out of the window I could see the garden with all the grass worn away and the steam engines roaring through the bottoms throwing sparks and fire at night.

This became our home in London. From here we went by bus or train to the West End to go the round of the agents; that heartless occupation which has broken so many hearts. From here we got news by telegram that we had landed our first West End booking at the Prince of Wales Theatre in Coventry Street, to appear on one of the first non-stop variety bills in Great Britain. Only two weeks after working on the fairground at Great Yarmouth we were to see our names on boards carried down Piccadilly by sandwich men in slow, isolated, solemn, procession, like religious or political banners telling the people we were good for their souls. In the other direction there was a group of Welsh miners moving also slowly and singing, with that clear light in the eyes which I learned later was only to be known in the face of a starving man: at that time I did not understand.

The billing made us very conscious and we scuttled into a

doorway to hide. That the public image outside ourselves was growing was something to be wisely frightened of, even though it fascinated us. This was a happy realisation: one to be remembered even more in the later era of television when one's image, like the painting of Dorian Gray, was at one's shoulder getting more distorted each day. That is what the world wants, and so it is created by manipulation of the image and the word until both are over life size: not only out of joint but out of context. Mephistopheles lecturing in Faust's cloak. The work a man does is the thing of importance; not this false image. So beware of him who creates this for himself; who is otherwise taken over by his own legend. The soul scuttles down the wainscot of its historic house, shrinking from the glare of the colour-killing sodium sun, and comes out to the procession in the street only when it can learn anonymity to such a degree that it may pass unnoticed beneath the giant effigy in the carnival which the world has built up to beguile us into the belief that this is greatness – so sadly is a saviour needed. To the empty giant the world offers its praises and throws its rotten eggs, while the true man hides to get on with his work without crucifixion. Only when the shafts of light connect through the wainscot does the mouse become a tiger who is dangerous.

Mrs Terminus was overjoyed with our news: not only because we would have some money, for we had come in with nothing and paid her nothing so far, but because it was work for us. Such was her trust. We relied on our perception of each others' fundamental goodness to get through and it was not such a bad thing after all. She was just as pleased because we were going to work at such a prominent theatre. Her heart was with us as the artists and the old pros in the photos on the wall seemed to smile too because of this. She had seen more than me of the vicissitudes caused by their indomitable pride. Perhaps we had ushered in a new era, in that we had told her just how it was: she had the chance to take us or not. She had grown fond of us and wanted us to win. She threw a party – a Fandango as she called it – and we danced and drank into the night until I was found deep in the feather bed almost

swallowed by Rosie. Her pale ginger sister who had lost her lover told Greta who in turn disappeared for the rest of the night – I never knew where – and my delinquency was ended for no reason. I sat by the marble fireplace alone, long after everyone had gone to bed, waiting for her return. There was a noise at two o'clock but instead of Greta it was old man Terminus, drunk as a fiddler's bitch. He had heard of her going.

'Never mind, my son. It'll be all right. She'll come back when she know you love 'er. She'll come back anyway, case my little Rosie takes you. Look at me! What happened to me? I had all the luck in the world, didn' I? I was all on me own like you and what did I do? I put me 'and in the lucky dip and out comes my old princess! I wouldn't change 'er fer no one!'

At that moment the door opened and in came Mrs Terminus.

'That's enough from you, you drunken old bastard,' she shouted, taking him by the scruff. 'Go orf to yer bed and shut yer bleed'n gob!'

I was alone again. Neither did Rosie re-appear as I had hoped.

The experience of the fairground had not been without its use for now we had a far more tough commission than we realised. The booking was done verbally. The agent told us in his rich Jewish voice that there would be one week's trial period and if we suited there would be a contract followed by several weeks on tour. Would we go in for a week at ten pounds, which is as low as any act can be paid?

'With the name of the theatre and the people that will see you it's worth fifty pound,' he said. 'Please yourself, my boy. You 'aven't got to do it, you know. I'm not forcing you. But don't be silly and refuse. There are plenty of acts that would jump at the chance; that would verk the date for notting to gain the publicity!' Which was quite true, of course.

As I stood looking at this good-humoured mountain of flesh, wearing a black Homburg, sitting in his revolving chair I realised one thing: that the performers were only the marionettes as far as the money was concerned, and whatever salary we commanded we would never be free from the agents

who were the particular kind of leeches who kept this profession's blood pressure down. We accepted, of course, and were told to report at the theatre in the morning, which was Sunday, for a full day's rehearsal.

Our first show was at eleven on Monday morning and our last at eleven the same evening. This meant that we did twenty-two dances a day and as we were on at the opening and finale of each show, between which there was no break, it meant we made thirty entrances. This was compensated for by the good stage and orchestra, a troupe of girls which we were able to use, proper lighting and stage management. With all these assets it was possible to do our full dances with nothing cut: far more exhausting than the fairground but more satisfying and of course the reaction and atmosphere of a West End audience was marvellous to know for the first time. We worked to our full power with all the inspiration and excitement the dance demanded of us. We gave everything; nothing but the dance.

The pace of the world was quickening and I suppose the ideas of non-stop variety was part of it: the beginning of the rat race of more modern times, later to start like clockwork in every youngster when he took the eleven plus exam. It was already going at the Windmill round the corner off Shaftsbury Avenue, where John Tilly was on, and Billy Bennett, 'Almost a Gentleman'. We had done an audition there a week earlier and been turned down by Van Dam. The Prince of Wales, like the Windmill, had its share of Moulin Rouge fame, quite genuinely so, which was a direct link with Lautrec: like him I was drawing but only spasmodically because of my continuous presence on stage. But I was able to watch all the time, which is the visual artist's great gift once it is developed – the habit of seeing and of recording not only forms and colours but the sensations these things give him. The miracle of unearthly beauty in seeing those young girls naked on stage, the strong lights giving ultra-radiance to their bodies was for me a visual happening of a high order. I was not precious about it. The transcendental power of the naked form seems to me to absorb sex as something which is contained in, and not the reason for,

being alive. A wonderful thing even then. And of course artists had been experiencing this from time immemorial. Sex was never my first reason for loving the human form unless the women wore the secrecy of beautiful clothes. The revelation to the eyes of man is in seeing that which is made well by the hand of God: this may best be seen in the naked human form – 'the human form divine', as Blake called it. If one would know at one moment in time all the laws governing the physical universe – space, form, volume and mass, rhythm, colour, light, energy and darkness – one would do well to turn to the human form. Spiritually as well it is as old as history. The only reason Adam's sexual excitement spoilt Paradise was that it caused a break in the natural unity with the Unconscious, where sexual activity was involved as part of a God-created activity. Lust is an intellectual thing. Blake said that too and he was usually right. Marvellous, but not everything!

It was difficult at first to understand why the auditorium was full of licentious businessmen sucking cigars and leering. But this of course was why the girls were here. The sale of sex was and is an ancient enough thing and one can't blame the tycoons for doing it if it benefits mankind, which it probably does one way or another, but from the point of view of the girls who had to climb seventy-eight stone steps between each number to change and do scores of dances in a day for three pounds ten shillings a week it is possibly another story. No one could work harder. Sometimes they fainted and had to give up. As we ourselves did, they had to eat on the job between entrances and often would start a new number with a sandwich half swallowed. But laughing, always gay, never self-pitying. Often they were doing this work as a way of keeping a widowed father, or to get away from a broken home, or some unhappiness resulting from a broken marriage. Most of them were beautiful and, no doubt, had come to the stage under the obstinate belief that youth's vision of the stage was real. Few, very few, were easy to get. Nearly all were down-to-earth and realistic about their job; if they were not, this booking made them so. Only now and again was one corrupt or fast or merely foolish and usually she fell in the cart very

quickly by getting pregnant or poxed up or prostituted –
or worse. One at least became a great actress. Most were for-
gotten.

The business as I knew it was too tough to be the sink of
sexual excess and drinking it was generally believed to be.
There are ways of doing that without working so hard. I have
even seen people disappointed when they have realised this to
be true. Nor did the girls want it so. They were too tired.
Instead of the Stage Door Johnny there came now the
corrupt schoolboy and the rich businessman, to whom gold
and flesh were the ultimate walls of existence: if the great dam
were to burst its sides he would be swept away – a raving
lunatic. This was a safeguard; it was as well to let off the
pressure.

People wanted to be entertained more and more, giving
them less time to be still. After all, somewhere in the deep mind
of man there was a war brewing; and if they were still they
could 'remember burnings by the hewn stones'. Probably the
thing that brings down most civilisations is that they do not
invent a proper device for forgetting.

We got back to Mrs Terminus and her vast motherhood
some time after midnight in an empty suburban train – empty
save for a few drunks and a lonely businessman who had been
to see his mistress perhaps and now slept through the tunnel
that would bring him to morning and breakfast remorse with
cornflakes and the laughter of his children. Outside the carriage
window the stars moved slowly like ships on which the dead
stood motionless. The street lights swung away in curves and
arrow-heads pointing also towards dawn. Yellow lights in the
windows of houses spoke of unknown destinies; of dreams
that would break or change the world; of children rocketing
to the stars, whose waking was to be manhood; of sleeping
men and women locked in the arms of fate, their tears, and the
lines sliding like eels towards the end of their journey to breed
in the ancient Sargasso of the future.

At Terminus House, as we soon came to call it, from which
all things seemed to start and all things had their end, we drank
hot cocoa and began to get ready for bed. I wondered why a

man grew so tired and to what purpose he had entertained these ghosts. I looked at Greta; her slim strong figure was integrated with work and courage. Because her head was erect it seemed her nose was a finer arch than was usual. She was dressed in a simple black velvet dress and being so tired, with her hair undone, she looked pale and beautiful in the gaslight. But when her eyes were turned towards me, usually so blue, they had whites of solid red like meat, where the blood-vessels had broken through doing so many swings upside-down – at least one hundred times a day. She said nothing. When I asked if it was painful she said:

'Not really. Only a bit uncomfortable, like match-sticks would be if they were propping them open. They look fright-ful, which is the greatest blow. But I can't see a cure for them except by stopping work for a few days, and that, darling, is impossible as you know. So best forget it. It won't last forever!'

'That's a comforting thought!' I muttered. 'I hope it won't harm you in other ways. It's not much of a life for a woman.'

'I don't know about you,' she said, avoiding my remark and wish to talk, 'but I'm off to bed.' She kissed me good night and went upstairs. We were too tired to love one another and treasured the harmony that flowed between us; it was a matter of which way to make it last. When she had gone I got out my books and read into the rest of the night.

> 'When you fix your heart on one point, then nothing is
> impossible to you!'

I don't remember who wrote this, but it is curious that from one time to another when nothing seems to emerge from life but pain and over-tiredness, one goes on guided by an unseen hand. That is how it has always been with me; I am drawn to a single point of concentration. Only the end emerging from later experience – usually years later – explains the value of this quiet work in the dark of the night when only the secret thrill of delight keeps you going. It is then the constellations of other skies are printed in the mind. This capacity for work and searching is inherent in the young artist as surely as the young

swallow homes to Africa for the first time long after his parents have left: only on arrival does he realise the truth.

In the same way I went on dancing, even doing it towards the end of the week in a kind of dream: and reading at nights.

This booking at the Prince of Wales was valuable in many ways; above all it was getting us known. We soon learned that it was not publicity but the atttiude towards publicity that was the spiritual danger. When we opened the *Chronicle* on Sunday there was a large circular photo of us on the centre page. This did not only mean that we had been taken notice of, but that our future bookings would be more certain. We were taking the opportunity of breaking in our new dance, the Storm God, which was dramatic and frightening with plenty of real danger and a little beauty because we were working now as a single person, often in faultless unison. There could not be a tougher school in which we could integrate. The fact that I held the life of someone I cared about in my hands put me on profound trust that I should perform well. This I did.

The dance was introduced by a skein of girls in flimsy dresses doing a mist and rain dance, which was probably corny by modern standards, but curiously exciting to the audience of that time who liked anything with foreboding; things driven before the wind.

'. . . the leaves dead
Are driven, like ghosts from an enchanter fleeing,

Yellow, and black, and pale, and hectic red,
Pestilence-stricken multitudes . . .

Such exultations and ecstatic thought from Shelley was also within me, colouring all I did, from my long readings into the night and the continuous dancing of the days: days where I was indeed the Dancing Man, taking the maidens to the sacrifice in an electric maze. In some ways it was also a prophecy.

'Angels of rain and lightning: there are spread
On the blue surface of thine aery surge,
Like bright hair lifted from the head

Of some fierce Maenad, even from the dim verge
Of the horizon to the zenith's height,
The locks of the approaching storm. Thou dirge

Of the dying year, to which this closing night
Will be the dome of a vast sepulchre,
Vaulted with all thy congregated might

Of vapours from whose solid atmosphere
Black rain, and fire, and haill will burst . . .'

Greta, who was the Spirit of the Rain, was dragged on stage
and held there as by a wave of the sea. The tympanies thun-
dered. The audience was silent and apprehensive. But in spite
of my excitement about this dance the mechanics to set it going
were cumbersome and people used to faint in the audience
when I set them going.

In the wings I had a small cannon of the kind used to start a
yacht race, placed in position with a smoke device attached,
and one of the stage-hands holding the lanyard. On my cue
from the orchestra, which was the low roll of a bass tympani,
I got as far side stage as I could until I was at the foot of the
stairs leading to the dressing rooms. I ran fast, taking an
enormous leap, at the same time bringing down my hand,
which was the cue for the cannon to go off; this it did with an
almost supersonic bang. I appeared in mid-air, centre stage
from a cloud of green smoke and landed with extraordinary
agility on my right foot, dressed only in silver-grey satin trunks
and red shoes. My eyelids were made up with luminous green
paint so that they looked like caverns in my head from the
stalls. My hair was wild. Greta was thrown at my feet and the
girls ran off screaming. We started slowly to come together on
a tendril of sound from the *cors anglais*, the lights lowered and
the limes were upon us. Gradually as the sound increased we
could feel the audience being stimulated; even the licentious
businessmen were galvanised into action and moved in their
seats like wounded seals after their sexual battles. We ourselves
were bound together in an extraordinary way and there was no
mental effort in our actions, or physical it seemed: they

appeared to us to articulate themselves, using our bodies as instruments. We were not conscious of dancing well or badly but just of being there and knowing that what was happening to us was beautiful, moving exactly with the music. I am sure those hard-working musicians were completely involved with this as well, and the musical director. As the music grew faster, falling from its natural crescendoes in an avalanche of sound our dance grew faster and more daring, finishing poised in an exact position on an exact note with the shouts from the audience surging over us like sea. Such was our experience. It happens to a performer now and again; not often.

On the third night of this dance when London was in to be entertained and there was a full house, I was baptized in a full flood of laughter which took my pride from under me. The house was tense, the moment of the great entrance came, I was keyed up in the far corner by the stairs, the stage-hand was waiting with the cannon. The tympanies began to thunder, the cannon crashed, the girls screamed. At my cue I ran, took my leap in the air through the green smoke; but the leap was particularly high and I caught the cord from the tabs round one of my ankles. When I reached mid-stage in the air the cord tightened: I was flung headlong on to the boards with one of my legs suspended from the flies amid screams of laughter from the audience, and whistles. The more I tried to free myself the more I was in difficulties; I could not reach my ankle while laying on the back of my neck, which was fortunate not to be broken. The feeling of helplessness, of exasperation and of utterly ridiculous pose, like a puppet suspended on the strings of history, brought me finally through a rush of tears to laughter: it was like being reborn. I lay there unable to do anything while the house roared. Greta had gone on dancing, but when with a final flash of insight I was free, she was ahead of me with the music and I was forced to run round the stage after her trying to look fierce. Later we synchronised and harmony returned. 'We ought to keep that in,' she said as we came together smiling. 'A real house-buster, wasn't it!'

Even the cat-calls of: 'You lovely thing!' and 'Oh, look at *her*!' or 'Didn't you know, dear – it's Tiger Lil!' such as I often

got, at least from the gods, on my first entrance – entering with such absurd pride – even these were quelled by this metamorphic laughter. We did not have enough experience to keep it in and make it a comedy act. Perhaps I was too serious about it all. Comics, like poets, are born not made by chance.

At the end of the first week I was called to the office by a grey-haired man with a head like a post and an expression of distrust. He asked me if I would stay on for at least another month at the same money. I was delighted and very relieved and thanked him. He handed me some notes which I counted: there were only eight.

'Yes, that's right,' he said when I told him. I stood there in my gold dressing-gown and black satin suit, still hot from the stage, feeling quite fearless.

'But I was booked for ten pounds!' I said.

'There is no contract yet,' he answered, tonelessly.

'No. Exactly. The agent said there would be an extension of the booking almost certainly and the money put up, not down. It was only to give him time to make out the contract.'

'I was told it was to be eight,' he persisted coldly.

'Then you were told wrong!' I snapped, getting angry. 'How could I agree to eight, with agent's commission to pay and digs for two, plus fares; how is it possible?' Even if another act went in my place I was determined to get the two pounds owing to me. But quite suddenly the man gave over and said he was sorry and smiled.

We stayed at the Prince of Wales for three months and went on tour with the show for two years until we were booked to appear with the Crazy Gang at the Brighton Hippodrome.

All this time Mrs Terminus became the centre of our life whenever we returned to London. I did not sleep with Rosie after all, although later I payed as dearly for it as if I had done so.

9

Leavings of a Storm

WHEN the show finally went on tour under the title of *Nuit de Paris*, we were paid more and our fares were included, which made life a lot easier. It was difficult at first because we had to catch up with Mrs Terminus, but that soon found its level and working at number one theatres was luxury after the hammering we had taken so far since we joined partnership.

I had a tweed suit tailored and a large actor's overcoat with a wide collar. Greta had a cord suit made. We both had sombreros: black ones. We had broken through to some sort of personal freedom.

When we travelled, all our possessions were with us: my painting gear, which enabled me to paint all over the British Isles and in the dressing rooms between shows; a gramophone; records; two budgerigars; two wardrobe trunks; a large prop basket; and countless suitcases, filled with manuscripts and books, journals and a typewriter. A formidable cargo. This was part of being – or beginning to be – a conscious instrument to search into the ways of men and into the changing landscape out of which men grew. There were the hills of Derbyshire lit with a golden almost holy light; the diabolical pike-toothed Pennines; the table top east where the eye like a billiard ball collides with sun and moon, knocking quietly at the stars; the soft green-breasted downs of Sussex where the faces of men and women were Celt-boned like the Cornish; red Devon lush with fertility, its seaboard ancient with England. There was also the granite of Scotland, her inland waters reflecting mountains that plunged fathoms to the monsters in the deep mind, projected with our ancient fears: this was disturbing. The cities of Scotland made me feel lonely and afraid, perhaps because they were also the deserted places I met in dreams. All this was part of the Island Man which had grown out of the

centuries with oak root through him and granite head, cliff-face and river-thigh. Thus the fields of England waved corn in our hearts, so much so that I could better understand the corn and rice fields of the Camargue through paintings of Van Gogh: England's corn was different because it was Constable *and* England. Ireland was indelible with Jack Yeats and his brother William Butler. So each country has returned its soul through the eye of man: the burning glass of its genius.

The cities also: I wept over Wigan, shuddered over Liverpool, was haunted by Glasgow, hated Birmingham, warmed and laughed over London, sparkled over Brighton. The bridges and rivers and buildings became one great city in my mind where so many strange things lived: a city that my Viking forefathers had invaded and my ancient Briton ancestors had defended. Ice pierced my soul and forests and gentle flowers.

The shifting aggregate of our experience added up from day to day to a more complete view of life, of ourselves and of our efforts to become artists. I knew now that I had that rarer thing – the Inside Eye; a point of insight that gave me an aspect of truth, though I did not know how to use it. What I did realise from this and from the great libraries and museums and art galleries, which housed the quickening dead (but seldom the dying quick), that to create, a man must be deeply involved with life in every way, particularly with the life of the heart: for me art has never lived without the things of the heart, even though the heart be cut out by the sacrificial knife. I did not yet understand what it was to be involved by death and destruction, which things give that ruthless finality to art and to life such as there must have been at the Resurrection. How important death was I did not know.

About this time there was a sense of foreboding. Just as one cannot always recall where a theme recurs in a symphony, so I cannot be quite certain of the year I met Léonide Massine, the early or the middle thirties; but that does not matter for there was a recurring theme of Destiny during the whole of that decade, growing stronger each time it was heard. It was epitomised in the work Massine was doing then and by which my life was intersected at Birmingham, where I was working

at the Hippodrome and he at the Alexander Theatre producing a ballet of his own called *Les Presages*: The Omens, The Forebodings: written round, or constructed into, Tchaikovsky's Fifth Symphony with its recurring Fate Theme. I did not meet him as an equal, of course; not as a dancer or even as a choreographer – that would have been presumptuous – but as someone who was able to teach his *corps de ballet* one particular thing at which I was expert – to lift their partners above their heads and keep them there for any required period of time.

In the mornings of that week the whole company came to the Hippodrome to rehearse. They were different to my rough music hall pros and stayed within themselves a good deal. They were more ascetic, removed from the coarser texture of stage life it would seem, but harder from self-discipline and more tense in spirit and mind: rarer people perhaps. Coming as they did from the great schools of Russia and Paris this was to be expected. Massine himself was startling. 'Like a bird – a seagull!' was what I exclaimed to myself and wrote later to my brother in London. His eyes were piercing and his nose arched beautifully, his head noble.

> Or like stout Cortez when with eagle eyes
> He stared at the Pacific – and all his men
> Look'd at each other with a wild surmise –
> Silent, upon a peak in Darien.

Keats struck the same archetype, just over a hundred years earlier: the same Massine gave to me, as he stood near the footlights with his taut figure beneath a greatcoat and his hands and voice directing his dancers as though they were an ocean.

It was in these group-arrangements that the men had to lift the girls above their heads and often they could only just get them there but not hold. Lift is different to thrust; they had no thrust, no brute strength. This I could not give them but timing the lift and locking the position I could teach and I did by demonstrating with Greta and then lifting them. They were not *loose* like we were; this made it difficult. They were delighted and thought I must be a man of rare and fantastic skill. They did not realise how I envied their elevation, their pre-

cision, their poetry when they were at their best; more than anything their setting in which complete dedication was possible and did not go unnoticed. But in spite of my bastardised dance there was a point of contact here (as between Ariel and Caliban) and I was grateful for it. The others on the bill with me treated them with the same silent respect. And conversely the ballet people were thrilled by our dances because of their speed and daring.

In return for all this Massine arranged free seats for us at the first performance of his ballet. This was an experience which was never to be repeated with the same unique feeling of immensity. For the first time I realised that here was an artist creating out of people and music something that was built into his time. A long skein of humanity surging and rising like the sea, receding and shrinking away with fear and foreboding, rushing forward as the Fate Theme recurred in the music, foretelling perhaps the disaster ahead of us all, even sensed a little already in the Storm God I had created, but with those premonitions of destiny that only great music and the universal movement Massine drew out of each dancer could bring. I feel there should have been voices lamenting behind this exultation and descent of life, like a giant wave falling through the ages. For the first time I was conscious of history and of the future. I left Birmingham a wiser man.

Came winter, came summer, came Kingston-on-Thames, with memories of cycling with Leopold as a boy across Wimbledon Common and Putney, down a street of tanneries at Kingston that smelt pungent like silage, to where a dinghy was tied to a coal barge. We used to steal the dinghy and paddle with a plank of driftwood to the landing stage of a posh hotel and ask the Commissionaire for a glass of lemonade, which he gave us to get rid of us, although I could never see why we should not drink it there at our leisure. We paddled away in ragged elegance to do our day's fishing. By each thing that happens memory is triggered off like a one-armed bandit and all manner of coins pour out if the images synchronise.

Thus the theatre – and after the theatre a late cabaret at the same posh hotel after the last house. This was always a re-

munerative thing to do – at least £15 for the single show, and sometimes £20 – generally enjoyable, except for the small floor. With the skill I had acquired I swung Greta over the heads of the diners, making them duck into their soup or spill their wine, waking them for a moment from their long dream. The head waiter had that humorous polite hatred some waiters have for their guests and was very much amused by this. In a excitable effort to please me he offered a jug of water as I came off with my mouth like cork inside. I took it and drank the whole thing right off, not realising it was iced. I was thrown into almost immediate convulsions. When I was told that you could die from drinking a pint of cold milk in the snows of Northern Sweden I did not argue. Perhaps in this case, although I did almost die, some curious rhythm left over from my visit as a boy had inspired this misplaced kindness – or why should I smell the tannery again and feel the grit of coal-dust on my tongue?

It was as a result of being seen at this cabaret show and later at the theatre that we were invited to do a charity show at a home for disabled soldiers one afternoon during the week. Someone had come round in the usual way and asked us; in the tradition of the music hall we did not refuse. It was here I saw the emblems of sacrifice, the exfoliations of war twenty years after it had happened: the theme of destiny was awakened in me again, I heard it as clearly as when I saw Massine's ballet and the great surge of life it performed with its dark omens, moving through an ocean of heartbreaking beauty and belief.

We were taken by car. I had the strange feeling I always have when I go near these places. I have it when I pass through Enham Alamein. I had it when I reached Park Prewitt in 1944 after a night journey across England in a hospital train: such a feeling also from asylums, which of course Park Prewitt is in time of peace – though which is the greater lunacy I cannot tell. But this time I had no experience to go on; it was therefore an attack on my innocence. I did not know of these things.

Of the horrors of the First World War I had heard, and with some kind of persistent curiosity I had looked at photographs of atrocities. I could remember the Zeppelin raid over London;

the news of my uncle dying on the way to the dressing station
– crying for his mother, they said. My mother crying with the
telegram in her hand. Ethel weeping over her Devonshire boy
with his fine white teeth, his rosy cheeks and blue eyes. He had
gone away never to come back; missing, believed dead.

The war had seeped through in this way but each thing was
an isolated incident, like part of a macabre fairy tale, and had
sunk to the bottom of the mind because life in childhood is
bright and real and beautiful at times, returning only in dreams.

The first war had a particular quality. When I see photo-
graphs of those men, marching from Tipperary to death, I
always notice the naïve smile soldiers give to death because
they don't yet know its reality: how quickly the spring is
released, how quickly the back is broken, leaving them to
whimper, then go silent and still as after an orgasm. About
these men in their putties and peaked caps there was a special
tragedy, not only because they were our fathers, but also
because, having forgotten Napoleon and Caesar, Alexander
and Xerxes and Genghis Khan, the world had regained its
innocence: these were young men and like myself they did not
know about the Kaiser and later about Hitler.

After war there are some who come back but cannot be
seen: for men, as with children, do not like to show their
broken dolls to anyone. They are put away and kept on charity
and grants, attended by the world's guilt. It hurts to remember
them; it is a shock to be told they are there.

> These are the hollow flowers of war
> The exfoliated forms of science
> The leavings of an equinoctial storm.
>
> Cordite and steel have no morality
> Respect or discrimination:
> Only life
> Is patient and pitying
> And immortality
> The beginningless and endlessness of strife:
> The lonely soldier under the broken hill
> Watching the star-shod rockets fall.

I wrote these lines later, after my own war, when my own innocence had been disabled. To get behind this to that bright afternoon so many years ago when, in the fullness of youth, I danced to those broken men, is now most difficult. An experience is lived many times in one life; each time it is seen as if from a different point in space, like a sculpture: in later life things become more complete as a result, but the first impact is not dulled so much as hidden round the other side of the years.

The little stage at the hospital reminded me of the one at the fairground. The pretty nurses and kind doctors helped with stage management. Trolleys were wheeled in with parts of men on them, in some cases tilted forward or hoisted so that the motionless eyes could look out of skulls that were strapped together. Behind these were lined up on wooden forms those who merely had no arms or no faces or could not control their articulations, making as it were a complete comic side show at which nobody looked, especially staff for whom pity is not often a good prophylactic.

A comic went on and ran through a routine of jokes with an army twist: very sharp, very quick, glittering. Following him was a young soubrette with a saucy song and a tap dance, making much of her figure so that those who could, whistled. A magician producing rabbits and doves out of the air which always irritated me whenever I saw such things. Then ourselves, with our hands and feet and eyes all intact: strong as the north wind, fast as deer, timing each trick and step and swing to the last split second, with all the skill we had gained from working in every kind of difficulty. We danced over the last embers of war, of sacrifice, and of laughing grateful men.

After we had finished the whole cast was asked to go among the audience. When we did this they were lined up on their forms at long tables laughing and joking over tea. One man thought he was still at the war; there was a frightened look in his eyes. He showed me a photo of his mate and asked me if I had seen him up the trenches. Was Jerry falling back yet, the bastard? Soon he would have to return. Another asked me to take a message to his wife if I was going to Blighty, and all the time was trying to hand me a small parcel which flew away as

his muscles contracted involuntarily. Although I was embarrassed by this it was after all no different to the conjurer making his rabbit disappear or the comic with a funny prop. I laughed with them. For some reason, perhaps because they were simple men, I was close and at ease. Even my stage make-up and costume did not intrude: probably helped. We talked as best we could. I was in disguise too.

The impact of this codicil to war was sudden and went deep. Coming back to the theatre in the car I felt white under my make-up, which I had kept on for the evening show, and watched the bright Thames flow towards London with its free and laughing crowds of people. I vowed then never to kill a man; never to leave a man for dead. Little did I know. This was the thirties: there was plenty of time to kill. By the time the Spanish Civil War came I had turned inward in my search, if not for a world then for salvation. This experience had been decisive in making me a mystic in search of God rather than a political man in search of Utopia.

So it was I saw death as well as life of which I was to become so vividly conscious later: and the half-death lived by these men caught in the machinery of life so they could not get out and work themselves towards fulfilment, but only perhaps to some unsuspected goal through pain and spiritual aloneness: for the most part inarticulate. It was not death that mattered: death joined to life was a complete turn of the wheel: a circumnavigation by which I was always intensely interested. It was the suspension of life and death that seemed to be so terrible. My search was to be a search for understanding, an attempt to enshrine loveliness for all to see. As yet I thought the emphasis on beauty and the shutting away of horror to be the only way: it was not till the iceberg turned over with some of the monsters of the deep still clinging to it that I saw I was wrong. A man's experience must be complete before he can create: he must be touched by evil. I think Léonide Massine knew what I could only surmise and hear in the ultimate pulse of destiny in his work.

Variety Theatre

ANNA PAVLOVA was almost a spirit who flittered in and out of my early years, never to be quite caught, never to be known but always to be present; present not only in her constant appearances on stage but in drawings by Augustus John of fine and exquisite delicacy, a poorer painting by Lavery of her with the swans' feathers on her head: her crown of death. She had obviously influenced Carlotti a great deal and in doing so Greta must also be included. No doubt they saw her many times and I think Carlotti and she had met or even worked on the same bill. For me she remained a spirit, an essence. I never saw her. One day Greta said excitedly: 'Come on now. Get ready. Pavlova is on at Streatham. We can get in on our cards and there is a matinée.' Something stood in the way. I was drawing. I was reading my bloody books. I was writing. It did not matter.

'Oh, shut up, Greta! She will be at Lewisham or even at Penge in a week or two. Much nearer. I will take you then.' The next thing Pavlova was dead. And I went about weeping inwardly and spending long journeys on the open-top buses composing an elegy to her. It was an elegy of grief. She was the image of my inner self at that time. Her strange Pan-like personality haunted me. I thought of the year before that when Greta and I had worked at the Winter Garden at Bournemouth. Destiny had disjointed the hours again: she was there the week before us – we followed her in and were reminded of this by the Musical Director, Sir Dan Godfrey, who was irritable at rehearsal on Monday morning when I checked a mistake. I was always very reticent because of my lack of music but I knew the band parts so well that it was almost a spontaneous act to find a beat missing. And because the orchestration

deviated from the original Sibelius score, he insisted on playing it as it should be, not as I wanted. So there were some angry words until it was right for me.

'What's up with him? Silly old bastard!' I said to the Stage Manager as I came off.

'You're lucky, mate,' was the reply. 'You should have seen him last week. Pavlova got so angry she slapped his face. There was some barney I can tell you!' Whether she slapped his face because he got the music wrong or he got the music wrong because she slapped his face, I cannot tell. He was a man of irascible nature and the demands of a great artist, which he was not, may well have exasperated him.

'Funny woman!' the Stage Manager went on. I can't remember him now. He is faceless with the wearing of the years. I just see a blue waistcoat and shirt sleeves, hear a voice.

'A new dance, see. At least I think it was. Marvellous really like everything she did. But I couldn't quite get what she was at – what she was trying to say, like. So I arst her. I says right out "Why did you do it? what for?" For a moment her eyes flashed – she had lovely eyes – and I thought I was going to get one round the kisser as well. Then she said: "If I had known I wouldn't have had to do it, would I?" Marvellous answer really, when you come to think of it!'

Renée Houston and her sister Billy were on with us. Such was the kind of variety bill on which Pavlova worked and one of the reasons I felt so close to her, although it would seem she was more of the world of Massine than of Florrie Ford. Nevertheless her appearances at the Palace in London with Mordkin had firmly established a place in variety for ballet and is no doubt how the bastardised dance, the Adagio, came about. Had Pavlova stayed with Diaghilev, had she not refused to dance with the young Nijinski, had she fully accepted Stravinsky, this closeness with my own work might well have not happened. It did, and it gave me at least wider understanding if not greater skill.

The truth is that Pavlova was a great and lonely genius of the kind which is denounced to-day because it interferes with the establishment, and when it *is* identified usually carries with it

the seed of its own death: in this case as already symbolised in the dances: *Les Papillons*, the *Californian Poppy*, the *Dragonfly* and of course *Le Cygne*, inspiration for which she found in her back garden at Golders Green and at the Swannery at Abbotsbury, which she used to visit. If Massine indicated the omens of the future and for me the destiny of war, Pavlova danced the death of an age before the First World War, and the Diaghilev Ballet indicated the breaking up of old forms and the emergence of new forms, artists such as Picasso and Stravinsky were to extend well into the future. She was caught in this quicksand of history and knew she was not able to escape. I think her loneliness and her secret were in the intuitive knowledge of her own death and even the desire for it. An occasion when creative ecstacy takes on the love of death as with the eighteenth century poet Kirke White. All the ephemeral creatures she portrayed were extinguished in this way; in doing it she was expressing the longing of so many people bereaved of the youth that would have constructed the new age, and left with the age they knew, fallen into ruin like a castle on a broken hill. Hers was not the dragonfly crunching love's fingerbones by the lake but the diaphanous creature of a romantic age caught in the nets of death. In so doing so was Pavlova.

I speak of these things because it was as a young artist that I too grieved over her dying and extolled the patterns of the future, wherever they might lead, but never believing they would be as great as she. And when at her Memorial Show they played the *Le Cygne* music to an empty stage with only the limelight following her ghost in her last and most eternal dance I wept, perhaps because the time had come when the great artist and the things of the heart would soon cease to matter. It is upon such things that an age was built.

It was an act of mercy on the part of the Fates that I came into contact with the Crazy Gang in the early part of this particular decade, because it was they in their high office of Court Clowns who drove away the omens of evil that I found about me. Our contract with them put us at the top of our profession. It was success in the real sense of the word. We toured the top

theatres which were owned by the impressario George Black, a tall sleek man with a huge cigar that never seemed to go out, always friendly. It was he who started the Crazy Gang and he who began the great shows of variety at the Palladium, which have lasted well into the century and will probably go on as long as we have a Royal Family. We had joined the show at Brighton, but for some reason George Black had not seen us and we were asked to do our act on Sunday night when we arrived at the new Empire in Glasgow. We did it with all the cast on stage and Black and his associate Charles Henry in the stalls. It was nerve-racking, but when we had finished everyone started clapping and we felt for the first time we were taken right into the heart of the profession, because everywhere there was affection and laughter. This was perpetuated by Nervo and Knox, Naughton and Gold, and Eddie Gray who were always fooling, even off stage when there was no one about. They worked while the people were coming in, they worked during the interval and between the shows. At no time was the theatre without laughter. And they drank with the vigour that good comedians and great clowns should drink, growing more rude or more funny as the mood went; and the more we laughed at them from the wings the more they invented new jokes, until sometimes the show seemed to be entirely between ourselves. The Musical Director was a Dr Farmer, the author of a book on Arabic musical instruments. He was also a friend of Anna May Wong, the Oriental film star of that time, and himself a philosopher. I had two weeks of stimulating discussion in the dressing rooms and only one quarrel over the timing of our music. I also had a wonderful time painting Loch Lomond in the daytime. Glasgow was a memorable date.

Our place in the show was to do dances for them to burlesque. Sometimes we were left to take over and do complete numbers and there was no greater reward than to be brought back by Charlie Naughton or Jimmy Gold over and over again to a continuous ovation. But at other times they might come on and dance with us or round us, making serious work impossible. It was good to be burlesqued and in some ways fulfilling. At least one never wanted to be vain or pompous

again. At the Palace, Blackpool, they got George Formby drunk enough on a Saturday night to sing dirty versions to his songs so that the people of the north fell off their seats laughing, and later I led a procession across the Tower Ballroom with the girls in long elegant dresses and Greta in black satin, the clowns in among the people and the band going full strength. This was not art but entertainment by artists who had the power to touch in their audience the springs of laughter and affection and even love; who awakened a primitive need for communal gathering and ritual dancing. The clowning of those comics, who were from highly skilled circus families and could walk the tight-rope as well as they could do their phenomenal slow motion wrestling act, was one of the marvels of self-controlled silent comedy. This was the Festival of Life – simply that. I knew it and loved it as much as I came to know and hate the Carnival of Death in later years. And perhaps it was significant that this was so at this time. Perhaps it was the other side of the masque which Massine presented to us and Pavlova had turned her back upon.

When we got to the Portsmouth Hippodrome for two weeks we were travelling to London every day to rehearse at the Victoria Palace for a new production at the Palladium. It was exhausting and we began to realise that the life on the stage demanded everything and that we were never able to rest or to be free from the needs of our occupation. This would have been well had we desired nothing else, but we did. Greta spoke more of settling to home life and a family. Perhaps she remembered what Alexander Zass had said: 'ze woman, she's finish at dirty!' I was tormented more by my need to be a painter. The great day when we could give it all up would never come because that is not how life works and I knew that when one was chosen for a vocation, as I believed myself to be, it could not be compromised. So it was part of an unconscious resistance movement of growing strength for us to turn down a request that we should marry while we were with the show and before we went on to the Palladium production which would be put on after the summer. Teddy Knox married Clarice Mayne at this time and it would have no doubt been a

good thing for us if we had married also, but there was something in us both that recoiled from using this personal ceremony for public purposes, to promote our show. Of course it was harmless but we were young and very green in these matters. Moreover we liked the way it was because we had no reason to doubt our faithfulness to each other. But as always in the profession, there were counter-demands from unknown would-be lovers whom Greta was not interested in. We insisted on keeping our lives to ourselves; it was fatal.

Late one night at Portsmouth after the last show, I fell down the area steps of the digs and put my hand through a window, slitting my left thumb from top to bottom. I had not been drinking, of course, for at this time any excess was detrimental to fitness, and to work well one had to be hard and mean to oneself. I was simply tired out. The wound bled a good deal before a doctor arrived to stitch it up, and I felt sick with pain. In some ways it was a warning to slow down and the doctor was good enough to point this out; that the next time might well be on stage – and even fatal to one of us. I thanked him. But there was no way of slowing down and the management did not like it when I marked the dances through at the Victoria Palace instead of doing them. My capacity for intense work always left the doors of the mind half-open and the visit to the sanatorium to dance for the wounded soldiers brought on dreams from deep places where my mother still wept over her dead brother. Through these tunnels I came also to where years before I had put out the Eternal Light and I was drowning as a penance in deep waters where all these poor men were half-destroyed because of my act of blasphemy, and they floated by me on a tide of blood.

I was glad when the first weekend came and we could rest: especially as each dance split the stitches in my hand and blood spurted everywhere. It had no chance to heal.

Sunday morning was cold and clear and beautiful. I decided I would not go to the theatre to-day. After breakfast, dressing slowly in my tweed suit and wide-brimmed hat, my long actor's overcoat, I walked with Greta across the green places of the city, between the monstrous civic buildings, so naked

and so ugly in the Sabbath sunlight. We passed a memorial to the glorious dead which reminded me of the inglorious living I had so recently seen, and so to the sea front, feeling that marvellous exhilaration at being alive which an on-shore sunlit wind can bring.

There was a sudden twang, as though a steel wire had caught our legs. We jumped. Someone said it was a naval shell. I had not thought of that on Sunday. It may have been a salute to the dead.

> I would carve in stone
> For those who are alive
> And stand as monument
> To those who died alone
> But had not time to shrive,
> I would carve an empty seat, a single throne,
> One that was coincident
> With dawn and held the light of sun
> For those who came and went
> And those who are to come.

My thoughts were full of meanings and any shock like the crack of a shell set them in patterns, like sand on a tray: like seabirds and the shades of the dead they came and went. This would explain a good deal later. But Greta was looking away, I thought bored with my recitations.

'Look at that poor dog,' she exclaimed suddenly. 'I do wish we could help it!'

The sea wall at Portsmouth slopes at an angle of nearly 45° from the promenade to the water. At the bottom of this where the stonework had gone green and slimy was a dog, a black spaniel that had slithered into the water chasing a ball. Because of the slippery weed it could not get back. Its owner, a woman of stout clothing and behaviour, glasses and bunched hair, was commanding it to return to dry land, but the creature with its ears floating on the water, only slipped backwards, getting more tired and pathetic. The sun shone. The people walked up and down in their Sunday best, wondering perhaps what I was doing, some with prayer books looking peaceful and devout,

like people who had been in hospital. Some wore the roughness of their days and the irregularity of their behaviour; others betokened good citizenship and conformity in dress and posture. A blonde whore made her way like a bright thread through this sombre English scene. To add a touch of fantasy the family of midgets, working on the same bill at the same theatre as I was, walked with the crowd. Willie Pantzer's Midgets, the same family I had known as a boy at the Crystal Palace Circus: a complete, wizened, miniature people with a curious pride in their lack of magnitude and in their microcosmic society. Meanwhile the dog was dying.

Seeing the plight of the dog I left Greta's side and walked at an angle down the sloping sea wall to where it was struggling: being tired it began to slip finally away into the sea. When I got close enough to be almost able to touch its head, the animal got excited and, tensing all its muscles, scrambled near enough for me to pull the hair on the back of its neck. In a moment it shot past me and was gambolling after its mistress, stopping now and again to shake a spray of water into the bright morning air. I saw his mistress turn round with a 'so-you've-come-at-last-you-silly-dog' look on her face and walk away.

This was well, but as the dog shot by me, breaking the stitches in my thumb, I found myself sliding helplessly into the sea on the same green weed. The crêpe soles on my shoes could not grip; there was nothing I could do about it. Slowly I felt the icy fingers of water searching through my warm clothes. My long actor's coat became heavy like the leaden cloaks of the hypocrites in hell. My huge hat was taking the splash of the waves and going floppy at the brim. I was helpless – and ridiculous. Greta stood at the top of the wall, pale, passive, remote. Then I saw the tiny people lined up jeering at me: the midgets who were getting their own back. This was an infuriating humiliation. I felt the sea sucking me back and held on to the stone wall between the blocks as best I could, but my injured hand and the intense cold made it impossible to remain. The skirts of my greatcoat were working like the wings of a manta ray, but not to my advantage.

Throwing my head back to get rid of my hat, I saw a man walking gingerly down the sea wall towards me, holding out the flimsy belt from his cheap trench coat. After missing several times I caught one end of it, but under my increasing weight it snapped. The midgets laughed, pointing their tiny hands; around them was gathered a crowd of giants. Greta remained pale and motionless.

A little way along the wall – about fifty yards – there were some iron rails and steps set in the stone. I tried to reach them but the current pulled the other way, making too much strain on my frozen hands and I dared not let go to try and swim in my heavy clothes. At the top of the wall on the promenade, I knew there was a lifebelt: I had seen it but it was now behind the crowd. I shouted for someone to get it, but no one seemed to hear or understand. The crowd seemed to be in a dream watching me; as in a dream my shouting had no effect. Only the midgets answered with their squeaky voices, telling me not to be late for the first house. Was this my new act? It would bring the house down if I didn't go under. And they laughed some more. Then all at once, as I was slipping away into the water with fatigue, just as the dog I had rescued had done, a hard little seaman with the lifebelt in his hands appeared from nowhere. It was very difficult to stay afloat now with my arms aching. The water was deep and affectionate. Inside something called for me to go down into the cavernous green womb of the sea, cradled forever with the weeping seamen who danced in the deeps; laughed out of life by the midgets and the great giants who watched me from the wall struggling between life and death, making more ridiculous gestures than the abbreviated men in the sanatorium. At last I got the lifebelt between my stomach and the wall. They shouted for me to hold on and began to pull: the rope snapped. Another rope was found and doubled with this one. Again they pulled: the man with the raincoat, the sailor, a boy and the midgets. Gradually I moved slowly and upward on my belly, clawing the air helplessly, like a giant crab from the Sargasso – from one element to another, from unconscious to conscious, from death to life, eternity to time.

When I got to the top of the wall I climbed to my feet, shaking with cold. I felt awkward thanking the seaman and to cover my embarrassment I forced my hand into a wet pocket and drew out several hard, bright, silver coins which I offered to him: he refused, smiling in a kindly way. I felt even more foolish trying to pay for my life; what after all did the coins mean? I shook his hand impulsively, because we were two people come together on the brink of a wall on our journey through eternity and for no other reason. This he understood, because it was as it should be, and nothing was said.

'That was a near one,' said Greta, slipping her arm through mine when he had gone, and we stood watching my actor's hat floating out to sea. 'I wonder what happened to the woman with her dog!'

Soon after this happened the tour ended and was to be resumed at the London Palladium in the autumn. We would receive our contracts in due course. After hanging about in London for a time, trying to get a summer season, we suddenly realised we must opt out for a spell and went to Cornwall where I started my studies in art and literature and stayed till our money was gone. When we returned it was too late. The contract never came through – it had been given to another act. The crowning date to our achievement had gone and with it the Royal Command Performance. We had to start all over again – almost from the bottom of the profession. Having tasted Cornwall and the deep pleasures of study, even to delivering a lecture on Thomas Hardy and attending life class; also living close to the rocky face of that most dear place, we were reluctant to return to London at all. We felt we had found our home, but we had to go back to Mrs Terminus and get our act together again.

Glass Fountain

AT this time Ravel's later music had come from Europe by way of America and we had a dance arranged to his 'Bolero' at the cost of two pounds an hour by a vital little woman in Dean Street called Zelia Raye, who ran her own School of Dancing. This broke entirely with Carlotti's influence and gradually the hard work of the now old-fashioned Adagio Dance, as we had known it for nearly a decade, gave place to the influence of rhythms which were emerging from Spain and South America. It was the time of the Gypsy band. We arranged dances ourselves to the Carioca and the Cucaracha. We were almost entirely exhibition dancers and were not so worn down with danger and over-work.

We did a good deal of cinema bookings which were not to our liking because they lacked the life of the real stage and like all places of machinery were silent and dead; beside which the organ notes that were played for us to dance to were so long and soft that we could not keep time. There was no rake on the stage. The audience was cold and unreal. Where possible we combined these bookings with late night cabaret in the fairyland of the West End of London, running through the back-streets from one night-club to the other in full make-up to save changing – to be accosted more than once by whores and pimps and those gentlemen who thought I was a lovely thing sent by some queers' heaven to give a touch of paradise to a sordid corner of Lyle Street. We had great fun about this, reciting the insults flung after us when they realised they were wrong. But of course it was taboo then.

An American agent booked us to work with a Gypsy band, in which of course there was not one Gypsy but only a few Spaniards, an Italian boy from Charing Cross Road, and one or

two Cockneys. They were good rough musicians and we enjoyed working with them but to maintain continuity of performance was difficult because they would suddenly strike before the curtain went up and I had to talk them into going on or promise to get them more money from the American. Otherwise they were not there and I had to collect them off the streets where they were busking or drinking. Then quite suddenly tragedy struck. The handsome Italian boy, whom we all loved, went to the baths in the morning and walked about all afternoon busking with his shirt open in a cold wind to show off. He contracted pneumonia and was dead by evening. We continued without him, his close friend always shadowing Greta and me to find silent comfort and write on the dressing room walls TONI IS DEAD wherever the show went, until the day came when we fell apart and went our separate ways.

This was the thirties with their splendour and their ragged hopefulness, starvation and riches, spectacular films and tall beautiful women, its dream of Utopia that was to become a catastrophic collapse. H. G. Wells looking into the future with uncanny accuracy and Hugh Walpole looking back. We ourselves floating from date to date with some success but no purpose because now there was no longer the same passion in the dance or the same meaning. We had tasted tranquillity, the interior joys of study and home life quietly in the country and the beginnings of personal creation – of becoming a creative man. We wanted nothing but to return. Then something happened that seemed so symbolic of the time and particularly of my own life that I was shocked to the roots.

Although I had lived all my early life under the shadow of the Crystal Palace, I was in Ireland when it was burnt down, making a great funeral pyre of the past. A comedian was saying to me in the dressing room: 'The Crystal Palace is burnt down.'

'Impossible!' I said, lining my eyebrow. 'You're codding! It can't have!'

'What do you mean – *can't 'ave?'* he snapped. 'It bloody *'ave!'*

'But it's all glass and iron,' I said, still not taking him seriously. 'How could it burn?'

'I don't care if it's Cinderella's fucking wedding cake,' he shouted, thinking I was taking the piss. 'If you don't believe me, look at the bloody paper.' He flung me a Belfast edition of one of the English dailies and there most certainly were the pictures of the great glass building which was a Victorian's ultimate dream, which had been a palace for my childhood as surely as if I had been prince of urchins, now helpless like a great dinosaur with a broken back. Who would have thought of it burning. Collapsing: yes! But never by fire! For many miles the flames were seen and are still remembered. From the hills of London to the north and the hills of Kent to the south, from Surrey to the west and from the Thames Estuary to the east – probably from much farther afield in every direction. It was the signing of a treaty that ended childhood, also to end peace: the back of the thirties was broken. The zeppelin of the First World War was still coming down in flames.

As I came over on the Irish Packet, plunging in moonlight, watching the phosphorous sea hissing with beauty as the foam-headed waves slid by into the remote world of things gone, I thought of those great galleries collapsing, of the glass melting and running like hot lava down West Hill where Liszt used to stay, the girders sagging like wax, acres upon acres of floorboards splintering, cracking with fire, and the great tunnels underneath drawing the flames till they roared like the flues of hell, until the whole thing was a glowing mass. In my mind it became like the vision of a long furnace in which moved the figures of all those I had known in childhood. There was Kusinov, the old Don Cossack with his golden horse, and the beautiful Susan Jean in her blue velvet riding habit and three-cornered hat; Jacques the Clown on his uni-cycle with his hands raised; the Stey Family carrying long balancing poles for their high-wire act, which they always performed in white tights; and the great stallions Day and Night. Ghosts of my childhood. Myself in a svelte suit and winkle-pickers, killing the black satin girls with their golden hair and silver shoes, long earrings, swaying to the mournful saxophones which had wailed over the death of the twenties – the swaying bodies of our adolescence, our teenage days purged by fire, watched over

by the angel of the future and the pulse of destiny. I was a man!

The dawn broke over Liverpool – and rain. There was the journey south.

Being anxious I went straight to see my mother and father. They had been excited, especially my mother, who had made my father drive her to Croydon in his 1922 Jowett, because, as she said, they thought the South Tower was going to fall across the block of flats and bury them alive. As it happened neither of the towers fell during the fire, but they stood for a long time like sculptures of the future to mark the place where the great glass giant had fallen.

When I saw the Palace again it was a pile of twisted metal, still smoking and ominously foreshadowing days to come when I stood and looked at Plymouth and later at Caen with these same feelings. This very metal may have gone into the guns and planes of that terrifying time. A war that would be 'all in the air' they used to say – 'over in about two days' – just as now when they say the Bomb will wipe us out in a matter of hours and the whole human experiment will be over. If it did – what matter? An incident in the evolution of the universe. That creative energy would continue to stream from the original fountainhead and bring about a new and better experiment in a few aeons. In which way can the human race be named sacred if it makes this Mephistophelian act of extermination come about? Were the shadow of evil to put out the light of the world it would only mean that an eclipse was being seen from one hill in time at a frozen moment, which, however agonising, would pass into eternity. Light would be created again.

The Palace was in so many ways a place of lost civilisations. The Egyptian Temples, the Moorish Courts, the Greek Colonnades – all had fallen before the fires of time and with them some of my deeper dreams that had begun as a boy and were now emerging into reality and increasing my passion to interpret life, because it became apparent that one was faced with this process of creation and destruction and one must understand it in order to arrive at the wisdom of paint or of words, or indeed of stone. Old stones that cannot be read, new stones that create an enigma: symbols of the unconscious.

But I did not think only of these things and of the circus people and the pretty girls. I thought also of the white cockatoos with their sulphurous yellow combs, screeching at the invading flames as they might at a forest fire, but chained to their perches and unable to fly away. I thought of the great carp in the ornamental lake that boiled when the glass fountain melted and poured into the water. These were the sacred fish of China; they had been in the Palace for nearly a hundred years; their backs were slippery with algae. This I knew because as a boy I used to watch them moving slowly, like thoughts, below the surface of the water; quietly my hand touched them and often they would not move, sometimes they marked the gentle shock with a flick of the tail. For me it was as though I looked through a sight-hole in the side of the universe and saw how it worked. This was the very close thing of experiencing the life of another creature as your own life, so that you knew the origin from which you both came: the great mind which contained all things and for which we provide consciousness. Although the fish had gone olive-green and slate-blue, flecks of gold on the scale tips could still be seen and one felt very much that this was only a time-skin which covered an immaculate and ideal beauty – for the most ideal is also the most real. Fire and molten glass were strange things to end this pool of life; no less strange than the end of Pompeii, and that which was so soon to follow when the flame-throwers would play, not on the beauty of ancient fish, but on the innocence of young men, causing their skins to run off them like hot fat, just as the molten glass had run from the fountain into the water. So contemplation of beauty and of violence may go close together – almost with enantiodromic nearness.

The Crystal Palace Parade was a prospect of ruin a mile long, on one side, ornamented, as we might imagine, with a prediction of twisted iron sculptures from the forties. On the other side there were the eternal sunsets over London – which was I to choose?

The grounds remained unaffected; the complex of stone terraces were like a Greek excavation with most of the statues in place. The great lakes we used to fish were still and watching

where iron tyrannosaurus and archaeopteryx had their being and towered over the tops of the trees. For me this was an important transportation to prehistoric times and it did not seem incongruous that we used to hide from the keepers within their cold bellies and smoke Woodbines, where some other boy had shat and left a stale smell.

Zeus was even now a glory of the whitest marble wings near the maze of Mithras, where an answer might be found. An answer to what? I had already forgotten. To life – and death perhaps. They were the interesting things. But my search was through the labyrinth of experience, not the catechism of fact. We stood there as man and woman who had just ended our sacrificial dance.

All this was of importance to us both, because the emergence of another and fuller person was making itself felt. My contentedness with the life of a travelling acrobatic dancer was beginning to go. Greta talked of children. We thought more of our own home and of me becoming a painter. We were tired of the road. Although we earned good money – the equivalent of £150 a week by values to-day – and I could buy materials, even pay for instruction, I could not go to art school because of the move from one town to another every week, so the whole plan defeated its own ends. Had we stayed with the Crazy Gang we would have been resident in London, which would have been perfect – and with even more money. But there would have been other difficulties. It became more clear as time went on that we would have to break for good.

Unless you have the force of an outstanding genius or happen to synchronise with a need of your time, there is a point in the theatrical profession beyond which it is impossible to go, without certain licences and touches of corruption. It was ever thus. We had gone far by sheer force of talent and hard work, appearance and personality, but not quite far enough to hold it on our own, even though we were counted among the star Adagio teams of our time. When one morning I went to see an agent and found he had arranged a bribe around a contract – that is a cut-back besides his usual commission – without even consulting me, I realised the truth of what I had

sometimes heard. A comic on the bill wanted to sleep with Greta; she was not my wife but she would not go. It became clear why some of the women in other acts could be seen making a fuss of the most uninteresting comic who was nevertheless top of the bill and ran the road show.

Becoming suddenly aware of these things they seemed to be all around me. We were caught in it. Obviously we had not seen it before but it must have been going on. Innocence is a protection, but naïvety never. We declined parties because we were used up anyway and did not want to get involved. The bookings became less. We were looked upon as a dead loss. After all we had a common purpose in life and that was enough. Besides which the urge, ten years ago, to realise my talents had grown stronger instead of less. Because I put these activities first Greta was at a disadvantage and it was probably a reason for not wanting to continue with the hard life on stage. Because of the work, I imposed self-control and found methods to cease desire, which was resolved into a process of purification. This was difficult for her but did not decrease our affection. She was quiet and intelligent, she loved the dance but fulfilment would not come from it and as our physical beauty was as transient as youth we knew we could not go on forever. The shade of Alexander Zass came back in our lives with his philosophy of strength and time. And he was no fool. The more one aged the more dependent you were on vanity and the ventriloquial Ego Doll. Moreover the fluid thing that was the dance was keeping Greta from having children and creating out of herself, which is essential to everyone who would live a complete life with a sense of permanency. In her passive way she did not complain, but I have often wondered if these restrictions, coupled with the experiences she had at home in earlier life, did not drive back the creative force that would have saved us untold pain and death in later years. Take hold of creation and you have the tiger by the tail; resist it and you will be destroyed.

The melting of the glass fountain had just as deep an effect on me as when I blew out the eternal light in the chapel: early fears were awakened; especially as the hot glass had hissed into

waters that were always for me the dark places of the mind and of the spirit. In the same way the Temples of Karnak at the north end of the Palace had been threatened by the waters in the tanks at the top of the North Tower, should they burst, flooding their colonnades. The melting of the glass fountain was the ultimate sign that war and destruction were to come – indeed the possible breakdown of the whole civilisation. No wonder I was deeply disturbed.

Taking the path of a dancer had not been wrong; instead it had been an apprenticeship that could be gained in no other way; it was necessary to prepare me for the future, even if only to make me tough in skill and deeply experienced in humanity and in the moving structures of form and colour, patterns of forces, laws of growth. As an art student, had I become one at the time I had wanted to, I would no doubt have been one of the many that are etiolated by despair and boredom simply because they are never taught these things in relation to drawing or painting. But now the wheel had turned full circle; I was back at the point where I had started. It was to become an act of faith that I made the next move. I did not turn back, in the face of want, because I believed that the destiny of man depended on his power to create: even though he might be destroyed doing it. Death does not matter.

One day, walking round the residential houses of Sydenham as we had done when we were younger, I said to my brother:

'There will be another Great War in our lifetime, in which we will both be involved.'

'I know,' he answered. 'Not just yet though. Another five years I give it. Not longer.' And of course he was right.

These realisations were largely intuitive: they made no real sense since neither of us was a political animal. I was at the other pole, the creative pole as I thought. I could not understand why the poets were going to fight in the Spanish Civil War. I had turned my back on the sun and watched my own shadow: the world was not with me. I must first know the things of the mind and the spirit that generated the miracle of life.

The thirties were a hard time. It was not the day of the

ordinary man; he was underfoot. There was a modicum of honest violence in the Cagney punch-ups and young men even looked like him; the girls like Garbo and Dietrich, as later they looked like Munro, the last goddess, who was thrown to the machinery-headed lions. The thirties still needed their ideals, their mythology of sex and luxury, because there were still hunger marches and poverty. It was a strange time to decide to become a painter; the society of that day had no place for the artist.

Then something happened to help my direction: like nearly all such happenings it took the form of misfortune.

I was working at the Brixton Empress. It had been rebuilt and was now quite a nice theatre with all sorts of advantages over the old music halls, such as the Metropolitan in Edgware Road, the Old Bedford at Camden Town and the Queen's, Poplar, all of which I had worked at one time or another: every advantage that is, except the ghost of the place that was gone, while the others, like Victorian coster-women a bit drunk on a Saturday night still held the warmth of heart we loved so well.

Having now some standing in the profession we usually shared top or bottom of the bill with another act and therefore had a good dressing room. Under these conditions I was able to paint or write. Often I have run on to the stage in the middle of a sentence, straight from the dressing room, and come back to finish it after a dance: writing up-stream with all the force of youth. In this way a huge romantic novel was written: in it a heavenly fair-haired girl wove the fabric together with her sexual and spiritual beauty, but with a curious doom and sense of destiny over everything. It was something between Charles Morgan and Jacob Wasserman with a touch of Dostoevsky.

My paintings were quite elementary and rather chalky or else rather black, because I could find no one who knew anything about colour. And I haven't found anyone yet. In the end I had to discover it for myself. An attempt at a sunset over London after coming up the Thames on the paddle steamer, *Golden Eagle*, on a summer evening from Southend, was a complete heart-break. I knew nothing of natural harmonies and discord in colour, the powers of light and of hue and

luminosity, the majesty of form and space, how they could be constructed into symphonic themes. Even after watching Turner for weeks, and then again the evening sky, and then my paints, I could not see how it was done. I could get no more than a mass of dead paint. It took me thirty years to reach a result.

I read the poets and the letters of the great painters. I collected photographs of great men, which meant anything from Hardy and Baron Corvo to Tutankhamen and his beautiful queen. Somehow I would enshrine the miracle of life as these men had done; the beautiful and silent performance that goes on behind the daily greed and power of mankind. My work has been a ceaseless effort to do this.

As this inward centre emerged, the dance became more an expression of it, for once a man starts to grow the process must be completed. The branches of the mind, and indeed of the soul, must spread in each direction, hopefully towards the stars; growing out of the main trunk from the roots of history one is no longer free, but an instrument of an unseen power. It was up to me to become skilful not only with the dance but also with paints and words.

That week there was another dancer on the bill whom we called Ching, though he was really from the Philipines. He was a person with a marvellous agility and power to dance and he did a strange 'Cigarette Dance', also a dance he called 'The Dragon Fish' which was completely beautiful. We rehearsed with him in the mornings because he knew a lot of new steps and he had with him a small group of African Negroes who played tom-toms. This was particularly valuable because each time they played differently, bringing from within themselves new rhythms and sequences of rhythm by some kind of purely intuitive process which involved the heart and emotions but not the intellect. We in our turn picked up the beat as it materialised and *created* steps to go with it so that we were really dancing out of nothing for the first time. It was like being at the beginning of the world and regenerated energy instead of making one tired. Ching made some masks, one for each of us, and we started to arrange a Blues dance emerging

in a natural way from these African rhythms, the three of us weaving in and out of one another and changing identity by putting up the masks, then taking them away, so that in effect we appeared to change sex at the same time. Often the Africans would get so excited that the drums beat at terrific speed and our dance became a thing of whirling beauty. I sat a lot with Ekomo, the leader of the group, in between dances. He wore a round tiger-skin hat and was a man of great natural intelligence and kindness. We talked of his music and of him working with us, arranging a new act to include Ching. Ekomo was interested in this and said he would do his fire-eating dance for us, which was part of his ritual dance in his own country as witch doctor. This he did with extraordinary power and truth, arising as it seemed to me from the very fountainhead of life.

The only one I was doubtful about was Ching, who could dance better than me and and draw better. This weakened my position and he took over as choreographer, producer and director. I found Greta was dancing better than ever before, but with him; not me. She was the heroine of my novel, the centre of my dance, the light of my painting, the earth of my family to be: Ching was taking her away.

This realisation centred me: my own dance on this particular night, became a complete and absolute expression of my life at that time. Never before had I felt the *duende* rise within me as I did then.

On a darkened stage we came out from opposite wings and were at once picked up by powerful limes from the circle as we walked towards each other very slowly to the beat of the tympanies: myself in black satin, Greta in white – *yin* and *yan*, *animus anima* – a cadenza rippled as she swung into a slow turn showing the brilliant red lining of her skirt. We slid into one another, she glided away – I followed. She became elusive, gentle, moving ever further away then with the crash of a cymbal she turned and stepped into me, held herself strong and defiant against me. I yielded – allowing and loving her mastery, as though she would triumph. 'Come on, you bastard,' she said in my ear. 'Take me now!' The music rose in tempo and as the strings soared in rage I rose up and took her, smiling and

powerful, lifting her to the heavens, dashing her to the ground, flinging her in a series of wild pirouettes round the stage, her skirt circling in a labyrinth after her. As the music built up I did some static pirouettes of sheer ecstasy then followed her in a swift arc of spins. It was now that the immortal clown who sometimes conducts our lives stepped in. My trousers, which were wide at the bottoms, wound round my ankles and locked my feet abruptly. Still spinning I was flung beautifully across the stage on to my face but by turning my head and shoulder slightly converted the fall into a roll which returned me to my feet again. This was something taught me by Alexander Zass and used spontaneously. The audience made a noise between consternation and laughter, drawing in its breath like a huge animal, then realising what had happened when I came to my feet and smiled, broke into applause, not knowing my back muscles were twisted in one direction and that I was paralysed with pain as Greta came towards me for the last triumphant lift. The awful part was that had I been able to untwist there would have been no injury. I could not let her know in time. She came and I took her like a bird. The centre of gravity in this lift is the centre of the back at the lumbar curve. I felt the roots of the great erector muscles go as the curtain fell and I could not get up to take a call.

Between a stage hand and Greta I was helped to the dressing room. An ambulance worker – one of those anonymous men who do so much for people in the harder corridors of life – was there to massage me until the next house, which was an hour and a half later. I was able by then just to walk to the wings to make my entrance. After the first few steps the pain was so intense that I went numb and felt nothing. The mind was a transmitter, bouncing back the waves of pain and sending messages to the body to engage in the symphonic behaviour of the dance. We danced magnificently. When the curtain fell I blacked out.

That night Greta had to cross London to see her mother who was ill. She left me anxiously at the stage door and I had to watch her go off with Ching who insisted on seeing her through to Hampstead Tube Station. When she was gone I started my

journey to the digs, which was only half a mile: it took two hours. Somehow I got there with the help of a stick of African hardwood lent me by Ekomo, the witch doctor. Had it been with Mrs Terminus I could have called for help and Rosie would have helped me, but it happened they were booked up and I was in strange digs alone. I did not like to call the land-lady. Somehow I climbed the stairs and fell whimpering into a strange brass bed without any supper. She probably thought I was drunk.

I felt as though the fountain had melted within me; I was a lake of molten glass, burning with pain.

Dragon Fish

I ENTERED a long dream in which Ching kept appearing with a mask, and then without it: his face oval and opaque, his eyes oblique, his shoulders square. He was doing his dance of the Dragon Fish, at first in a kind of limbo and then it became apparent that we were in a rehearsal room in Soho where I often worked with Greta; a bare, faded place, the July sunlight pouring its columns of honey gold dust through the window. In one corner sat the four Negroes, grotesque in the shadows, each holding an instrument – the jungle tom-toms, a guitar, an oboe. I had just finished a routine with Greta. She sat on the other side of the room in a red taffeta practice dress which had a full skirt sweeping to her feet, but was open up the front. Her bosom rose and fell.

Ching was preparing to do his dance: he stood in the middle of the room waiting in silence. The leader of the strange orchestra was the African witch doctor, Ekomo, who had done his fire-eating dance earlier and now stood with his round tiger skin hat speaking with his hands to the musicians; in turn they answered him with notes and rhythms, fragments, patterns of sound already existing in the room, in the silence behind the clatter of traffic in the street, music and voices from other rehearsal rooms. He took and rejected, shaped, fitted, threw back until the more complete rhythms emerged and began to enter the atmosphere and ourselves, our nerve-endings, our feeling-buds, our sensitised beings until we were taken into it and were in the sound-fabric being created by Ekomo. It was a dull underwater rhythm, carrying the round-ness of wave, the crash of foam and the mysterious light and shade of the deeps. It was thunder in the heart of a dewdrop. As oboe and guitar began to weave a strange little melody,

Ching began to dance. His movements were slow, gliding through his lithe body like the alternating light on a fish. His arms and beautiful hands drew an abstract in space, developing the illusion that he was a fish under water: now in the shadow, now in the half-light, now in a pool of sunshine. Greta was completely absorbed in watching him. Her face was lit with an inner radiance, which he was able to bring out of her. This made me angry.

The music swelled; I realised it was the actual pulse of creation emerging from the witch doctor and travelling through us all. Ching continued dancing. What colours were changing! What desires were passing through him! Now in ecstasy, then in languor, now in wailing sadness, then in pain caught on the barb of an invisible hook against which he fought. He seemed fish-like: his mouth, even his eyes changed. Then in a shrieking discord he fell at our feet.

Still in my dream we went back to Ching's flat for tea. It was a silent, half-naked little room smelling faintly of scent, grey walls, a carpet without pattern – pink perhaps. I felt ill. The drums were in my head. Greta took no notice of me. She was restless, moving about the room. There was the quiet swish of a curtain being drawn back and I saw she was standing in front of a large glass tank looking pale and frightened. A shadow passed in the water.

'What is it?' she whispered. Ching seemed to be laughing behind the dreamy smile on his lips as he switched on the light in the tank. 'The Dragon Fish, of course! What else?'

Images from old legends recorded by de la Motte Fouqué rose in my mind and identified themselves with the fish before us. Its mouth was loose and fanged, almost indulgent. Colours passed over the spiked integument of its fins and scales flashed like armour, casting infinitesimal variations. I shivered. There was the throb of its great heart; the beat of the drums filled the room. We were all enclosed in the evil which Ekomo, because of his craft, was able to centre upon and drive out from the corporate body. Greta's face was still alight. She made as if to touch the fish. Ching smiled and said nothing.

I must have woken for a time from my dream because of the

pain in my back. I lay in the strange room half afraid of the dark and the outline of unfamiliar furniture that kept its secrets. At last, having found a position of relief, I experienced the heavenly cessation of pain. The core of sleep unfolded like a rose; I sank into oblivion and then again into my dream.

In the second part of the dream I became suddenly strong and, taking the African stick that belonged to Ekomo, I made an interminable journey across London in empty underground trains and through lamplit streets until I came again to Ching's flat. The door was unlatched. I stood in silence: the same vague scent hung on the air, mingled with the smell of seaweed. There was a splash. I switched on the light and the shadow of the fish passed in the tank. I shuddered, not knowing what evil was there. I don't know now if it is inseparable from fear and distinguishable from the danger it presents. I only know it can be overcome by purity of mind and stillness of spirit; but I was nowhere near that, though a certain innocence protected me.

Pinned to the wall was a portrait drawing of Greta done in a few faultless brush strokes – with that ineffable light in her face. She gazed out at me as if from a former existence. It could only have been the work of a few minutes. It was marked 4.35 a.m. C.

I was in a rage and with my rage all my great strength rose up like a wave. I swung round and faced the fish who was identified with Ching in my imagination. With one stroke of the heavy African stick I smashed the glass of the tank and, with the water pouring over me, beat the creature as it slithered on to the floor, twitching, its back broken.

I awoke from this dream to find Greta at my side holding my hand in hers in the cheap lodging room in Brixton. There was something homely and safe, almost pathetic, about the sunlight pouring on to the threadbare carpet.

'Goodness,' I said, 'I thought I'd lost you!'

'So did I,' she said after a little while. 'It's all right now!'

This experience taught me that I must paint and write my books: that these things were not just ambitions but of a deeper need. The deeper half of the iceberg that had turned over and

revealed itself. In denying it I would be denying the inner voice telling me of a vocation from which I have never since deviated, and to which I dedicated myself as a young man in the National Gallery.

'I must be a painter!' I said to Greta.

'I know you must,' she said. 'The dancing is at an end: for me too. I realised this when I was dancing with Ching. You are right: you did nearly lose me. He is a good dancer but an evil person. He mastered me like a snake. I am glad you were stronger.'

'Not alone. Ekomo helped. He gave me his fiery serpent like the man in the Old Testament. Drove out the devil.'

'You remember Ching took me home last night?' Greta went on.

'Saw you home, you mean!'

'No, he took me home; to his home. No, don't be angry, darling. Nothing happened. He did a quick painting of me – quite a remarkable thing really – and afterwards when I watched the dragon fish he started to dance to me and fell down, quite suddenly – unconscious at my feet. I thought he was dead at first; when I found he was not I got out of the place. It was too late to go home so I got one of the early buses and trailed across London to be with you.'

I looked into her tired face and then told her of my dream. She did not seem very surprised: as if in some way she knew.

'You see, darling,' she went on, 'it's a warning. There was something more in it than just the dance: it was the force of evil against creation – a destructive force. I don't mean sex: something else. Something that Ekomo knew about because he was a witch doctor and directed away from us. If you don't create, it brings about the destruction of the human mind and finally of the world. The only thing we can fight with is the flame from inside. God knew this and put the Flaming Sword at the Gates of Paradise: it is the only thing with which evil cannot deal.'

'You speak like a prophetess,' I said smiling. 'Ever since I blew out the eternal light in the chapel I have been groping in the dark and monsters have risen up and tried to destroy me.

Now I see what to do to bring about the metamorphosis and grow.'

'At any cost?'

'At any cost,' I said. 'I am strong enough.'

'Any rate,' she concluded, 'it will be a completed life even if you fail, and that is a rare thing these days.'

'Only history can tell that.'

'History,' she said, looking in the dusty mirror, smiling, 'is the woman with the other face who turns and sees the truth.'

Somehow I finished the week at Brixton Empress, because no artist worth his salt ever denies the truth that the show must go on. We felt this very deeply after ten years on the stage and gave our last and our best to this great and ancient tradition with its marvellous people. But, like Zass, I had gone mean with pain.

After that the heat of the summer was upon us and there were no more bookings; we were caught in this little back-water of London. The streets of Brixton were stifling hot: even near the shade of the awnings in the market where I used to go and watch the colours and the people and the men speeling, there was usually a gentle breeze and the general movement of the traffic, but this summer it was almost unbearable. We realised our savings were almost gone. Mrs Terminus had a permanent lodger in our room now, which was understandable since we were always coming and going, often without any money. She always welcomed us with her shiny red smile and a pot of tea if we called on her, and pretty little Rosie prancing about in the provocative reticence of the shadows.

I said to Greta one day: 'Why on earth did you ever go for Ching like that? I can't understand you really.'

'Can't you,' she said, folding her hands in her lap. 'No more can I understand you going for that beastly little Rosie Terminus. If I thought you had slept with her I'd leave you at once, you old bastard.' Then added: 'But I know you haven't!'

'How do you know?'

'I know. A woman does: it's part of her job.'

So there was another fragment set in the great dome of life, but I still didn't understand how she knew for certain.

'Rosie Terminus!' I exclaimed. 'Christ! How did you know about her?'

'Do you really want to know? Apart from what her sister told me, I opened the front door one night after I had come back from my mother's and you were in the hall kissing her. You didn't see me. The door was on the latch and I closed it quietly. That is why I went with Ching – when the chance came.' She lit a cigarette and blew out some smoke while she was speaking. 'Little bitch,' she snapped. 'She wants her head punching!'

I smiled but did not answer. A woman never knows anyway: she only thinks she does.

In the face of the problem of living we decided to look for a place of our own and, after some searching, found a basement flat in an old residential quarter between Penge and Sydenham. We bought furniture on the hire purchase system and before many days had passed, moved in. Life suddenly became very exciting. It was as though we had unlatched a lock gate and water came pouring in to lift us to a new level, giving impetus to everything. No longer was all energy sacrificed to the dance, and, without this, it flooded through us. No longer the nervous tension, the different cities, the going from one digs to another, with our home on our backs like the snails. Instead there was contentment and quiet happiness between two people building a home and doing what they must do at any cost.

Now I was face to face with the problem of becoming a painter. All this time I had stayed outside it, putting the dance first, saying I could not learn new techniques because of the travelling which prevented me going to school. On my birthday of that year Greta gave me the Phaidon book on Van Gogh: my brother gave me a book on Gaudier-Brezska. Here were two men who did it alone. One, a painter, went mad and shot himself: the other, a sculptor, starved and was shot in war. It was then that I made up my mind, knowing, that even if I had to face a firing squad I must not turn back. I must do this thing. I still say that. From that day I was inspired in a new way; everything in me came to a new centre and purpose – to learn to draw. This was the basic factor behind painting and

sculpture. I had not thought of becoming a sculptor yet, but it was interesting that this influence was put before me at the time when I had just given up the dance, which, later, was so to influence my sculpture: the two things are closely connected, as also is painting. Painting is an extension of drawing into light and colour; sculpture is a transmutation of drawing into space and form; dancing is an extension of painting and drawing and sculpture into movement, and is the link between these things and music. To master them is to be a very complete person, expressing the whole personality. At the time I was not conscious of this: instinctively I already knew, for I had the pride of the peacock.

I commenced my task with the most difficult thing: the human figure. I was drawing all day and half the night, nude after nude, with Greta as model; day after day, week after week, month after month: I filled as much as eighteen yards of paper at a sitting. Cutting off the good ones, selecting and destroying as I progressed. I learned from Rembrandt and Gaudier and Michelangelo, but 'all over again from nature' as Cezanne put it. I followed Si Ho and learned his Six Laws. I lived in the museums, read every book available, always trying to understand the mechanics of the human form and it slowly came to me that Rodin and Gaudier and Rembrandt and Si Ho and Matisse and the sculptors of Chartres had all arrived ultimately at the same solution – a spiritual essence which was common to all man and expressed a central and divine quality in life that could only be won by searching, by contemplation and by work. This was the end point after learning had been forgotten; possible only then. I had to learn. Teaching my hands to know that which my body had already learned was not so difficult as absorbing the structure of the anatomy, for which I tried to obtain a dead body, but this proved impossible. I had to content myself with a collection of bones and skulls.

For formal studies I got a pass to the Crystal Palace grounds from the fabulous general manager of my childhood, Sir Henry James Buckland, who still walked everywhere in a silk top hat and morning suit. Even though his Palace was destroyed, like a deposed king he remained a loyal figurehead to

a past age. I did drawings of the 'Discus Thrower', the 'Torso Belvedere', copied faithfully from the Greeks and intact. But not till later did I understand the magic of their original stone and the vitality of the sculptor's hand. I found them useful also for practical anatomy and for vision in space.

There was something tragic about the place now. The ghosts were glad I had come back but I was no longer a child and could no longer properly talk to them. I worked while they watched. I drew the lake, the boats, the trees, the fair, the old cart under the tree, as well as the Towers that still stood sentinel. I drew also in the streets and the parks: the gentleman, the tramp, the weeping ash, the woman, the hill, the valley and the insect. It seemed to me there was a common law behind all things and this, as I penetrated day after day, I saw was true. A law of mass, of form, of space, structure, growth and that miraculous thing nature so seldom uses – line: and the miracle of light. Through light I followed into colour and the adventure had begun.

Among artists from whom I learnt most of drawing, besides Rembrandt, was Hokusai, who seemed to be his exact counterpart in the east and often came to the same answers. I was haunted by the 'Pearl Divers' and 'Harlots' of Utamaro as much as by the elegance of Watteau and fierce stability of Michelangelo; the spurting energy of Brezska that spat in the world's face and crackled out. From these I learned to master direct pen drawing where the first stroke was the last and therefore charged with the original vitality. I would have no truck with the dishonesty of the india rubber. I believed I had found the truth; like a rat who had found a candle I gnawed at it incessantly from first light till midnight and often through till the next dawn.

These influences, along with those of other ancient civilisations back to the caves, were to be the basis upon which my art was built. It seemed to me that the intellect should not be given final domination, but used in its proper place as servant; that the images drawn later from the unconscious should not come from its sewers but from its mountain tarns.

Carried along on this tide of work and discovery, I did not

notice the time passing, until we were into the winter and our money was entirely gone. No food, no fires. I signed on the Poor Law.

The first time in the queue was a strange experience. I was relegated to the legion of lost men. They were the tramps and throw-outs I had known as a child and had sometimes spoken to; or said to Ethel: 'What's the matter with these poor men, Effel?' as they sat on the grey oak seats with crutches and sticks propping them up like Rembrandt's beggars, smelling rancid, puffing at dog-ends, smiling and showing their black teeth. With these men I now lined up for relief from starvation. It had the effect of making me feel very fragile with a desire to dissolve into nothing, but in no way sorry for them – or myself. These were the fallen men chosen to be our foundation stones because of their constancy and devotion to their purpose of doing nothing: it seemed right that society should support them. Their smells now, in this dimly-lit lobby where we waited to be paid, reminded me of the granite fountain in the park with its cup chained to it, the running water in the early sunlight; of yellow daffodils and the ducks nuzzling the bread thrown over the railings by nurse-maids and their infant charges. All smells are important to childhood because they make you remember the lovely and more stringent things together and one reaches that kind of poignancy and happiness the dying Mozart wove into his last music. I was granted twenty-one shillings a week: our rent was seventeen and sixpence, so we had three and six for food, which was a stiff budget.

Poverty is not a state for which to feel sorry: it is an occupation of a most difficult and high order, out of which the greatest value is squeezed and states of intense pleasure obtained for nothing. It can be the strongest design for moral integration, the conservation of energy, the expression of love, the exercise of meditation, the practice of creation and the communion of the soul with itself: all worthy things. About it there is no ostentation and the heart does not run in couple with fear. It is not publicised because the world does not wish to know about it and false images are put aside. At this austere function no mask is needed; each man knows the other for what he

is and there is no comment, for the price of entry is destitution.

As we built the days together, and indeed the nights, for often at our activities we heard the first step on the cold pavement at dawn, we started to know life newly. Sometimes we went out when it was snowing and the snow muffled the noise when we tore struts of wood from the Crystal Palace fences, which went off like pistol shots, and from the fences of old Victorian houses. These we tied up in a kind of sledge and we dragged them home to burn. With loud beating hearts we even passed the police unchallenged in the dark. Such fire as came from this was of orgiastic warmth, melting the blue cold out of our hands, making our faces glow. We stayed up all night so that we could enjoy the burning and did drawings by the light of the fire. Sometimes I went out and did drawings of the snowy suburban streets in the yellow hoods of gaslight. We bought twopenny worth of bacon ends, a stale loaf: our stomachs glowed after eating. Our minds were clear, our perception quick, our skill enhanced: all things seemed to give out an extra radiance, were more beautiful, as if filled with a holy light.

This face of poverty is the one chosen by saints and visionaries: it is austere and gentle, in no way complex, without acrimony or malice, sweet as wood smoke and as alone as the dawn sky.

It helped to read Evelyn Underhill on the transcendental life; Chuang Tzu dreaming he was a butterfly; Alexandra David-Neal who met an artist with the devil on his shoulder in the Himalayas; the letters of Van Gogh; the poems of William Blake, that greatest of all Cockney mystics, who worked and starved likewise but a few miles from where I was. All these people had one thing in common; devotion to the good life and the pursuit of that vocation.

In the rain we stole roses and ate them and laughed at one another. In the high winds we gathered branches blown from the trees. In the moonlight we stole cabbages from allotments, apples from orchards. But in the towns there was nothing to hunt: only the other face of poverty, which is its Caliban, is

hard and ugly: a killer. It is the face of greed and awakens fear. It snatches, has no charity, crushes, hates, destroys. Once the coin was gone the machinery of daily life was automatic: the milkman put his foot in the door and was nasty, the baker stopped delivering bread, the hire-purchase firm came and took the furniture, the gas and electric light were cut off and we worked with candles.

One day we got married and came home in a bus to drink hot cocoa with no milk or sugar. We had pledged ourselves for life. The metamorphosis from the external life of the stage, which is centred so much in personal pride and vanity, to this emergence of the inner life, the impersonal pride, like the dragonfly leaving the nymph, spreading its weak and shuddering wings in the light, was quite a positive process once the time had come. It was no hardship to let the old casing fall away. We were full of spunk and certainty.

Socially we were not quite outcasts because of our name on the stage, which still lived on, but we were nearly so. Immediately the individual steps outside the community he is for trouble; it is a threat against conformity and conformity is the glue by which society coheres – thus convention has a very real use. Rebellion must always be for a purpose, never for a fetish. We noticed this when we married. Although no one knew, we were treated at once as man and wife. The community with its one mind picks up every vibration to protect itself; we were dangerous because we had taken a bid for freedom and to be creative. We must pay.

My parents had moved back to Sydenham after the fire at the Palace and were quite distressed to find we had given up the profession at which we were obviously successful. They found it hard to understand. My father said that it seared his heart to see the posters for the Crazy Gang at the Palladium without our names on them. Mother was carried through by instinct and belief even though I think she found our behaviour perplexing. She had no idea of our privations and sometimes gave us a meal without realising it was our first for several days.

'Never mind, dear,' I heard her say to my father one day. 'I

am sure he knows what he is doing. He will be known one day.'

'Ach, balls!' said my father. 'This bloody art is no good to him. Why can't he join the Bank or one of my Scandinavian firms in the City, instead of wasting his life like this?'

These words were said with some anger but with as much concern for my safety and well-being as for his own sense of propriety. And in the thirties it made sense. But I was like a mule and would not even listen.

I do not think my mother and father were very happy at that time and this situation became a fulcrum for discontent, although one would have expected a little calm to enter their lives now we had all gone. Karin was still in the theatre and Leo had taken a job in Persia. But my father was a lone wolf and my mother was so bound up with us she could never really believe we were away; having the kind of make up which lacked barriers of space and time we must have been nearer to her more often than we imagined. One day I called on her: her tiny figure greeted me at the top of the stairs.

'But it's *you*, dear. I thought for a moment it was Leo, your footsteps are so alike. I quite forgot he was in the front room.'

'In the front room!' I exclaimed. 'Is he home then?' And I rushed past her into the front room to find it empty. 'But where? Where, mother?'

'Oh, how silly of me,' she said, looking at the empty armchair. 'I saw him sitting there a moment ago. You know how it is. I quite forgot he was in Persia. I do hope he is all right. They say there is some sort of telepathy, don't they dear? Especially if something is wrong.'

I stood looking at the shabby old chair where Leo always sat, his books still in the oak bookcase: Anatole France, Joseph Conrad, Henry James, Marcel Proust, many of the philosophers, and rarer writers such as W. N. P. Barbellion, Marie Bashkirtseff, Madame Guyon and Amiel.

'Of course, my dear,' she said without apologising. 'I must be going dotty. I saw him sitting there quite clearly, just as when he is at home. I was even talking to him. When you are alone a lot and the children are gone it is not surprising!' She

added rather sadly: 'My old mother comes and whispers a few words sometimes – when I am in trouble. She was such a dear person.

'But never mind,' she said brightening up. 'Let's have a cup of congo and some toast. The fire is just right. I'm so glad you are married at last. It does make a difference, dears; people talk so, don't they? It doesn't matter, but you know what they are.'

With her bright face and blue eyes she was like a little bird with the same smallness and quick movements. I realised she had been beautiful when she was young. It was so like her to have seen Leo. She took it all as a matter of course: outer and inner were never much different to her. She herself was like a little spirit. I am sure that is why, when the wild apple is flowering in the Forest she still comes near: even after so long.

On our way back that afternoon we went into the Crystal Palace grounds and sat together by the lake. It was quite still, reflecting the trees, and I could see little flotillas of young perch cruising up and down under the rhododendron bushes, just as when I fished there as a boy. The Victorian houses were half-hidden by the trees. I could just see the roof of one in which I had an appendix operation when I was six.

'I got double pneumonia after the ether,' I said aloud. Greta looked at me with her deep blue eyes. 'Nearly died,' she added, smiling.

'Sorry, darling. Have I told you before?'

'Yes, but it doesn't matter.'

We sat in silence for a long time till our minds were still like the water, and everything was seen twice – inner and outer, upper and lower, known and unknown – quite complete. There were six worlds. People didn't know what they were talking about. There was the answer: the same as the question, which there was no need to ask in the first place. How simple it all was. But I did not speak – out of fear of spoiling the moment. Greta was in the same magical state and this is what could not be told. A mist rose on the water and the air started to grow cold.

'Do you realise,' I said after a time, 'that we are going from here?'

'Yes, I do,' she answered.

'Do you know when?'

'No, but quite soon. We will know to-night or to-morrow.'

When we got home the place seemed suddenly to have lost its ghost, as though we had already left. The furniture – what remained of it – was desolate, the table bare and the cupboard empty. Yet everything, because of Greta's courage and love of having things right, was clean and orderly. Then the surprise came. A knock on the front door and there was my old friend, Bamburger.

'Hallo, you two,' he said. 'How would you like to go to Cornwall?' I could hardly believe my ears.

'There you are,' said Greta, glancing with her dark eyes over her shoulder as she heard the greeting. 'What did I tell you?' It was uncanny.

My mother had given us a packet of tea and some tinned milk so we enjoyed a warm drink while we talked to Bamburger, and laughed while he covered a nude of mine with his pocket handkerchief, pretending to be shocked – which I suppose I half was:

'A nice piece of Prime Canterbury, my friend, but not for me! Too much sex. I can't do with too much of that nonsense.'

He seemed to know how tough it had been for us but who told him we never knew.

'Anyway, with all that, you won't survive here!' he went on. There was a chemical light in his eyes and the scar showed where he had burnt himself as a boy with silver magnesium powder we had stolen, and nearly lost half his face. 'You will be wiped out in this place. In Cornwall it's easier to survive. My friend knows a cottage on the North Cliffs for six shillings a week. He can get it for you, what's more. Yes, Lantern, that's right: Claudius Lantern. You remember him, of course.'

'How do we get there?' I said, dropping the question like a stone.

'I can help,' he said, straightening his delicate figure,

sticking out his arched nose like a macaw. 'What have you in pawn?'

'A typewriter, a gramophone and a watch: that's all I think. About ten pounds – or the equivalent.' The plan was worked out that night. We had not many things to move other than books and beds and painting materials. But there would be nothing over to pay our debts. I was troubled by this.

'A moonlight flit: that's your only way!' he said. 'After sunset and before sunrise the dunners cannot get you: or on a Sunday. After all, the rent is your only serious debt. Those bastards will throw you out on the street anyway if you don't pay: then what happens? You have no home and they haven't got their money. You have to go to the workhouse or on the road as tramps and live in Trafalgar Square with the others.' I remembered the night I had spent there ten years before.

'Look, man, you want to be a painter? Then be realistic about it. You can't buy a nice mystical loaf of bread or some spiritual sausages or some poetic butter if you haven't got the bloody money can you, you silly bastard? I'll get you to Cornwall and the rest is up to you!'

We assessed the pawn tickets at eleven pounds. I gave them to Bamburger in exchange for the money and he left us to look at one another in bewilderment.

'How on earth did he know?' said Greta.

'Yes, but what is more strange, how did *we* know?'

I looked in the mirror and saw my own face as a painter sees the face he must paint; subjectively and objectively at one and the same time. It was the first time the painter's vision had operated in me on its own, and I knew that my skill would be enough. I started to paint feeling that strange dream-like state of being when the inner mind takes over and the machinery of the whole man is at work. I knew what to do instinctively. In two hours my first self-portrait was painted.

That night we began to pack and the next day I found a man who would call after sunset to collect our things. We drove in the front cab with him to Sydenham, trembling as we passed the estate agents, and dropped off to see my mother who was distressed at our going so far away. I gave her the painting to

pacify her. My father drove us to Paddington in his 1922 Jowett: a perilous start to our journey. We caught the night train. I awoke at dawn crossing the Tamar into Cornwall: beside Brunel's bridge spanning the river there was a double rainbow. I took it as a good omen.

'Strange, that man who danced like a Dragon Fish,' said Greta dreamily. 'This is all through him in a way.'

'Yes,' I said. 'I think he must have known all along, don't you?'

PART III

Farewell, O Dancer!

Fare thee well, O Dancer from the Capitol:
the time has come for us to part: fare thee well!
Japanese: NO PLAY

Atlantic Cliffs

DAWN rain cleared as we entered Cornwall under augury of dissolving rainbows, giving the little round hills an added remoteness, with their few square cottages, clumps of bush and stunted tree, grey stone hedges: an increased greenness: a *shutness*. This contributed far more excitement to the strangeness of first light – of silvery and slightly golden light – as the train charged through it, than crossing the tall suicidal bridge over the Tamar of Brunel, which made everything seem so small. This in turn added to the feeling of metamorphosis taking place inside me as our discovery of the future began.

After the white pyramids of St Austell, which gave a lunar quality to the landscape and a greyness to the skins of men as though they were more ancient than they should be, we hurried in our steam train to Truro with its Walpolian Cathedral not yet mellowed into history. After this the track entered a broken landscape where ruined engine houses above open shafts of the closed tin mines began to show themselves; decayed granite, scrap-iron, tall stacks that go with this industry: the same tin the Phoenicians came for – and gold: pitchblende for the future. The houses and cottages scattered round these workings were also ruined, or many of them, and the landscape was scarred as after war, throwing up little hills and cairns, levelling out to a lonely plateau towards the great and watchful blue of the Atlantic.

The speed of the train gave Cornwall a mobility. I saw it in long grey sliding panels which could well have been a sequence of Alfred Wallis paintings, though I was not to know this till later; the ghostly animals and dark nightmare hills gave out powers of green and black behind the talking cottages. Here and there little sections of violet road, golden river, blue sky

were revealed by the turning pages of the landscape as we sped along, then were hidden by a field, a house, a chimney stack or a man – a Cornish man, digging, perhaps, in his garden with his long Cornish spade, or hedging, or horse-hoeing a field out of which grew teeth of granite as large as a giant's head. Yet everywhere, in spite of the dereliction of the mine workings, like the exposed vertebrae of a dying animal, there was a Christopher Wood weirdness, the opiate-induced quality of a dream. This was something that Cornwall could awaken in one by its very ancientness and its closeness to the first feelings of awareness in man – perhaps even as a prehistoric creature.

The enchantment of life on the stage now seemed unreal, even though we had travelled so much on trains during those years. The fight of the great cities was already fantasy; the clowns danced and laughed outside the windows and disappeared into the hills, for we danced no more in the limelight; Greta was offered no longer as a sacrifice to randy businessmen; not again the ecstasy of the Storm God or the melodrama of the Apache Dancer, the tragic exultation of Massine or the unbearable beauty of Pavlova. Already life was becoming more objective and visual with a certain right of way through the eyes to the soul: the excitement of new forms, colours in the intense peninsular light, were awakening future inventions. A feeling of relief and carelessness came upon me, a curious abandoned happiness. In spite of the hideous and torn landscape and the feelings of disappointment that went with it in our hearts, there was magic. This feeling started right away as we entered Cornwall, but grew stronger as we passed between the great pyramids of china clay which blazed white in the sunlight: tombs of the northern pharaohs. And we carried it into the places of disintegration.

Finally we approached the twin towns of Carrington-Truth, which were more alive because one of the mines was still open and working in quite a big way, though the towns themselves had nothing much to distinguish them in other ways. It was here, at the little station, that the train stopped for the second time since entering Cornwall, and here Claudius Lantern stood waiting on the platform for our arrival as though he had been

painted there by an ancient Etruscan artist. His tall angular figure, long head and wide-apart eyes seemed quite fantastic. Outside he had a Harley-Davidson motor bike with sit-up-and-beg handlebars: an early twenties model. It had a high perambulator side-car into which we climbed. He called the machine Bucephalus and looked himself like a modern centaur when he was mounted. The speed he drove at was sickening and the bike bucked wildly between the stone hedges along the roads outside the town, through more broken mine workings, which seemed even more distressing close to, until we neared Lantern's house on the hill.

'I've found you a cottage!' he shouted over the roar of the engine. 'I'll take you there later on when we have had a meal. It's on the Atlantic Cliffs. A bit wild but you won't mind that. One of the conditions is that you work on the farm, but I don't think you'll mind that either, will you?'

'Of course not,' I shouted back. 'Think of it: a job and a cottage right away. Who could have thought of that? It means we are safe.'

Greta, with the silence that was so much part of her, smiled and looked pleased but said nothing. Her face was more than usually pale with tiredness: we had not slept much in the last two days and nights and events had been closely knit as they are at a time of great change. I watched Lantern dismount, smiling to himself.

'All gods demand their sacrifice!' he said, as if going on with the same conversation. He switched off the engine. 'At least the god you have chosen to serve; or has chosen you.'

'Yes, I know,' I said, unconvincingly. 'It will be hard work. Art comes out of that or it does not come at all. That at least is certain.' I knew from the early days of the dancing that it would be difficult. I knew also that a man cannot be an artist, a painter, any more than he can be an acrobat, without dedicating his mind and spirit to the ways of colour, form and space: that the creation about him must be concomitant with the world within and his skills must become, in their own way, vehicles of transmission so that he is bent and shaped in the ways of creation like the long handle of a spade. There was no

way to pilfer that experience, only to win it from the year ahead. For the sunsets that soak into a man and emerge as paint, it takes a life. No common dabbler can poach this royal ground.

We entered the quite ordinary granite house, which must have originally been built for a mine captain. Claudius Lantern's wife Pervada was a little Indian woman. She welcomed us and gave us a simple meal; this was eaten in the dreamlike state that comes upon one in a strange place when the whole apparatus of life is changing, so that one seemed singular to oneself and was aware of identity only by looking into the face of another person and seeing how mysterious it was. The furniture was like a silent watching crowd and the sunlight falling through the curtains had its own otherness on that day. Visual life was thus thrown into trance and because of Pervada's Indian influence the interiors gave out deep, closely-toned colours, so that we might have been sitting in one of those Rajput miniatures a century or so earlier. There was no sense of foreboding here as one felt in the cities, but peace and contentment that comes from learning and the love of art. I was already turning towards myself, not knowing how difficult and how dangerous this new adventure was to be: a good job I did not for I was finally to pass the ego sticking up like a rock out of the sea with a light always winking to attract attention – likewise a warning – and voyage on to another frontier of which I knew nothing.

In the kitchen there was a Rhesus monkey in a wire cage. He looked at me with clear abject eyes trying to bridge the evolutionary gap between us. He sat in the corner of the cage and sadly watched me walking on the other side of the wire in *my* cage. In a state of high sensitivity I felt equally lost and was bound to the animal by a common aloneness. He was tired; it seemed his natural rebelliousness had been defeated: mine had not.

Lantern's mother was sitting in a chair by the fire hunched up with rheumatism; the glow from the black Cornish slab – the stove on which all cooking was done – lit her pale face. Her shoulders looked exactly like those of the monkey as I ap-

proached her from behind. She touched my fingers with her hand which was almost a claw and looked up at me with the same look as the little animal in the cage. A gentleness and frailty pervaded her. There was peace and tranquillity: not freedom.

This was a curious introduction to Cornwall; perhaps one more significant than I realised.

But then Cornwall is a curious place. You might find a person of any calibre there: a French Count, a Japanese potter, it would not matter. He who searches for personality must find a place alone. Cornwall is full of such places, and such people. More often isolation is chosen from selfish motives; only a few achieve the stations of the soul. To suffer a period in the wilderness, a period of purification in which the spirit was strengthened enough to return to the world as a vital factor, was rare. Lantern, who was on a quest for understanding, led by the light of a marvellous mind, perhaps stayed too long, I was to realise later; he got cut off by his own shadow in the wilderness and saw it cast before him as the darkness of the world.

Enclosed in the labyrinths of intellect his guidance to others was masterly. With him I travelled the ways of the great philosophical writers and was introduced by way of Hinayana and Mahayana Buddhism to Tao and Zen, which have been major influences in my life. Access to his library of books and records enabled me to listen to music, see pictures and read the poets and philosophers during the rigours of the years ahead. My own little collection of books was but a pool by this vast lake of knowledge into which it was made possible for me to cast: not the least part of this was his appreciation for things I eventually made out of it all. The polarity which existed between us made our friendship exceptional. His mind – my instinct; his reason – my intuition; his factual knowledge – my imagination; his power to relate – my power to create. All these things met on a common point of poetic insight, contributing each to the other, welded by a mutual Cockney humour and healthy affection for one another.

In the afternoon of the day of our arrival Lantern took us by

motor bike to the Atlantic cliffs to see our cottage. I had complained to him about the ugliness of landscape down the spine of Cornwall: after the tale of high order of beauty given me before I came I could not believe this to be true: I was fooled if this was all there was to see. I had been to the peninsular a year or so earlier but at that time had not been fully awake to my environment because I was absorbed in my studies and travelled very little. Lantern said nothing: only smiled. We drove through the woods surrounding the sanatorium which was housed in a stately home of the late Lords of Carrington-Truth, built in front of an ornamental lake with an eighteenth century peace to adorn its quiet waters, where the thoughts of those who rested there to be cured floated in and out of the ward windows like shadowy fish. The scent of pine and beech mingled with the salt of a strong on-shore wind made us exultant as we drove up to the north gate which opened on to the moors and the sea: thus to the cliff edge. For the first time I looked out across the vast Atlantic towards America: blue, blue, blue beyond blue, going turquoise and emerald over the sandy shallows, ruby over the rich dark rocks and thickets of weed. The cliffs were so tall their violet shadows seemed like enormous men armoured and cloaked, standing before the parapets of time, guarding sunsets and royal treasures in the skies that belong to the eternal kings of darkness.

To the south the blue hills over Cuckoo Town were visible, hiding quaint ghosts of my future. To the north the heads of Vose and Stowe and their ever-flashing lights. Below us the gulls sailed slowly like trapeze artists swinging from cliff to cliff, and the seals wailed in the caves underneath to the golden trumpets of sand and the clarinets of foam.

We stood here for quite a long time, in a timeless landscape we were soon to know as of unrelenting, ruthless, intractable beauty. The heather was rooty and strong, so also was the sharp gorse, its sweet-smelling pods going off like pistol shots in the sunlight: sharp also the granite flashing its quartz eye. This was the foothold of immensity, where her sandal was set

against everlastingness, and always the incessant unbroken
sound of the sea on the rocks below.

I thought of the cottage and Claudius directed us quite soon
to where it was along the cliff road. It stood against another
cottage but otherwise was quite alone on the moor – square,
austere, made of granite. Four bare rooms with stone floors
downstairs: in the largest of these there was a Cornish slab,
which was for heat, cooking, hot water; the heart of the house.
The front door – which was at the back away from the weather
– opened directly on to this room. No tap water, no electricity,
outside sanitation: five shillings a week.

'Are you sure about this?' I asked Lantern. 'Isn't there some
mistake?' But no; he assured me the rent was so.

'If you work on the farm, as I think the farmer expects you
to,' Lantern added, 'the cottage will be rent free, with milk and
vegetables thrown in as a labourer's perk. You will have to
see Mr Croggan about that. I should see him anyway fairly
soon.' Lantern looked around, picked up a silver insect he
said was of a species he was working on for a scientific paper,
and added: 'I'll leave you now. You won't mind walking back,
will you? I have some work to do. To-night you can sleep in
the loft and come here to-morrow to receive the furniture.'
Then he was gone.

There was a little garden:

> In a coign of the cliffs between highland and lowland
> The ghost of a garden confronts the sea.

Swinburne had written to the same ocean but perhaps a kinder
coast on Wight. The granite and the hard myrtle leaf here were
more austere images as basis for poetic emotion. Perhaps
Milton knew better, was closer to the brutality of the wind
rattling through the brittle leaves and violet flowers so soon
to go brown.

> Yet once more, O ye Laurels and once more
> Ye Myrtles brown, with Ivy never sere,
> I come to pluck your berries harsh and crude,
> And with forced fingers rude
> Shatter your leaves before the mellowing year.

The lines were so clear I spoke them. What other way could I tell of these brittle leaves rattling in the sunlight against a low granite wall? Nothing of my fierce hands could be spoken and how they would smash the afternoon to smithereens: my violence. I had not realised how it would be after I had stopped dancing. Milton had said it; God praise him for that. Who would not have given their eyes to do the same? I would.

By the front door there was a piece of charlock growing through the concrete. It was pale sulphurous yellow and very beautiful with its construction of stems and green leaves. The paint on the door was dull red and blistering. Greta looked at me with her blue eyes, I kissed her: her body was supple and strong from dancing, under her voile dress.

'It's going to be tough!' I said.

'Yes, I know that. But we'll manage. Don't worry about it. This is what we want, this is what we must do!'

It was a moment of premonition. The thing one never knows about a sacrifice is whether the gift involved is worth it. At the time it seldom is, but only in this way has it a chance to develop and be made real. The nobility of true sacrifice is always in the making; mostly by an act of folly. Greta had this nobility and, as a woman, probably saw more clearly than I what the price was to be. We added our strength together. It was at this point we had turned completely round from the external action of the stage life to an inner purpose which was with us both but only definable in spiritual terms until I became articulate as a painter.

We walked over two fields to inspect the well where we would draw water and then once again to the cliff-head. We realised at that time we were quite alone in our purpose and it was only each other on whom we could depend; we could turn to no one else, not even Lantern who had done so much and whose liability was now ended. I remembered the young man and woman – the two who stood against the fountains in Trafalgar Square all those years ago – against the world because to live in their own way was the only thing of importance. So it was we stood against the sea.

This was the sea that took men to her, sucked them into her

great mermaid's belly; swallowed treasure and planets, spewed out fish, ate ships, roared like the Minotaur, gulped wine, drank blood and stained her watery loins, her scaly thigh.

We climbed down the narrow cliff path to the sand. To do this was an adventure. The path was quite difficult and in places a little slippery where water had trickled off the cliff. The cliff-face was awe-inspiring; parts of it were quite wet with water running in long single girders to the sea, recalling the waterfalls of Hokusai: little rivers run out of land. On the ledges were nests of seabirds and nearer we could see razor-bills flying, and oyster-catchers with their wild call and scarlet legs. Passing below the general flight level caused us to look up instead of down; halfway was like being on the rim of a wheel that was turning – the Great Wheel in the fairground at Yarmouth perhaps – until in the end we could look upward entirely at this face of England with its quartz teeth and green hair, its birdlike ears, its flashing eyes of mica, its scarred knees, as we felt the ocean bind our feet with ropes of foam and crimson chains of weed: the sea with its caves of light and its fish-eaten dead. Greta's toenails were like tiny pink shells under water and her high insteps, hard muscular bronze legs, might have belonged to a female centaur come to enchant me, for here so soon fable fell on the heart and cold air reflected from the cliff made us feel tall and free in the sunlight, even though death was in the shadow: the shadow that moved over us as we started to climb slowly to the top as the evening advanced, Greta following, holding up her skirt in the old-fashioned manner as was her habit.

'The sun will be setting soon,' I exclaimed. 'How marvellous all this is. I can't believe it!' There was no answer. Only a catch of breath and then silence.

I turned and saw Greta fall. Like lightning I took her hand as it vanished over the edge of the path. She immediately locked in mine with her dancer's grip. I took the shock. We could not see each other at all. After a pause I drew her up with the strength of one arm until I could see her head appear and she was able to help herself with her other hand which I could not hold because my free arm was being used as a prop to save me

falling after her. Below there was a drop of four hundred feet to sharp rocks; over this she was suspended. The edge of the path was loose. I slipped once or twice but finally was able to pull her into my lap as I fell back across a wall of flat rock. She was very pale.

'I'm sure something snatched me over there!' she said. 'Positive! Thank God for the Adagio dance. Otherwise I'd be a gonner.'

Lime Pit

BERT PENDEEN stood firm and square with his head like a granite gate-post, his eyes sapphire blue, his stubby hand holding out a can of milk. His countenance was *visage fermé*, although his long hard mouth seemed to have a smile playing in the corners. He was completely silent in the sunlight, his beret pulled down over his ears and the fields with their tempest-torn trees behind him. The image was of one as honest and simple as stone – in that way beautiful; disconcerting because he was so much contained within himself that words were superfluous. A peasant, a man of the land who had held on and lived through the lean years and mastered them because he was the stronger. Although it was my doorstep I was on his threshold, not he on mine. I was the intruding foreigner. Nor had I the experience of country people to know how time is different for them, perception slower, acceptance perhaps does not always come. He would wait. What he did not say I would not know. That was his protection.

'Thank you,' I said, taking the can of milk from him. We stood facing each other in silence.

'Mister Croggan want to see ee at farm, you!' he said at last, without any change of expression.

'How do I get there?' I asked.

'Mowhay Tree,' he said abruptly.

I must have looked perplexed, for in a little while he pointed across the twenty-acre field on to which our cottages fronted, to a Scotch fir, which I learnt after was the Mowhay Tree: the tree in the Mowhay. The Mowhay is the place where they used to rick mown hay during summer for winter use, near to the farm houses and easily accessible. When I looked back he had vanished into his own cottage next door to mine. I started

off across the field, wondering at the clarity of mind that could reduce life to such simple proportions; as clean as a granite post. More of this I was to learn later when I was taught to cut granite. I cannot but believe that each pattern of experience that came to me now was guiding me towards my understanding of space and stone and the use of tools manually, just as my dancing years had guided me towards music and painting. This was another limb showing only as a bud.

Croggan was a big man for a Cornishman, with a red face and black beard – almost a Devon face. Perhaps he was Devon; I had not thought of that.

I found him beneath a tree outside his farmhouse; a weeping ash that seemed to float in the morning mist. He stood motionless.

'Good morning,' I said nervously. 'Mister Croggan?'

'Good morning,' he replied after a pause. 'I don't know why you come here. You don't belong to be wi' the likes a we. What do you want?'

'I understand you want me to work on your farm if I take your cottage.'

'Take my cottage? You'me no business in my cottage.'

'But Mister Lantern said . . .'

'What did Mister Lantern say? I'm farmer here abouts. You could've come to me, mind to! It's my cottage, not Mister Lantern's.' He was angry. I did not realise there was a misunderstanding and felt awful because I had already moved in. I knew enough not to be patronising or to think I could bamboozle this countryman. I was not on the stage. There was no use joking or ad libbing. I was defeated and could only apologise, saying I thought proper arrangements had been made.

'Do you want me to leave your cottage?' I asked.

He looked at me appraisingly while chickens pecked about the yard. For me it was all new smells of pigs' piss, steaming dung, warm animals, rotting mangolds, milk, thrown over my senses like a net. I felt held down by it.

'No,' he said, to my surprise. 'Bide there and come to work on Monday, mind to. I'll give ee the cottage rent free but

seeing you don't know anything about farming I can only give ee sixpence an hour. That's what I pay the slingers.'

Slingers, I was to find out, were men who worked a few hours on the quiet while they were on the dole. I could not do that because I had no stamps. It was a hard deal, but I was so glad we had a roof and a means of survival, however little, that I did not mind. The situation, I suppose, was the same as Jude the Obscure's – in reverse.

'Thank you, Mister Croggan. That will suit me. I'll be there,' and made off.

'Don't be late mind. Seven o'clock!' he shouted after me.

'I won't!' I shouted back.

As I crossed the fields towards the cottage with the line of the Atlantic behind it and the wild moor, I wondered at the farmer's attitude to me; half respect and, in some other way, half contempt. I would probably be put through the mill one way or another, but this was no worry. Perhaps he wanted to know if I could stick it or not. Anyway it was a start and the first foothold was to be in many ways the most important.

We spent a good deal of the day settling our furniture in, such as it was, and making the features of our new home. My studio was a long room upstairs looking inland to the Mowhay Tree and the blue hills that were so ugly with mine workings when close to. And the trees of Carrington-Truth. A cheap easel, my box of paints, a jar of brushes, a desk improvised from a double-elephant drawing board I had used as an engineering student and my books; the poets mostly. We put up a few paintings I had done about the country while touring, to brighten and familiarise our surroundings, but it was a simple and meagre enough home. Essentials; nothing else.

Then we walked down the long hill to Port Rock to buy groceries, a primus stove and paraffin; with our last money I bought some labourer's boots and we squeezed a precious packet of cigarettes. We knew nothing more could be got now till I drew my first wages a week later, which would be a short week less my insurance stamp; not much left out of twenty-one shillings. I had managed to buy a threepenny notebook which would allow me to do one hundred and twenty drawings if I

used both sides of each page. I schooled myself to close structural observation so that my material should not be wasted. The pieces of the pattern slipped into place. The stone floors of our cottage were emblems of the sternness of our life to be.

Bert's wife, Mabel, was a huge, rosy, friendly woman who could eat a broccoli raw and work in the fields herself if it was necessary. Such women have held our race together for centuries: strong, vigorous, trustworthy. She made friends by giving us some eggs. Unlike Bert she talked without restraint and arranged to show Greta how to make Cornish heavy cake and pasties in the real country manner. Bert seemed not quite certain of me and was withdrawn for a time. He was pleased Croggan had taken me on – and surprised. From the moment he had handed me the milk, with shut, immobile face, I trusted him. We were to be close friends. In such a man there could be no disloyalty.

In the evening we were asked into their home; they lived mostly in the large front room (which in old Cornish cottages means back), the great iron stove shining black with its brass glittering, the bright red fire in the grate, the kettle gently boiling. No romantic nonsense here but the vehicle which got them through a tough life in which there was little bounty. We had tea and heavy cake and talked of the scattered little community living on the moors; of how wild it could be, how frightening in a gale, how bleak and cut off in winter.

'He should ha been here when the wine came!' Bert said to Mabel, his eyes flashing.

'When the wine came?' I ventured.

'Ayse. Did ee never hear tell of the night of the wine? The whole countryside was drunk from Trevose Head to Gwithian Light, from Cuckoo Town to St Just and on to the Scilly Isles. Every man drunk. The sea was red with wine, my beauty. There were barrels and barrels on it.' Bert's weather-beaten face was live with the memory. 'They burst open on the rocks as they were washed in: lost their hoops and showed their ribs; splintered like egg-shells, large barrels and small ones, even hogsheads and tiny kegs; all corked and bunged and sealed. You never seen the like of it!' I noticed Bert's hands were

horny and split with work, his arms knotted as he delicately took a Woodbine from the packet. Mabel was smiling.

'When he gets on this you can't stop him,' she said.

'But where did it all come from?' I asked him.

'Shipwreck, see. A wine ship went down on the Stones north-west of here. Every soul lost mind ee. A terrible night with an in-shore gale, blowing straight in here and the wine with it. This cliff along here was lit up like a city, right to Hell's Mouth. You would never have believed it. Everyone was out: farmers, labourers, cottagers, miners, seamen, police, town people, kids, fishermen. They had lights and torches as they belong to, but also they had pressure lamps, hurricane lamps, carriage lamps and even candle lamps; every kind of light you could think of. They didn't wait to find the pathways down the cliffs. They let themselves down on pulleys fixed to car wheels, some on ropes tied to a rock, some on a system of pulleys like we use on the haypole round these parts, with a horse – a boy leading the horse back and forth as each man went down or up. A lot got drunk on the beach and couldn't get up again. Two or three that were using self-operating gear pulled themselves up and got stuck half-ways. Swinging and swearing and singing they was, my 'ansom, and all the lights spinning like a merry-go-round in a fair. Others walked into the sea to save the barrels from splitting on the rocks. In the morning the sea was red with wine as though there had been a battle, there and it was blood, you. Never saw the like; never will again.

Bert was properly excited and Mabel looked on enjoying the memory of that wild night when men and women went mad and poured like lemmings into the sea. The year of the wine.

'Were there many fights?' I asked, catching Greta's eye, who was smiling at me, goading Bert on. The children who sat quietly in the corner were told to wash and go to bed as Bert was lighting the oil lamps and the last light drained from the sky outside. The room was filled slowly, as though it was being poured in, with that golden, friendly light civilisation thought fit to dispense with; like the glow of good people with warm hearts. I am sure such things go together. It was a light that made the eyes bright and brought out true colour in face and

clothes, so the old working jacket Bert wore was a warm marvellous green and Mabel's face a glowing red and golden brown. It was a light that described form and colour by carving it from deep shadow, like Rembrandt working broadly on a dark bistre ground.

'Fights?' he said at last, sitting down. 'I should think there was. Fights with each other – in the drink, mind. I don't know what it was about that night. It had such a queer effect upon everybody. They weren't the same somehow, yet very much more as they really were if you understand me. Old quarrels and arguments in families that had been going on for years – hundreds of years maybe – flared up and broke out all over again: like the Clivelly's and the Thomas's, the Pendeens and the Probus's. Bastard fathers of bastards cursed the preachers, and the mistresses of married men cursed the wives, the husbands of married women cursed the lovers. All sorts came out. One man was arguing about a locket that was stolen from his great grandmother a hundred and thirty-three years ago by a relation of mine who went to the Yukon and died in the Gold Rush: can you beat that? There were fights going on – fights to the death. It was like the ocean once it was going: a great tide you couldn't hold, man. They were pitched into the sea, thrown back by the waves, beaten into the sand, smashed with stones and left for dead. But you couldn't tell – no one could tell – which was which, drunk or sober, live or dead, killer or killed, or just sleeping peacefully. Many an old score was paid that night and because of the dark and the wine it was all anonymous.

'The Customs were down there; they got knocked about a bit. It was all right if you had a barrel in the sea: it was yours and you could drink as much as you liked of it, but you try and bring it up the cliff and see what happened – Jesus there was trouble. The Police came in and later the Army. But everyone was corrupted by the wine. Anyway no one knew the cliffs like the likes a we belong to. Half the time they couldn't follow us because they didn't know the way.'

'How did you carry all the wine?' I said, getting equally excited. 'What in?'

'Anything!' said Bert. 'Anything at all! Milk churns, piss pots, water jugs, cans, bottles, jars, saucepans, kettles: two blokes even had a bath full. It went on for nights. Never to be again!' he muttered wistfully. 'I was drunk for three whole days. Never no more!'

'Well never mind about that,' snapped Mabel. 'Give them some to try. Get out a bottle now. This is the time to drink it if ever there was. I could do with a drop myself.'

Bert went to the cupboard and got out a bottle from which he poured wine into teacups; the precious life-blood of the past. The Cornish are not wine drinkers but this seemed to have awakened some memory that wholly delighted them; the taste of Spanish wine and violence after the Armada perhaps – or of Roman wine before that, Greek, Phoenician, French wine – who knows? and from ships they themselves had wrecked. The event had unlocked a cupboard in the house of the Cornish soul and heaven knows what ghosts came out.

In the morning I was to start work. Bert said he left home at six-thirty, so I should be there to go with him. He would show me a few things before Croggan was rampaging about.

We returned to our cottage late at night, glowing inside and feeling heady from the rich wine and the tale of its importing. Outside the stars were clear and huge. In the silence we could hear the sound of the sea which was incessant from above the cliffs. Our cottage was cold: we had not lit the slab or trimmed the lamps, no friendly ghosts had yet taken residence. We went to bed in the light of a single candle and fell asleep in each others' arms.

I have never found it difficult to waken early. It was no trouble to get a cup of tea and a plate of porridge. Bert was waiting in the silvery mist outside and we made our way across the wet field, a sheep scampering away here and there at our approach. As we neared the farm Bert began to call the cattle in a high-pitched voice.

'Cow cow cow cow cow cow!'

In another field I saw great animal forms begin to move forward, cruising slowly through the mist to the gate. They were lowing gently.

'They belong to be by the gate waiting when I come up. We must be a bit early this morning,' explained Bert.

As we reached the gate, which was iron or steel fitted into granite posts, it squeaked back and the cows plunged forward in their somnambulistic fashion, their huge bovine smells covering us. Their muzzles were wet, mouths drooling, some squirted green shit from under arched tails with glorious insolence and look of feminine deceit in their brown eyes. The horns were scaly at the root and sometimes broken, their cloven feet squelched open in the mud and splashed their silk stockings. A mixed herd of brindle, black and white, chocolate and white, gold; the great pendulous bags swinging like balloons between awkward knees. Their spines bent like suspension bridges from pelvis to shoulder with the weight of their bellies and in their bellies their calves. These animals had walked from the caves of the Dordogne and Altamira on a twenty thousand year journey towards extinction, hardly changed. With awkwardness one animal tried to mount another.

'She's ready,' muttered Bert to himself. 'Put she to bull!'

It might seem that in setting course on one purpose I had ended in another – farming instead of painting – once more diverted. It was almost so at first, until I came to realise that the visual arts evolved as much from physical and emotional experience of other things and creatures as from looking. I came to approach the drawing of animals in the way the cave artists approached it, not by copying their style or manner but from their point of view, by knowing and handling and smelling, by helping to birth and by killing: it was this that added to my understanding, as against the stilted draughtsmanship of those who draw with the eye and not through it.

The cows entered the cowhouse and each animal went to her own stall with her name painted above her in primitive letters. They roared and swung their heads. There was another man there, Clivelly Hoskin, putting corn in their troughs while we put our arms round their narrow necks and chained them. Hoskin was of tall, dark, Iberian stock. His eyes flashed when I came in, which made me sense, not immediate danger, but

the need to be aware always and never to cross him. The
tension was exactly of that combination. Bert Pendeen would
say nothing. He was part of the closed community and his face
and mouth were shut. He sat on a stool against a cow and
turning his head sideways so that his beret slipped between his
cheek and the hot hairy belly, began to milk, telling me to
watch him. I could see nothing but only hear the milk drilling
into the empty bucket, so I bent down on my haunches to
try and see properly. The cow knew this and without warning
kicked out, sending me into the gutter among an unseemly
torrent of hot piss from the other cows; it was almost as though
they were laughing with the men. Then, with his peculiar
puckishness, Bert turned one teat on me and squirted the milk
directly in my eye: and they laughed more. I tried milking but
it was quite some time before anything came out; only my
hands ached diabolically. I almost wept with exasperation, but
the laughter saved me.

'Never mind. It will come!' said Bert reassuringly. 'It will
come in time. Unchain her.'

I leaned over to do as he said. As the link came free the cow
swung her head round to go out, her long horns made a swift
arc towards me which I did not expect. I jumped back in-
stinctively, sticking my bottom out and my stomach in. Even
then the tip of one horn caught in my flys and tore my trousers
wide open; fortunately without touching me. I swore at the
cow and at the laughing men, whom even Croggan had now
joined.

'Well, Mister Berlin,' he roared, 'that should teach you not to
waste your time with the likes a we when you should be in the
luxury trade.' I did not answer.

Bert helped me to wash the cowhouse down and carry the
churns out ready for the lorry, to swing them on to the plat-
form built near the road for this purpose. I felt foolish and
disgruntled. A few more men turned up at eight for the day's
work. They were all slingers, like myself, on sixpence. But
when I think that Bert, who was a full-time experienced
labourer, only got thirty-two and six a week as a standard
maximum wage, I was not doing too badly. And like T. E.

Lawrence in the Air Force I was getting the obscurity and austere conditions I wanted for my own reasons.

Croggan called us together and told us to go lime-spreading. There was one field that had been left out and although it was late this was just the day to get it done with the wind as it was. Before we went off Bert told him about the cow in season and he agreed she should go to bull right away. Bert signalled to me as he opened a door and revealed an immense bull standing in its stall, sweating and trembling with life, done up on a short chain, his eyes rolling. He lifted an upper lip and roared, his body heaving. Meanwhile Hoskin had put up a barrier in the yard so that the cow, separated from the herd, could walk about on her own with a provocative look in her eye. We stood each side of the entrance with pitch forks so that the bull would go straight into the yard.

On the word Bert unchained it. The animal swung slowly round and stepped into the yard with nobility, carried forward, it seemed, by his weight. He stopped for a moment and roared again like the seas of Knossos, then cruised after his lady, licking her vagina with his long tongue, his neck outstretched. In this way they went twice round the yard, she quickening her pace a little and then going slow till suddenly she stopped and presented herself. He reared upright, looking for a moment like a Minotaur with his horned head, and then, with that touching stateliness of a large animal, hugged her sides awkwardly with his front legs. His long red penis shot into her like fire and was withdrawn, flashed a second time up her, then under her belly before he let her go. I could not believe how quick this was – and how beautiful to see these ancient forms of male and female together in

> . . . a necessarie conjunction
> which betokeneth concorde . . .

The cow looked back at her dark lover with affection and walked away, and the men came forward with their pitch forks to drive him to his prison: men who had watched with quiet sympathy and interest, now became raging madmen, prodding and jibing and swearing and jabbing at the bull. Only Bert

remained calm and dignified; he walked quietly into the stall, talking gently to the animal with nothing to defend himself but his loving care. He slipped the chain through the copper ring in the nose and made him safe, then locked the door.

'Why do you lock the door?' I said to him as we went on to the next job. 'He is in the dark all day.'

'The old man won't have it any other way,' said Bert. 'Those are his orders.'

'But why isn't he out in the field, running with the herd?' I went on. 'And why does everybody carry a pitch fork? Surely it's all wrong!' Bert stopped and turned to me.

'It's all wrong,' he said. 'I've known that for a long time. But they'me all frightened, you. And some gits jillis! It's best keep quiet.'

We mounted the truck for the lime pit. The lime pit was under a shelter open at the side so that a lorry could drive in. We drove up to the edge of the pit. The men got suddenly excited.

'Come on, Ben,' they shouted. 'You first. JUMP!'

I knew nothing. Without hesitation I jumped into the pit. At first I was startled because the pit was about six feet deep and it was nearly full. I did not even know the lime would give – for some reason it looked solid – but give it did and I went in to my throat. The deadly white powder puffed up in my face filling my mouth and eyes and nose. I took down a great draught of it that burned the inside of my stomach and lungs with agonising pain. I could hear the men laughing again but I could not see: my eyes were filled as though by a flame. Where there had been sight, for which above all things I most cared, there was now only white fire. I fell forward on my face taking in more lime, shouting with pain and coughing, until a strong arm took mine and led me quite sightless out into the sunlight; it was Bert. He turned and swore at the men to load the lorry and sat by me waiting until I could see again and I had stopped coughing. I regained my sight in a few hours but I have not yet lost the pain in my lungs.

Branch of Fire

I LEARNT quite soon that these little spurts of violence would come without warning, with humour, with no malice save in those who hated me: 'just to make a man hellish', as they said. It was possible something in me triggered off the violence latent in these country people: something I had used up when I was dancing. In creative men there is an extra charge of energy which, if not deployed through right channels, becomes destructive, and I had not mastered my new way of using this. In the end it was to take sculpture – granite at that.

Probably they all thought I would leave after a few days. Croggan, I am sure, did not expect me to carry on through the summer: broccoli-planting, horse-hoeing, potato-picking, hay and corn cutting, thrashing, hedging and ditching. If he had known I was working on half-rations those first weeks he would have been less certain. He was not vicious: simply he 'wanted to be a gentleman of leisure', as he himself put it, and play golf all day. I suppose it irritated him to think that I should give up what he called 'the luxury trade' and go through the tough and unrewarding job I had chosen; to be a common farm labourer. There was no way of telling him why I did this and he, like most others, obviously thought the stage was a romance. Why anyone should want to play golf all day was more mysterious to me. I did not even play it when I was in the profession whose special game it has always been. So I let him think I was an amiable eccentric who was glad of his tolerance – which of course I was – and I hoped it went on for a very long time.

This was a time when the old methods of farming were still in use on the smallholdings in Cornwall. There was no machinery used; no tractors or milking machines or combine

harvesters. We did everything by horse and by hand. The nearest thing to a machine was the binder with its wooden fan pulled by three horses or the thrashing machine which was driven by steam and fed by hand. But, as with all forms of advance, the skills stayed where the methods were most old-fashioned: the men were stronger and more able, but were paid badly: so badly that survival was only just possible.

As the weeks advanced I grew more skilful, even to using a Cornish spade which demands the whole body and strong arms. My hands grew stronger and milking came more easily, once I had got the knack of drawing the milk down in the first two or three long strokes: after that it flowed and would go with the lightest touch. I could milk my share in record time, shear a sheep with the old-fashioned hand clippers, clear a ditch, harness a horse and hoe a field. My natural powers of endurance increased each day and I grew to love the life.

Greta slowly caught up with the food. With the help and advice of Mabel she was able to produce a full Cornish tea when I came in at six, which was enough for a man for twenty-four hours. These were the ways of managing known to the peasants over the hard years when they were getting less money than I was as a slinger. It is true that too much pastry and potato and too much damping rain that soaked through everything, even the granite walls of the cottages, brought on a lot of tuberculosis among the farm workers. This was still a prevalent disease in those days and the hardships I endured at least left scars on my lungs. But it was balanced by growing fresh vegetables in the garden, which every farm labourer must do, and being always in the strong air from the Atlantic. We kept well and we prospered under the hard but kind hand of Mabel Pendeen. In time it was even possible to have cigarettes again. Bert chewed some kind of black tobacco called 'Battle-axe' which cut the throat beautifully, but I could not stand the strong black juices going into my stomach, so I settled for 'Woodbines'. With this stern discipline we began to take on an unexpected happiness.

At first I got the evenings to draw and paint but as summer matured there was overtime and I could earn eight shillings a

day: this gave me no spare time or energy for anything else. At first it was gruelling because I got far more time in the stage days when I was earning big money, but I realised this was the first tip of the scale – the next tip was to be worse: in the other direction. I say no *spare* time: no time, that is, except all the time. My close observation went closer and difficult things went into my threepenny notebook, so that the swing of a man's body working a Cornish spade, the action of a horse working a hay rake, the behaviour of the binder and three horses, men milking, stooking corn, planting broccoli – it was all recorded on my tiny pages, or stored inside me. I let nothing go, whether it was a cloud running over a field like a fox or a smile on Mabel's face in the golden light of the oil lamps. I even tested myself by drawing the country bus while it stopped to take on a passenger and start again on its journey. The value in this was quickness of perception of basic laws; when applied to a nude it became vital. My dancing helped: when I was using the long spade I could visualise the position I was in and drew from that. These things were planted deep in the earth of imagination for future growth when all I had learnt had been successfully forgotten, so that what came later, though distorted, was true.

Life with the men went on. They accepted me. They respected me perhaps for not giving in, even on an eighteen hour day when we finished thrashing corn by moonlight and then milked thirty cows by hand at eleven o'clock at night. My skill increased because I insisted on doing everything well, even though the injury to my back I had sustained dancing made me whimper at times. But they did not know about that and I was getting what I wanted. In time I became very much part of their lives: a butt for their buffoonery and, in a way, perhaps a touchstone for something outside the things the hard centuries had taught them. I never really learned how they managed on their money; perhaps our needs were different. We did not find it easy and what clothes I had soon became beyond repair from the hard wear at work. There was nothing to do but make my own, which I did from hessian potato sacks stitched with string. This was more imperative in winter, for my one warm

garment left, my actor's overcoat, was no use on the field because its long skirts got saturated with rain and mud.

Summer wore on: we hardened into this new and beautiful life which held high values at such low price. I grew to know and love my fields quickly and deeply. Even when Croggan, in a roaring voice, ordered: 'Go to Polly Widden, Mister Berlin, and pull charlock!' I went with a good heart and pulled the yellow mustard plant till my arms felt to be falling out. Even then I tended the piece of charlock that grew through the concrete by my front door, and I did drawings of it, adding to my knowledge of the structure of flowers and how a field's colour may be changed and by what human agent. The only way to stop charlock seed is to pull it by the roots and burn it. It was astonishing to Croggan that I thought it beautiful; even to Bert. They used to tease me about it.

Came the hay. Men and women and the older children turned to the fields under the burning sun and worked as one family to cut and dry, gather and stack the slippery, strong-smelling valuable hay for winter. Even the babies and young children were along with us.

We built the ricks with a hay-pole, which is probably an extinct instrument by now. It was a telegraph pole of tall pine set up at the side of the rick site on strainers. There was a pulley at top and bottom of the pole through which a rope passed, one end was fixed to a huge hay grab with four teeth and the other to a swiveltree behind a horse at the bottom. When the horse was led forward the grab swung into the air, a cord was pulled and its load was released over the rick and the grab lowered by the return backward of the horse. This operation was quite quick and we ourselves moved so quickly that the open grab slashed its teeth each side of one of our heads each time it swung outward for the descent. The rick was built on a foundation of logs and twigs for drainage and aeration.

Croggan tore about the field with a buck rake fixed to the front of his lorry, 'Going like blue ell' as one of the slingers said, scooping up the great mounds of golden hay ready for the grab, while the women in neat formation turned over each

remaining dram with their prongs to give it a last sunning and allow the gentle breeze to pass through it by frothing and teasing it out: they joking the while.

As the day wore on the field grew clear and empty and larger – the rick grew higher. We stopped to have a meal in the field. Croust, they called it. 'Bit a croust, you!' and there the miraculous result of home cooking in a Cornish slab was revealed by the women, with heavy cake and pasties and the like eaten with tea made in the open: lemonade for the children. The pasties were a foot long containing chuck steak, turnip, potatoes and gravy: more than I could manage at a sitting. Yet a native would sit and work his way through one of these like a caterpillar through a leaf. England was a better place for this. However much we may welcome new ages and new ways, as indeed we must in the time of their coming, we may well grieve over the passing of such things, for by them men and women were held together as by a natural law. It was 1938: premonitions of war had not yet reached this isolated community, although they may have been apparent in the little spurts of violence that came my way, and I had already witnessed them in the ballet *Les Presages* of Massine some three or four years earlier. All manner of things such as birds augur the nature of future disaster, as though they could see farther from where they fly than we who creep on the ground.

After croust we went back to our work, more mellow now, faces stung with wind and sun, arms brown, hay dust burning our eyes and with the harmony that comes to men and women when they pool their strength to work together for survival. Far more happy a state than that of a man separated from the herd by his search for an answer to his creative vocation, which I was soon to know: though I know nothing of why I did it.

The older men told me how it was not long since, in teams of three or six, they would cut a field of hay with the long-handled scythe, standing at intervals on the diagonal-like plough shares, and move slowly, day after day, to the rhythmic swish of the blades passing under the grass, the women turning and raking it behind. It seems to me that this machinery of simple levers

extending the body, with the whole frame being used as in a dance, created a harmony and equilibrium which is not possible any more. Time was with us, not chopped into the short chaff of gigantic profits, and therefore a certain beauty and understanding through hardship and skill, and the long straw that would thatch the years more safely from the rains and the rats of greed and destruction, for which money is so poor a substitute. The spirit was still alive.

I climbed to the top of the rick which Bert and I had been building all day, while the others brought in the hay and the grab started to work. It was getting high; soon we would be able to start topping it off. It was short and springy underfoot so that we sank to our waists. The grab flew up from below, swung over our heads, opened, flew empty past our faces while we pronged the load it had dropped. This was repeated many times. Then, as though the sky had cracked, there was a loud report. Men shouted: 'Look out!' I saw Bert come forward to grab my arm, but before he got there I felt a sharp blow across the shoulders and was flung forward on my face unable to move. The hay-pole had snapped and fallen across me.

Men were all around me. Huge hob-nail boots seemed almost to scrape my face in passing. They swore, they heaved, they shouted. I lay quite still like an insect feigning death, knowing instinctively that to do so was my only way of escaping serious injury. I had read somewhere in Chuang Tzu that the drunken man who falls off the cart is not hurt because he is in harmony with natural laws. This was such a situation. I was not drunk but I was with nature and had complete faith; utter dependence on chance would prevent the men treading on me or the pole slipping farther and breaking my back. Everyone was disturbed: I was calm and comfortable. Bert Pendeen, the good spirit who defended me against evil at this time, got the men under his authority and the pole was lifted. By lying deeply relaxed in the loose hay I had gone down and avoided the pole's full weight. Everyone fussed around me with that curious interest people have in someone who has narrowly escaped death. I was a hero; on that day I was crowned. Only Clivelly Hoskin seemed not to be pleased by

my escape. Memories of a fatal accident with a hay-pole some years before, were related and the relationship to the man argued about for a long time. Croggan was quite touchingly concerned and because he was a man not used to showing his emotions I was moved by this. Right at the end Greta walked up looking pale and nervous, but almost as a matter of convention for the sake of the others. 'You all right?' she said. To which I replied: 'Yes, of course, love! You would know if I wasn't.' She walked away, knowing that all the time we were linked inside and there was no need for words.

We never found out why the hay-pole broke. A new one was brought from the Mowhay and erected after being closely examined for faults. None could be found. We worked on till late and I for one was glad to watch the rise of the great orange moon.

As the tide of summer moved on I became happily embedded in the work I had come to do and decided that later I would ask Croggan to take me on permanently to learn the wheel of the seasons and be of real use in farming. I did not reckon on him breaking my heart. It did not matter that my work as a painter was once more delayed, because again this was a way of life and of maturing the spirit. I did not know then that my gods demanded all. It had always seemed to me that technical achievement could not replace richness of experience. I preferred Millet to Mauve, Vincent to Ingres, Constable to Ford Madox Brown, Turner to Claude, John to Orpen. So it was. Moreover I was fulfilled, even though I found time only to read a page of Browning late at night. There was no physical problem: simply the frustration of wanting to paint. I could now keep up with the hardest of them in the fields. Although dancing had trained me for short spurts of endurance I learned from these men and their horses how to spread my powers over long periods of time; enjoy whatever I did rather than look upon it as a penance.

A field squared out and planted with broccoli is a pretty sight. I felt proud of it after Bert and I had teamed up and spent days on it – one digging, one planting, then turn about – watching the wilting plants pick up under the June sun, some-

times watering them with diluted cow dung, or even planting them with their roots soaked in it, so that one was plastered with the stuff. Later on to horse-hoe them. To laugh when the great animal stood on my toe pressing my boot deep into the earth, and Bert leaving me to wait, knowing the horse would not move until he said, me pulling for all I was worth between tears and laughter with the intense pain. Then: 'Come on, my beauty! Geet on thar!' and the mammoth moved over and away from me setting my foot free.

'Is it still there?' said my mate as he passed. 'You want to wear steel toe-caps on your boots like we belong to do. Blacksmith'll make ee a set!'

'Christ I will!' I said, limping.

I got back to the mare's head, her feet digging down beside mine in a steady rhythm, the edge of her shoe flashing through the thick feathers, her breath mixing with mine, hames glittering, chains jingling. The working of animal with man was not so uncommon a thing in those days and seemed to me as life should be, harnessing nature instead of replacing her; although I don't suppose there is one man who would wish away the easier times the machine has given him. There was harmony and movement cutting out the weed the horse bruised with his great feet; his velvet nose by my hand, the smell of his hot coat. These were everyday adornments to work and things every workman loved and took for granted, not romantic ideas. Bert gave me a lot to do with the horses and I was always glad to harness them for work or take them back and settle them in for the night or put them to field. Friendship and unity of feeling: these things were good for a man.

We were returning home in this way when we met Clivelly Hoskin with a load of hay for the farm. His cart was bogged down in the mud; deep ruts that took the wheels nearly to the axle. The horse was straining forward almost on his knees, Hoskin pulling at the bit and beating it with a stick. His face was white against his lank black hair. Swearing and shouting he let go the head and, coming back, kicked the animal in the belly several times as hard as he could with his steel-capped boots, until the veins bunched and knotted, seemed they would

burst. The horse went down on its haunches, its eyes rolling helplessly.

'I'll teach ee, you bastard son of a bastard bitch! I'll get ee out!' he shouted insanely. 'You wait.' His tall gangling figure went striding over to the hedge.

The scene was so sudden that I stood dumbfounded by its drama, holding our horse. I wondered what was going to happen next. Clivelly Hoskin had torn up a dead gorse bush and come back laughing and swearing to himself. 'I'll fix ee, my beauty. I'll shift ee, me ole darlin! You seef I don't.'

He lit the bush with a match and in a moment the dull golden branch was a mass of fire, crackling and smoking. This he held under the horse's belly and when it did not shift beat it about under his crutch. The animal was screaming with pain, rearing back on its hind legs, trying to leap forward, ears back, lips drawn away, hooves plunging and harness straining, but still the cart held in the mud and the great load of hay had pressed it down farther towards the axles.

It was only then I fully realised what was going on and I felt myself go white with anger. I rushed forward, took the branch of fire from Hoskin and flung it far into a ploughed field where it burnt itself out. I faced him but he said nothing; he turned his back with a snarl like a cur dog and asked Bert to trace him out with our horse. I was no longer able to speak and was shut out of their inner sanctuary, trembling with anger. Bert hitched up the mare. Before we could get them going we unloaded at least half the waggon of hay, then quietly letting the horses take the strain, gently, one after the other, the cart moved forward out of the deep rut.

Going home I asked Bert about this.

'Burning out, you. That's what they der call it. Taz a very old way of getting a hoss goin'. We don't see it often now: not like we belonged to. I've seen a whole team of hosses burnt out. Once the fire is there they gotta go, see. You get one lazy hoss and the rest is no good. Same as we; get one bad'n among us and everything goes wrong.'

'He's a bad bastard!' I muttered. 'He won't do it when I'm around. I'll break every bone in his body.'

'If you want to stay around I shouldn't upset him,' said Bert, after a while. 'Clivelly Hoskin is not a nice customer when he is roused.'

'I could deal with him. I would kill him with my hands,' I said with quiet but fierce confidence.

'I dare say,' replied Bert, smiling. 'I know you could. But Clivelly doesn't fight that way. He's yellow. He has other ways, shouldn't be frightened.'

'What ways. Would you use them?'

'No!' said Bert firmly. 'On him I might, but not on you!'

'I see,' I said, swinging up a sack of vegetables and taking my milk-can from the hook on the cowhouse wall. 'I'll be on the lookout.'

'You won't know till it's over, anyway. He's too crafty,' concluded Bert. 'Nasty bugger.'

As we entered Big Field on our way home to the cottages on the far side against the sunset, we could see our women sitting on the granite stile set in the wall of my garden where the myrtle bushes flowered and the children played in the grass. The sun was like a burning branch held under the dark belly of the sky, but I no longer felt anger and violence, for this creature was free and would charge towards the cold dawn with a starry mane and the moon hung from his forehead.

Sheep ran before us. Some we had sheared and let run again in their pink silk body stockings. Others were yet to be done. Some had scabs where the flies had laid their eggs and now as we walked a sheep tossed and danced with a magpie fast to its back; the bird was digging with its sharp beak for maggots. This digging loosened the scab formed on the back and it flapped up and down like another wing for the magpie in the commotion and motion of pain and the wind and the setting sun.

''E won't last long,' said Bert. 'Shouldn't ought to keep sheep really; there isn't enough time to look after them. Either you get a shepherd and do the job proper or leave it alone. There aren't many shepherds these days. Hell, she'll be dead by morning.'

We watched the sheep, mad with pain, ram its head against a

granite boulder, stagger, gavotte, leap, dance, run, trying to free herself from the bird and the progeny of the avenging fly.

This was also part of the hidden drama lived out on the Atlantic cliffs: a drama about which nobody really knew anything. Life and death. Life had a sharp tooth; it was up to me to have one sharper.

Tall as the Sun

AUTUMN came gently upon us. When the last sheaf was thrown against the moon and thrashed, apples gathered on shelves, corn sacked and stacked, ricks settled and thatched, weeds had died back, dawns had grown later and the young swallows were following across the sea a month after their parents, by a chart and to a destination printed in their nomadic souls at birth, then the rains came, and the gales of the equinox. For me it was the cessation of work. The day came when Croggan put me off. I had expected to have enough stamps to draw the dole and was relying on a few months' sparse living with my time free to paint and draw, but I was two stamps short of the required number: I was not entitled to benefit. Nor had I enough experience to get work on another farm and in any case it was the wrong season. We were faced with destitution.

I had grown to love the Atlantic cliffs and the cottage had taken to our own ghost so that it became home. I had planted the garden up. All I wanted was for Croggan to continue my employment so that I could command a simple wage and a home while I studied the work to which I felt called. Of course I never thought of telling him why it was I wanted to stay on: had I done so he would most likely have changed his mind and looked at it all quite differently. Greta and I sat up at night discussing the problem. I had so much to learn before I could sell paintings. This we decided must come first while there were no children. We pledged ourselves. I would go once more to Croggan and ask him to keep me on.

The night was dark. It was damping over the fields and moors, a fine wet mist drifting everywhere, penetrating even the granite walls. When I reached the farm it had resolved itself

into steady rain. I found Croggan under his tree – the weeping ash – dressed in a coat and cap, standing quite motionless in the rain, a light from the house catching his wet red face and dark beard. I was startled and pulled up suddenly, sensing his presence, standing there as though he expected me. And I in my turn, in another part of me, knew he would be there. When you live in a wild place you understand things instinctively and sense when something is going to happen and someone is approaching. He must have known I was going to call. He stood often under this tree and perhaps the habit bespoke also a deeply rooted unhappiness of which I knew nothing.

'Good evening, Mister Croggan!' I said gingerly.

'What do you want, Mister Berlin?' He seemed to roar quietly.

'I want you to keep me on. I want to know the seasons and become knowledgeable about farming so that I will have a trade and a home,' I said.

'You have a trade already, Mister Berlin. The Luxury Trade. I can't afford to teach you anything on a small farm like this. Go back to London; that's my advice.'

'I hate London,' I said with some passion. 'I dislike all cities. And the stage is not what you think. It is hard and uncertain and unreal with never a proper home for more than a week at a time. You are quite wrong about it being a luxury. Only a luxury for others, who are already luxurious. I want to build a more real life: I don't mind how poor it is. Down here this means something to me. I must stay.'

He could not understand me and I believed it was no good telling him about my love of art: he would not comprehend. Yet I think now it was my limitations and not his that made him take the stand he did.

'I am not a hard man, Mister Berlin,' he said, 'but I can't for the life of me understand why you waste your life working as a common labourer. I won't contribute to throwing away your gifts. I think you're mad.'

The rain fell steadily and we faced each other in the darkness.

'I have no money,' I said at last. 'There is no dole for me. I don't know which road to take. It is destitution.'

He seemed to draw back in the shadow, the darkness of the tree, and his voice spoke out of it as though the tree was speaking.

'There is only one thing for a man in your position,' he said. 'The Poor Law.' The words fell like stones into my heart and silenced me again. After a little while I said:

'Can I retain the cottage?'

'Yes, you can work one day a week for the rent,' the voice said.

'Thank you,' I answered and walked away in the rain.

So the pattern had set itself. I would have a cottage for the winter, perhaps seventeen shillings a week from the Relieving Officer to cover food, fuel and painting materials. But all my time would be free to work as I wished save one day a week on the fields.

Greta's clothes which she had bought when we were on the stage were of cord and tweed and had not had the wear mine had. Mine anyway stank of sour milk and pigs' piss. By now, save for a few ragged underclothes, I was dressed entirely in sacks, which I found to be honest, warm, hard wearing and easy to renew. Even my feet were bound in sacks, binding single strips of leather under the soles.

I bought shelf paper from Woolworth's at eighteen yards for sixpence and several threepenny notebooks and prepared canvases from off-cuts of the sacks with which I had fashioned my clothes, using house paint and odd tubes which a dear lady who ran an art shop in Carrington-Truth allowed me on tick. This meant I could paint and draw all the time, which I did from the kettle boiling at dawn to the last candle at midnight. Drawing in deep shadows thrown by candle or lamp light helped me find the great laws of form and light as though I was cutting the images out of the darkness of stone. At least twelve to sixteen hours a day drawing; sometimes more.

Greta was involved with this and we took long walks over cliff and moor observing landscape, natural objects, flowers, birds, men, animals, work on the fields. How well I knew these things! I was beginning to understand my country as well as my craft. Every weed in the ditch, root in the bank,

became an extension of my life so that I was daily that much more than my self. I learnt the shapes of trees and hills, of waves and rocks and women and fields and horses. Nothing was too meagre. Ladybird, butterfly or sparrow hawk, oyster-catcher, curlew or turnstone; beetle, teacup or mouse. I went the whole round of creation doing endless drawings, making a great store-house of them in my mind with their attendant feelings.

As winter progressed the food grew shorter. The whole pattern was on a sliding scale which would provide less and less as time went on because the few shillings were not enough. The week I paid the lady at the art shop so that I could get more paints there could be no coal or else no oil or no food: always one thing had to be sacrificed. Credit was possible to ease the net for a little while but it grew tighter directly afterwards if one was to remain honourable. Some weeks it was only by the goodness of the grocer delivering without payment that we had food.

For all this the spiritual balance was kept and we directed these disciplines into spiritual channels: remembering only too well the words of my friend Bamburger: 'You can't buy a nice mystical loaf and some spiritual sausages or some poetic butter if you haven't got the bloody money, you silly bastard!' But we were not fooling. This was our vocation and our prayer.

On the 4th December 1938, I wrote in my journal: 'It is the anniversary of our wedding. It has been a hard day. We have not eaten since the beginning of the week save for a cabbage I stole from Mr White's field, which we had hot and then cold because we could not heat it again, having no fire.' In some way we were paralysed and I had not of course the experience I gained from the Gypsies after the war, so that I could go into a forest alone with a box of matches, a knife and a piece of string and survive a week or longer. My pacifism forbade me fighting even for ourselves, but we would not step down: belief is the one thing in man that offers all.

The journal goes on: 'The headaches which come on the third and fourth days without food were ours to-day: a steel

clamp over the base of the skull and neck. I cannot paint or draw, having no materials left. Outside, the mist comes in from the sea with snow, driving horizontally across the moor: a low wind whined in the telegraph wires all day, is whining now as I write by the light of the last candle burning low in my room. Always it is like some idiot playing a never-ending theme for cello, screaming with the gales that come in from the Atlantic and rock the cottage and flood the lower stone floors.' While there was no creation there was also no destruction: this was as dangerous as it could be; augured death.

The next day was the fifth day without food. The weather had let up a little so we went out. We were beginning to feel weak. Over the cliff-edge the gulls were calling: the cliff below, against which the waves beat incessantly down the centuries, outside life and death. The mind was clear and bright now. Snow had settled in a thin layer, making everything look remote and beautiful, the sea dirty. Drifts were caught in the gorse bushes which were in winter flower of rich yellow. A dead pine stuck stark against the sky. It was getting dark and the pale sun sank away in the mist. I put my face into Greta's hair which was damp with mist and snow. She held my arm. Besides this there was nothing, only the empty road before us and the receding telegraph poles and the blue hills over Cuckoo Town. That night I wrote a note, perhaps thinking we might not wake, for it was very cold and we were gradually growing weaker, even though some unexplained faith made us go on. In certain things it is wrong to turn back; this was one of them. Never for a moment did we consider defeat, or only in the little note which reads like a poem: maybe it is one, maybe when the spirit speaks in the wilderness with complete acceptance everything is a poem. Sometimes that is the only way we can speak and there is nothing to say.

> We are a Man and Woman
> On our way to Heaven
> Walking with our coats
> Hung loose.

Our life is a bird's song
After a shower
On a wet and lonely road:
A wet stone in the sunlight.

The law was to keep alive, but the depth of our privation
had been considerable and the fullness of understanding that
came with it seemed to extend life into other areas we did not
know before. The vision, the clarity of mind, the sensibility to
colour and light, the unity of objects so that one entered or
was them, flooded everywhere: 'the light that never was on
land or sea.' Life had a sweetness few will understand. There
was no longer any desire, therefore no fear: we could stand on
the frontiers of life and death and look across perfectly unified
and happy. Nothing had brought everything to us in the
fullness of love.

On the sixth day I woke and after lying for a little while
called Greta: we slept separately, not wishing to take each
other's life but to grow strong and give out strength. We had
gone past the groins of sex, so beautiful and so deathly. After
a time she answered: her voice was weak, but it was not as I
feared. I felt curiously uplifted, almost to the point of exultation.
This was a mystical state as I understand it. The daily occupa-
tion of the visual artist ties him to earth by image and material
and manual articulation. The limits of my physical world had
narrowed so rapidly that I had defeated my purpose in this
sense, but I had reached a state I had not expected and about
which I could do nothing. I have read about such states in the
lives of mystics such as Boehme and Eckhardt. I had gone
beyond dancing and painting: at centre it *was* the dance – of
creation, perhaps, or death!

When this had passed I lay in bed for several hours unable
to draw but reciting fragments of poems to myself; some were
my own, some were fragments I had learned and which had
stayed with me after several readings. Some belonged nowhere,
came from nowhere.

I am like a cockled star
Blown by the wind,

Washed by the changing tide,
Drifting afar
A cockled star
Wandering in mind.

Anchor'd to no sea bed
Or the uncharted sky,
As seems is the oyster moon,
But drifting instead,
Unpiloted,
Living I die.

I am like a cockled star
The tide impels,
Sunk in the silent seas,
Drifting afar,
A cockled star
Scraping among shells.

I was chanting this to myself when I heard a great hammering on the door downstairs. I went silent. The cottage stood listening. Then, quietly to Greta: 'Hear that?'

'Yes. I expect it's the coalman come for his money. Better keep quiet.'

'Think so? Perhaps it's the old bastard come for his rent or to chuck us out. I haven't been up there to work lately, sod him!'

The knocking was repeated. Always the door was open, unless there was a great gale blowing. We heard the caller come into the kitchen and shout.

'Anyone there?' But the voice was unfamiliar. We did not stir. Footsteps receded down the garden path on to the moorland road; a car revved and was gone. We listened till the sound had quite faded away as if this contact with the outside world was a fine thread which we would stretch into eternity even after it was severed by silence.

'Wonder who it was?' I said, feeling strange with my full voice. 'I tell you what,' I added after a pause. 'Let's go to Polly Widden field and pinch a broccoli, some sticks from Truth Woods, if we can make it that far, and maybe we will find

something else if we keep our eyes open, like we did those eggs that day in the hedge.'

The thing about this state of being, I learnt, was the same as when you were freezing. The positive machinery, the power and desire to act, is weakened because these things belonged to the body and to the physical world. All our energies were pointed in another direction with great intensity, so that our eyes burned with a new light. Although I don't think we realised it, we were dying.

I rose like Lazarus and slowly started to dress myself, put on my sacks, and stood for a moment looking at myself in a mirror, tall and very thin with a long neck, sunken cheeks, hollow eyes. Greta looked pale and beautiful; her eyes were huge. My head swam as I moved and I had the distinct feeling I was levitating.

'I shall get a job in a factory soon,' I said. 'We can't go on in this way.' Greta had come into the room, like a spirit.

'Of course you are mad,' she said, after looking at me for a while. 'Stark raving mad. Who on earth is going to take you to work for them anyway? You look as crazy as a ghost in those sacks. Christ, talk about "when does the ghost walk!" '

Very slowly I went down the stairs, weak as after an illness. There was a friendly shaft of sunlight falling across the stone-flagged kitchen from the window. On the bare wooden table there was a box of provisions. The grocer – even though we owed him several pounds and could not pay – had left the order for the week, even to candles, paraffin and cigarettes. At first I could not believe what I saw. In this condition hallucinations are common. I recalled a time before we left London, sitting in front of a huge fire warming my hands, and as the fire gradually faded I found myself huddled under a blanket watching a street lamp falling across the wall. I had created the fire; my need had been so great. So I was not going to be fooled this time; perhaps this too was a vision! I stole up to the table and gently touched the things and they remained.

'My God,' I whispered. 'My God!' Then I called Greta. 'Come on, darling! Come on down. The ghost *has* walked!' and

she came and touched the things with me. We stroked and caressed them, and tasted and nibbled and laughed and cried and shouted.

'It's food! Bloody food! Bloody fucking FOOD!' And we danced, a strange ludicrous dance like the dance of the consumptives in Kirke White's poem, until we nearly fell over. Together, breathing hard, we filled the lamp and sacredly boiled a kettle, and drank hot tea made with evaporated milk and ate a little cheese and bread as though it was a holy sacrament, smoked a cigarette as though it were the incense of inward spiritual grace.

The effect of this was almost delirious. We felt our bellies burn, our bodies grow warm, our blood course through our veins as our hearts, like silent turbines, started up again with a steady thud. The brain went cloudy for a little while, then dizzy, followed by a curious sensation like that produced by alcohol: we were drunk on bread and cheese, sitting by the empty grate laughing as our stomachs unknotted. Afterwards we slept, then had another meal. Strength returned to our bodies slowly, enough to walk to the wood and collect a rope full of branches and a bundle of twigs for the fire. With paper bags from the groceries we lit a flame which leaped and crackled through a scaffold of twigs, caught the larger wood and finally formed long orange galleries of flame along the green ash which sang as it burned and squeezed out its white spunk like life-blood sizzling in the grate.

> Ash when green
> Makes a fire
> For a Queen.

The next day I went along the cliff road to the winding hill over Fort Rock to meet the Relieving Officer, who served these outlying districts only once a fortnight. I found him doing his rounds among the cottages with his little Gladstone bag full of money; a kindly, sympathetic, old gentleman in a trilby hat and a baggy suit who dispensed the Government's meagre stipend with grace and sweetness to the very poor. With my few shillings I felt tall as the sun. I could even buy some stamps and

write home, and to my brother in Persia to tell him of the progress with my work.

Who would know of the strange journey we had taken to the frontiers of physical existence? Who would want to know? No one. It was our secret. Something to carry about that gave us strength and made us unafraid and put a light in our eyes: the light of hunger and the light perhaps of those who search for truth, for this it seemed was a time in the wilderness, a time of purification. We had written our legend on the sea. We had seen a reed shaken by the wind.

Lord of the Valley

'THE wind is north-west, Mister Berlin. You'd better go to Big Field and trim hedges,' said Croggan one morning. 'You owe me eight weeks rent so you'd better come two days a week for eight weeks to pay the debt. Big Field will be a good start. When you've been round the hedges, start lifting the ditches; when the ditches are done, start to repair the stone hedges. That should keep you quiet for a while.'

I felt relieved. The rigours of the past winter and the intense attack on my drawing had made it impossible for me to go to work for one day a week for Croggan as I had promised. He was a fair man: he only wanted his due. In the end I had gone to see him – to heal the dichotomy and pay the debt.

Bert was with me sometimes, sometimes I was working alone, but always I was drawing and very much withdrawn. He was friendly. Often he gained a perk for me from the farm; some milk or eggs or vegetables which helped with our low means. We did not talk about these things: he knew it was tough and a countryman, I was learning, leaves you to your own personal choice and will remain silently your friend, knowing all about you without your telling, even while he may not understand. He is nearer his origins and his natural intuitions are far more keen than those of the man from the town.

Big Field was the twenty acre field which had our cottages on the road side. It was flat and level and square. Strong blackthorn grows out of the stone hedges which border the fields and roads in Cornwall. These had not been trimmed for a couple of seasons. They were too twisted and short for cut-an-lay, which would have been interesting; the only thing possible was to use a wooden prong to guard your hand and

cut with a sharp hook, trying to avoid the long pointed thorns which, if they went down between nail and finger on a cold day, were excruciatingly painful. They also tore the face when they flew back and the hands were cut. I sharpened my hook on the huge grindstone in the farm, Bert turning the handle slowly and now and then pouring water over it from a tin can. I got the curved blade like a razor and kept it right by a fine carborundum stone I carried to the field in my pocket. I cut a good hazel prong to hold back the thorn while working and began to get a good close clean cut. Even then gloves were necessary after a time – for me anyway; not for Bert, who had so much more skill and endurance and did twice the work I did with less effort, as masters of a job will always do. It was hard but enjoyable work. Only the north-west wind, when it rose at times to gale force, was troublesome, so I turned my back to it and cut my way inland.

At croust time Greta came out with a jug of hot tea and some heavy cake which I ate sitting against the stone wall, encircled by the little herd of sheep who gave me their quiet endurance and long-suffering friendship, looking at me with their flat-irised eyes throughout the day and even waiting for me to draw them in their stony biblical simplicity.

I worked the field all round and burnt the cuttings as I went along, leaving those near the cottage to take in to light the fires. Then I lifted the ditches with my long Cornish spade, which was also shiny and razor-sharp. Finally I mended the stone walls. I felt good about doing the job so well and clearing my debt with Croggan.

' 'Tis done!' I told him on the eighth week. 'We are square now!'

'Waal yes, so 'tis!' he said, scratching his head through his cap. ''Tis done and I'm afraid I must give ee notice now, Mister Berlin! I need your cottage for another labourer.' My heart fell and I could have wept.

'Why is it he won't take me on, Bert?' I asked my friend as we crossed Big Field on the last day. 'I can't understand it. What has got into him?'

'I don't know, my beauty,' said Bert. 'You'me a good worker

you. He can't grumble at that. And I could teach ee everything in a couple of years: ploughing, scuffling, harrowing, sowing, planting; everything I know. And the rest would come in time: what to do in different weathers, fertilisers, dung spreading, or if something goes wrong with the animals. Experience, see. I don't know why it is; you would be as good as me or Clivelly Hoskin in time.'

'Yes,' I said, 'and I wouldn't castrate the pigs with a rusty knife like I've seen him do!' As we walked along my mind suddenly cleared. 'It's him. It's Clivelly Hoskin going in my cottage. Isn't it?' Bert turned and looked in my eyes.

'I told you not to cross him, my 'ansom. It is 'im – yes!'

'Bastard!' I said in a sudden rage and turned and strode off back to the farm where I found Croggan standing under the tree.

'It's that bastard Clivelly Hoskin, that's who it is,' I shouted.

'What about him?' asked Croggan quietly, without getting ruffled.

'It's him getting me out of the cottage, isn't it?'

'I've told you: I want the cottage for another labourer – and that means an experienced labourer, Mister Berlin – and I want him near the farm.'

'But you won't allow me to *get* experience. You throw me out for the very reason I want to stay and put that bastard in. You know why it is?' I shouted in a husky voice. 'Because I found him burning a horse out in the summer and it was me who stopped him. He had lit a fire under the mare. That's why.'

Croggan became shut as country people do in trouble, especially in face of a frontal attack; knowing better than I the value of silence and calmness in a situation like this. And I strode back across Big Field having blown my top and got nowhere, realising it was hopeless. The battle had been won, but not by me. There was nothing I could do but go.

The great thing we had learnt was that people are ruthless, no quarter is given, no mercy shown; innocence and inexperience are impediments, also straight-forwardness and truth. You must be harder, shrewder than the other man. The trouble

is that we didn't really want to win, but to do something else entirely. And poverty must never again become an uncontrolled condition. It only worked properly when it became an occupation and a way of life. Once this was realised we began to enjoy it again and to be eligible for the privileges of the very poor: above all, freedom and love of life.

> 'He who has once been happy is for aye
> Out of destruction's reach . . .'

That we were in exile with the outcasts was to become even more true, but in some way we were still back-stage and could see the workings of life from inside. We knew that we were linked up with certain trade winds and must steer our course accordingly, which meant it was no use resisting Croggan and his decision to put me out. After all he had his farm to run and I was an embarrassment. We must go; move with these tides.

We spent many long days walking the moors and lanes around the whole area of Carrington-Truth, following up every lead and failing time out of number to find somewhere suitable, as if we were going from point to point in a maze, like a terrified youth and maiden of ancient times. This led us in the end to a tiny lane which ended at the gate of a cottage, set in an orchard of apple trees on the side of a hill, sloping into a valley – known as the Valley of Gold, because someone had once found treasure trove there of Celtic gold torques and girdles and crowns. We loved the place at once and knew that here we were to live. Often the future is indicated; on a long walk the year before we had ended up in this lane and marvelled at the blossoms – or had I seen them in a dream? Now it was to be ours for three shillings a week.

The move was uneventful. Our few possessions were piled on the farm cart lent to me by Croggan and pulled by the mare I had rescued from burning, across the moor to the peaceful valley. The valley was protected by a long hill from the rages of the Atlantic, whose high seas, during our hard winter on the moors had smashed a lifeboat on the rocks, and by the tall cliffs that stood as monuments to the eternal dead, the courageous living who gambled with the sea for the lives of others. But the

long golden hill shut away our disasters, sheltered us from danger.

The valley itself had been made quite hideous at one time by tin-streamers who had set up sheds for washing ore over the river, stained like dragon's blood by oxides from the workings. Now all was ruin. Broken huts, concrete floors and pieces of rusty machinery with giant cogs and winches littered everywhere, reminding me of the ruined 'Archipelago' in the Crystal Palace where we played as kids: I almost expected to see the cast-iron prehistoric animals. The stream wound its way to Hyperion Beach, near the rock where the light stood and looked out on Cuckoo Bay to warn the voyager of the Stones, and to Cuckoo Town where one day I was to fight a bitter battle among the artists for what seemed to me the elements of truth – my elements, that is, against theirs. It was here the Red River seemed to mensurate into the sea, staining the bright waves red as the wine had once done and the blood of armies was to do later – though we had no idea how close war was: the final disaster.

My efforts to work in an ordinary job and yet to pursue my studies had proved a failure: it also proved once for all that art is a vocation for the few and a game for the many; that there would not be many critics if there were a few more of the chosen; that it is a search for new gold in old places and touches the very river bed of existence. He who dabbles should pick up his brush with respect, remembering Rembrandt used this: if that does not make him tremble he should leave it alone. I was resolved to get on with my work and turn my back on society, because it was only in this way that it could be done and added to society later – if I got through and was not destroyed by social processes, for no one does anything great by playing safe. In any case I wanted to do it, so to hell with society. Naum Gabo, the Russian sculptor, said to me later: 'Society ezz zee protoplasm: zee artist, he ezz ze spermatozoa!' I have never known anything more right. An artist has to believe this even while he is embryonic. I had accepted sackcloth with humour and devotion to my purpose – it now seemed that I could only make a lasting contribution if I had the guts to get

down to it with complete submission. Nothing else would do: no compromise was possible. As I had written of Van Gogh:

> 'No fool's game with you
> Who saw the purple ravens
> Across the corn,
> The stars unveil'd of God:
> Look'd your foe full in the face
> And took the explanation
> Of the silver bullet!'

If needs be it must be like that; we were not joking. Once we had decided at this third stage, we set our course in a more positive way. The earlier ventures in London and on the Atlantic cliffs had taught us a lot about what to do and not do in the matter of basic needs: food, water, fire. The Zen Masters and ourselves were not far apart; we were glad to commit the spirit to experience in this way.

Our valley became a haven where birds visited and rare flowers grew; where insects lived out their lives in the long grasses and overgrown stream-workings. Hokusai saw into insects – so did I, but with less skill at this stage. But I gained a great extension of vision by learning the amazing engineering structures of their framework and physical being, visual beauty, fierce existence. Here reptiles gathered heat from the sun in a sandy, dry, asphyxiated stillness on stone, waiting perhaps for evolutionary wings to take flight down the centuries and set their claws on the topmost branches of the tree of life.

It was Greta's silence that here came into its own: her intense recessiveness and receptivity made her a marvellous companion through the long days of golden light searching the valley for living creatures and flowers. We gained harmony with our environment so that the creatures came near to us. With my special love of insects it came about that grasshoppers would alight on my hand and I could take a dragonfly, gently, by the undercarriage with thumb and forefinger, and draw him with the other hand, then return him to his ravenous flight up and down the tin streams and ditches that stemmed from them,

watching him in turn take a wasp with the dreadful forward set callipers of the tarsus and, hanging upside down on the sorrel, crunch the captive, feeding him into the machinery of the mouth-parts, as though through a printing press, with the toothed forelegs: a ruthless, terrifying process which was all part of a great and immortal ballet that had no end and no beginning, set to the symphony of the years, whose decor was the golden valley and its changing seasons. And we ourselves, soon to be fed through the jaws of war with the rest of our generation.

A hawk visited us to try and get a canary I had been given and hung outside. He filled the apple tree with fierceness and anger, beating his great triangular wings, and I was able to draw him several times. He would not go away and when I tried to drive him from the cage he turned on me. I believed for a moment that I could capture him and train him like an eagle to the hand and perhaps this thought was enough to drive him finally away. The heron was not afraid of us and would go on grazing the pools for fish and frog while we watched. Robins came into the kitchen and settled on the table. Even butterflies settled on me. I am sure if this state of mind – which was clear and without fear, heightened by devotion and short food – had continued, the whole of creation would have been my brothers and proved to me what I always believed, that the ten thousand things are contained in the one. As it was I gained an insight into the nature of things I believed God had made, and there seemed little enough difference between us. I held the pulse of life under my fingertips.

Greta also had this insight and perception: after searching months for a single flower she stood suddenly before it in the evening light – the Great Mallow towering above us. What greater reward could there be?

The rabbits did not scuttle, for we would not kill them. We had starved for six days and had not done so, why should we now? We ate berries and crab apples when we were hungry and drank from the clear streams, made love in the grass, talked endlessly of the meaning of life and experienced to the full this our prayer, for whether it was the sexton beetle burying a

mouse as larder for next season's grubs, or the gannets diving in the blue bay at the end of the valley, nothing was separate in us and we ourselves seemed bound in one unity. We also fished in the sea. It all seemed far more meaningful than when we danced the Storm God at the Prince of Wales Theatre or Brixton Empress, even though money was short. Even though it may have seemed vain to outsiders there was no vanity. I was sure I was on the right track to becoming a good painter.

I planted my garden and in the autumn there were vegetables and potatoes: even some autumn flowers like country people grow. The blossoms had turned into hundredweights of apples which I gathered and took in borrowed sacks to the old cottagers about on the hillside who also lived on the parish. Doing this made me feel like Lord of the Valley as I returned empty-handed to meet the Relieving Officer at the end of the lane to collect my allowance for the next two weeks. I wrote in my journal: 'Few know the hidden exultation of being poor and to be counted among the worthless things on this earth: and, dear God, never let us fear the countenance of death after this or feel ourselves too grand to take on the stewardship of privation. Let us not covet gold or say to ourselves, we have not enough, so that we may not give. Let us be kept safe from the trickery of greed and the high sentence of pomposity. Let us screech like owls at all that is false and wrongly represented for the sake of self-seeking, and have no truck with deviators from truth. Above all let us not be traitors in heart or mind or body or land: for that is the worst thing of all. Let us not come to rest in the Potters Field.'

As the kind little man in his baggy suit gave me my money he said: 'You must go before the Board of Guardians at the workhouse before very long.'

'What on earth for?' I asked.

'They want to ask you some questions.'

'So?'

I watched him walk down the lane carrying his Gladstone bag with money for the poor, ordained to eke out their miserable allotments. He was a good man and would have given extra sunlight had it been possible.

Winter was hard but only in a way that would seem hard to others, for now we were organised. We had fire and fruit and vegetables and a few chickens we had hatched out from a clutch of eggs under a borrowed broody hen – eggs therefore. Only once did we slip up over food, when we found ourselves forced to live entirely on eggs for a week – I felt green. But my sacks wore well and my clothing cost nothing. Greta renewed her clothes through a club her mother paid into. My feet, now accustomed to cold, were bare save for a leather sole tied on by a leather thong, through the toes and round the ankles.

I went to Carrington-Truth school of art in the evening and learned from an honest master the logic of academic drawing and something of the growth of trees, the ways of rain moving over hills, dragging ochre winds over stormy seas. Through him I learned consistency of application, honesty of purpose and integrity of skill: we only parted on the ramparts of imagination where one man can never solve another's problem. I last heard of him overpowered by the tidal waves of administration and ill health. Of all my helpers he made the largest contribution to my modest achievement as a draughts-man. This teaching was enough to give bone to my own way of drawing without destroying its individuality, intention to my method of observation. I could not go the whole way on the journey but the distance I travelled with this man and the things learnt on the way were never forgotten. When a violet shadow falls from a rock I can think of him.

Such also was the case with Claudius Lantern. My friend gave winter lectures twice a week and collected me in his car on these evenings so that I did not miss one. Philosophy. Oriental Art and Literature. Psychology. Comparative Re-ligions. Biology. Over three or four years I studied closely, reading books from his library in each direction helped me to widen this experience and to give me some cultural back-ground: enough to follow my enthusiasms with intelligence. He now lived at the top of the Golden Valley. Sometimes we walked to his cottage to listen to music – a small cottage by some tall whispering pines under the long hill. The winters were a closed committee of learning which helped me to

interpret the experience of life and of nature: but towards the end of them we were tired, for they were hard and terrible times really, which only we knew about and could not speak. We longed for the spring and early summer when life was so much easier.

> Soon again we'll see the hillside bloom
> Along the valley where the heron goes:
> Arm in arm we'll view the golden broom,
> Await with joy the coming of the rose.
>
> Never let us rue the passing years
> As long as hawthorn blooms and roses blow:
> Though faceless faces bleed too deep for tears
> We'll walk the golden valley where the herons go.

The pattern developed, bound itself together with what I call the experience of purification, which enhanced my vision of life and only let through here and there diabolical images from the future.

Guardians of the Poor

HOWEVER brave one may be, and however well-meaning one's enemies may seem, there is always a time when coming face to face calls upon the main resources of the soul. It seems to me we live within the orbit of the fallen leaf and the early rose, and all is well if we can remain the same inside, for it is a continuous journey from which there is no need to escape. But man is conscious and the courage needed is insufficient to meet the moment when there is a dichotomy.

The state of mind we had achieved when we were in Golden Valley some would call an escape: but from what? Escape into life seemed the only possible answer. As far as the rest went – the rigours of materialism were there and the nets of material society were dredging for us. What we were doing, as in the case of most artists, was at this point too subjective to be understandable to others and would only be seen clearly as the results of our dream hardened into reality through art, even while the soul of society was sick of a mass illness –the epidemic of war which kills like cholera. Time had passed imperceptibly: we had trodden its soft, unsafe depths as into a bog, while history struck lightning overhead.

World patterns were reshaping. Munich, like a mustard egg, had crumpled, leaving a sting in the mouth not easy to get rid of. Albania and Austria had capitulated to the German Axis. But all this seemed dreamlike to us: even the Battle of Britain. To others we ourselves seemed to be in a dream. To departmentalise experience is idiocy. The deeper rhythms, the vital music were disturbing: ominous. My contemplations showed me a way into happiness through a simple device of sacrifice in a universal rather than a temporal sense. I played one level off against the other for I did not know how to integrate them

and things that seemed worthwhile throughout the ages now had a seal of worthlessness put upon them: the poet, painter, thinker, the sage and indeed the saint were of no social use in war and therefore should not be tolerated. At base it was the love of love opposed to the Roman bedevilment with power: a single person against a civilisation. Untenable to say the least.

My fourth or fifth visit to the workhouse to go before the Board of Guardians was coming up in a little while; this made me nervous and not a little afraid.

I could no longer work. I walked out on the grey arterial road that streaked round the outside of the town to think things out. There was a pain in my head, the wind was blowing, the rain was descending steadily at a sharp angle, scratching steely marks on the little round hills that rolled away to the moors and the open sea. The low cloud hid the ugly mine workings everywhere. I stood under some trees watching their brown and violet trunks. Between the trees, beyond the railway, I could just see the town dreaming in the mist: houses with their wet roofs grouped together in silent timid congregation. There seemed to be no life stirring anywhere. The road remained empty. My hair was caught by a tuft of wind. In the centre of the town the church tower stood as it had for ages, unmoved. I thought of the peace inside the church. It was peace for which I was looking and could no longer find. Like the others I had the plague; I recognised only violence within me.

I kicked the base of the tree nearest to me, stubbing my toes painfully within my shoes. There was a wildness in my head. Why? How could I answer this question so many times posed in the last few hours? Why, when I walked up the road did I want to quicken my step faster and faster so that my coat flapped behind me, and every now and then to turn pirouettes as though I was still a dancer? I made three clean beautiful turns on the road in faultless timing, when a large black limousine slipped slowly by; the occupants were laughing at me. I felt hurt and embarrassed like a child caught at a secret game; I wanted to cry.

In the town behind the mist I knew the men and women

were at their daily life, which I envied them. In the coal-yard the railwaymen with knotted arms and black faces were shovelling and weighing coal into sacks from great glittering heaps. There would be grit and laughter and filthy language. The mine was working. Men underground operated their great electric drills by the light of miners' lamps on their hats: there was thrusting and cutting and blasting. The softly treading mill with its heavy stupid sacks of maize to be ground, and men at work in its bowels; men of dust. Men in the factory, the garage, the barracks, the farms; the women too. Everywhere there were women: shopping, gossiping, cleaning, cooking for their men and their kids, making love and always talking – of men. The town had its life: its life was generation upon generation of busy bodies absorbed in what they were doing for each other and for themselves; for money to keep alive.

That was the most important thing: to keep alive. Simply to be men and women perpetuating themselves. None of them had the third eye that so much troubled me and kept me apart from them, trying to live without the glue of convention that held them together, the protoplasm, the social unconscious mind. The grizzling, the filth, the discontent: these were also salt to their lives; moreover the acceptance of something I was never able to accept – the imprisonment of the soul. So I was isolated. I had got outside the swim. The thing was to know whether I was strong enough to be alone and grow to a completed man or if I was to return to the world until I was strong enough, like the man in the story by Henri Borel who went to the Chinese Sage to ask to be taken in: he was told to go back to the world for forty years until he was strong enough to live by the law of Tao. It could be so. I was looking for something but could not tell that it was the desire to get back. I wanted to scream. Instead I completed three more pirouettes and was glad this time nobody saw me; then repeated them, laughing wildly like a clown.

Obeying an impulse I turned off the main road down a lane that led to the town and the people and spent the day drawing in the streets. When I got home I found Greta sitting by the fire with a haunted look in her face. I knew something was

wrong. The cogs of the outside machinery were engaging with our own. There was no escape.

'What is it?' I said, leaning over her, concerned.

'I'm pregnant,' she answered after a little while. She was crying. 'I can't go on any longer.' When this brave, silent person spoke these words I knew I had to face a decision.

The day came when I went to the workhouse, which was built between the twin towns of Carrington-Truth: a great eighteenth-century building of prison-like architecture which exacted a terrible fear and humility from my anguished mind, as I walked up the wide gravel drive to the entrance. In the vast gardens, old men (who will have long since died) were in quiet attendance. It was like some macabre paradise where those peacefully waiting for the unknown smelt faintly of death and the sunlight had about it a silent action that ate away like acid at their etiolated flesh and ossified bone. These were the failures in society: some of whose only fault was to grow old. Each smiled gently as I passed on my way and looked after me with faded eyes, perhaps wondering at my youth, and then went on tending the geraniums and roses with their scaly hands, or sat on a seat with that isolation that only Lowry has been able to get into painting: a human being on his own waiting to die after seeing the world for what it is.

With several other applicants, some from the little cottages scattered near my valley, I waited outside the board room in a lobby painted brown and green, a beige-covered door, bare floorboards. I was very nervous. Even reading my Taoist texts from a little book and chanting them over to myself could not quell the tension or the dryness in the mouth. No stage entrance had ever been more frightening and I had never stood so despairing in the wings with the other actors as in this macabre play. Those who waited with me looked with the eyes of people who had passed through the sieve of menial jobs at the bottom sink of the social order and now, by reason of bad health, mental deterioration and general dehabilitation through hopelessness, had become unemployable. Gentle creatures who would cling like giant straw-coloured grass-hoppers to one's clothing to gain strength; the dregs of the

human order. In spite of my gauntness I felt robust and vigorous among them.

When my name was called I opened the green beige door with its brass studs and entered the board room where I stood in a sort of witness box with the chairs of the Guardians sweeping in an arc. High up in a kind of judges' box was a man of iron grey hair with a kindly countenance who may well have been the chairman. This room also had bare boards and the same hideous green and brown paint on the walls, which was standard in government buildings of this kind in those days and, I suspect, is still dying a hard death in some to-day. Long shafts of sunlight fell through the tall windows; columns of glittering dust. Here I stood to be judged for my beliefs as Socrates was likewise judged for his over two thousand years before. They could not take my life, only my freedom, which was tethered to them as an angry cockerel by a piece of string to his master's stall. Nor would I give up my precepts or my pursuits. They could not offer hemlock, only slow death by starvation or insanity by social disgrace and the mind's dichotomy.

I had been here before. The room was no longer unfamiliar to me nor the faces of my jury as they flung questions at me. They asked with some acidity why I was not doing work of national importance.

'Gentlemen,' I replied, feeling nervous, 'I consider my work of the utmost importance to the nation. No civilisation can exist or be remembered without its artists; they enshrine the achievements of man, his spiritual experience and rarest thoughts in music and paint and stone – words also. If a nation should not use its artists it is doomed.'

My voice sounded very unreal to me and what I said even more so. I could not tell what effect it had on my judges. I was out of touch with the world and had heard nothing of the exodus from Germany of Paul Klee, Marc, Liebermann, Jawlinski over the preceding years. I was only obsessed with getting the Guardians to see the value of what I was doing: even though my painting was not very mature, I was now a good draughtsman.

'If I were a doctor, or a priest,' I went on, 'or a builder of bridges, you would offer me work accordingly. Why should I not be given work as a painter, say a war artist? If a society won't find work for its artists I believe it should keep them so that they can go on working from themselves, making an interpretation of things. This you can't stop, anyway.'

'Then you refuse to do work of another nature, like milking cows?' said a vitriolic little man with a bald head, working his fingers as if on a pair of teats.

'Yes.'

'You were transferred here from Kent. Is that right?'

'Yes!'

'When your wife has had her child we intend to transfer you back to where you come from. This county has no use for you. Do you understand?'

'Yes.'

'You come here to ask for an increase in your present allowance from seventeen shillings and sixpence a week because your wife is pregnant and yet you state quite cold-bloodedly and categorically that you refuse to work. We have no use for you here.'

At this point the kindly man in the high box with the iron grey hair and Schweitzer moustache intervened:

'You do realise there is a war on?'

'I do!'

'What will you do when you are called up?'

'I shall refuse to go,' I said firmly. 'The war is not of my making and I refuse to be part of it.'

'Conscientious Objector!' exclaimed a thin lady, who looked as though her whole concern in life was suffering.

The dreaded phrase was out. I heard it for the first time since World War I, remembering a neighbour being taken off to prison when we lived on Porcupine Hill as kids and those two terrible words were spoken, whispered from gate to gate about the time the Zeppelin went over in broad daylight. This memory suddenly became quite clear, so clear that I was there again and I saw my father in a well-cut suit and bowler hat looking up at the sky; and the strange man from next door

with a boot face and so many beautiful daughters who peopled the dreams of my childhood along with Ethel and mother and my father's secretary, Miss Avocet. Even the leaves against the cast-iron railings were clear and sharp; abnormally so. The memory vanished and I felt the room full of the Guardians of the Poor swim before my eyes. As usual I had not eaten for several days and although I was schooled to this I could not take stock without going dizzy. I must have swayed because the warden held my arm for a minute.

There was a conference between the members of the board and it was decided that, in view of Greta's pregnancy, I was to receive twenty-two shillings and sixpence a week from then on, with a rider that it would be considered in the meantime whether the whole family should be taken into the workhouse where we would both have to work till the child was born, when we would all be transported back to Kent, despite the bombing. This would mean that our child would be born a pauper, which would give him less chance than Mozart or Alfred Wallis, who both died paupers. It cannot be said what fierceness the act of creation can awaken in the hearts of men that they mete out such sentences as these. It was so.

The man in the box banged a hammer and shouted.

'Next case, please!' I was let out.

In the clean air I felt relieved and lighting a fag-end from the corner of my pocket I puffed ravenously at its yellow store of stale smoke and nicotine, which were my only savings from yesterday's parsimonious stipend. The old men watched me from their cage of sunlight, their islands of loneliness, their archipelagos of pain.

During the next few weeks I worked hard on making a portfolio of drawings and canvassed them round the shops and houses, selling one or two for five shillings and seven and sixpence, paying the butcher's bill with a self-portrait, which he preferred to a drawing of sleeping pigs. Other creditors were wary of my offer which distressed me, because after a time the need for both honour and credit leads to split loyalty if there is no income, and this is the thing that drives artists to shoot themselves. Perhaps that is why money is almost un-

consciously withheld by those who have it: it is the only reply to one who, when he is fully grown, has power over the spirit of man, and may account for the fabulous figures paid after he is dead – to gain that power and secure fortune through something whose norm can never be devalued. Whatever the case I had no other way of paying.

The district nurse, who was a vigorous, kind bachelor of some thirty-five years, bought a small painting and arranged an exhibition at the City of Truro, which followed one, my first ever, at the community centre of Carrington-Truth. But sales were more or less negligible although the work caused great interest and was notable for myself in that some of my first pieces of sculpture, which were carved out of stone found in the streams, were exhibited. I afterwards wrapped up the paintings and sent them to various friends of mine among the poor to whose ranks I still belonged, and a particular one of the Mowhay Tree to Bert and Mable.

By doing these things, which were my first attempts at the business side of art, I did manage to gather enough to get some clothes for Greta and extra things for her condition which was a great comfort. But it was no good. The strain of the last three years was cumulative: Greta had no stamina, no extra strength to give to the child. The country people were turning away from me, were reserved and suspicious where they had been friendly. I was forced to the point. I could sacrifice my own life: could I sacrifice the lives of others and, even then, the lives of those yet unborn? Had I a right to ask this of my woman? But whatever decision I made I knew enough to know that there was a deeper, chthonic area of the mind that could erupt like Etna and alter everything – outside my control.

The country people were related to the town's people: they were the same stock; the pattern was close. As the war advanced, their natural suspicion of the outsider grew. I was suspected of signalling to German submarines with a torch from the Atlantic cliffs. I was questioned by the police for drawing in a church at Carrington-Truth, not knowing it was

the headquarters of the LDV. Although locally I was a well-known and familiar figure I was called after in the street, persecuted in the Post Office, heckled in the graveyard. This was aggravated by my name and the fact that I was living on the Parish: living off the rates paid by these good people.

I turned more and more to drawing and painting the things I loved: Greta, the cottage, domestic scenes, insects, animals and life on the fields. At a time of disintegration these things were of great importance, and they were real; beyond them there was a sophistication that was breeding rottenness and disaster. Within them I saw the structure and harmonic miracles of light, the secret rhythms and essences of our inmost life and life of the people. To paint them seemed to be an act of adoration. While I was doing this I was sane and safe and technical problems were yet another lesson in sincerity. But underneath ran the dark world of fantasy and dream, the chthonic soul that belonged to war, the mind was becoming more disturbed as it was pierced by these things, progressively increasing conflict, till I thought it would break down. I wandered from point to point; the anguish was terrible. Lantern played an important part in my life at this time. On the one side there was the vision, the unattainable: on the other there was Greta, the child, society, war – myself trying to reconcile these things in my work. The images became distorted and tall strange creatures peopled my paintings, which, I suppose, were the beginnings of real expression.

I shall always remember how tired and alone I felt on those starry nights when I returned from Lantern's cottage after discussing these things, going home to periods of silent hysteria and violence in which I tore the armchair to pieces with my hands, slowly, deliberately, noiselessly with terrible power: destruction was within me no matter what my beliefs. Then the imaginative world was released objectively so that I saw terrifying images in the room; this had only one direction. As Lantern had so often said – I was going mad. I was going mad because I wanted to go mad. It was the only way out that would give me freedom. I was petrified.

One morning, passing the factory at the top of the lane by the village – the great milk factory that had sprung up like a cuckoo in a nest of robins, devouring the produce of the countryside for miles around – I suddenly turned on my step and went into the manager's office and asked for a job.

19

Outcasts

IN no other way could I have touched the ultimate friendship with the outcasts than by trial for life. They themselves would have understood this, perhaps better than I. It was certainly perplexing. For a moment no one knew who was going to be the executioner and who the executed. Indeed it was the outcasts who suffered in the end – as always. A pity; for me they were such great friends.

I met them first in the factory where I had taken over the great thirty-foot tall boiler. I had been partly trained in a heating-plant company years before and knew enough to try myself out as boilerman, so I told the factory manager I had practical experience and it came off. I got the job. Although I had to shift three or four tons of coal a day with my shovel I enjoyed it and there was still a good deal of time on my hands: it was a long day. Once I had raked the fires through, got up steam in my boiler so that the rollers in the milk-drying plant in the next shed were exactly right, seen that the separators upstairs had the right pressure and the refrigeration plant was correctly served, I still had time waiting about, except when milk was drying and being carried to the sacks on the conveyor belt. I had to be there each time a sack was filled, tie it, stack it, replace it: each full sack weighed two hundredweight. In between these activities I cleaned the brass on the pressure gauges and steam cocks and tested the automatic water pump and the manual injector in case the automatic pump failed. I swept the floors spotlessly clean. On the second stoking I raked the fire bars through and threw shovel after shovelful of coal into the mouth of the furnace with all dampers open so that the air charged through a sudden down-draught, the flames leapt out at me, roaring like a tiger and just licked my face; the tiger I had met in my childhood that lived behind the spotted laurel

bushes in Wells Park and was fed on young schoolboys by the tall silent keepers in cocoa-coloured uniforms and cockaded hats: indeed it was the tiger in my heart. When I had the steam up to eighty and the water low the pump would start working like an old man in an invalid chair with manual rimmed wheels.

I was fascinated by the furnace and often watched through the sighthole at the quivering interior, with tongues of violet, scarlet, yellow and orange flame, flame of peacock blue, of spectrum green and the softest greys and pungent ochres from smoking coals and burning gasses. In such a place the angel surely appeared to Shadrach, Meshach and Abednigo.

I carried with me in my boiler suit pocket a small book by Marcus Aurelius. I found comfort in reading this during the hours when the foreman would have preferred me to find work which was not there to do. It was a secret outlet.

> 'Take care that thou are not made into a Caesar,
> that thou are not dyed with his dye: for such
> things happen. Keep thyself simple, good, pure,
> serious, free from affectation, a friend of the
> Gods, kind, affectionate, strenuous in all proper acts.
> Strive to be such as philosophy has wished
> to make thee. Reverence the Gods and help men.
> Life is short.'

A passage like this read in a short time and then memorised could be a source of meditation for a whole day behind the hours of work and of idleness, and no one could tell what went on in my mind. I felt protected. As the days went on I felt that taking a job had done me good and I was happy. I had slipped back inside the perimeter of society, outside which it is so difficult to continue without lunacy and death befriending one: unless it is a Christ Man, and then society will at once destroy him. I found pleasure in doing my work and in going home to Greta with enough money for food. It was she who was grieving because I was not painting. For me it was a relief not to be able to. The torment left me. This was a time of respite. The battle would be resumed later. I had not given up because I was committed – and blooded by the gods.

Each painter knows the demands of visual observation, and the compulsion that exacts an interpretation. They go on all the time both at night and in the day: perennial. Although the laws of necessity had forced me off the track I could not stop looking: the sun falling through the boilerhouse doors and the shining fields laying down like green and golden girls in the sunlight; grazing cattle, men at work, birds in flight.

The Cornish custom of croust was the same here as on the farms. Every morning at ten o'clock I got out my flask of hot tea and my heavy cake and sat down to enjoy them with a page of Marcus Aurelius. I threw a crust or two to see if the birds would come in through the boilerhouse door. But no; they were wary. One morning I was startled by an animal running in to take the crust; a rat, about the size of a kitten. I remained still, making my mind recede, then gently threw another piece of bread. The same thing happened; the rat ran in and took it. Then I threw two pieces and two rats ran in. After a while they became less cautious. I put the bread on a ledge, but they seemed to know and after trying all manner of ways to reach it, jumped from another brick ledge in the wall a little higher and landed beside it. The many ingenious ways they tried to get the food each time I altered the pattern completely absorbed me – and how they used their long rough tails, which they seemed to be able to stiffen like files or to use as a prehensile limb. I got into the way of talking to them and quoting bits of my beloved writers of ancient times.

'Take care that thou are not made into a Caesar,' I said to them, 'that thou art not dyed with his dye: for such things can happen.' They would stop and listen but made no reply; at least they listened.

> 'Thirst not after knowledge, I have none
> And yet the evening listens . . .'

sang Keats and he knew how things were interwoven: the blackbird's song with the soul of man and the more passive soul of evening. Why should not two friendly rats thus listen to me, who was lonely and urgently in need of a sensitive ear!

In a few days they were not even careful or afraid. I was able

to move freely but only when my mind was recessive and my emotions still. If I was upset or had any strong feeling they went away until I was quieter: or if I made a sudden movement. Otherwise they came right up to me to take the bread, brushing my hand with their long whiskers. I was glad of this growing companionship. They came to recognise me and sniffed the air to see if I had not been changed. When the meal was over they sat up on their hind legs to clean the butter from their whiskers with their forepaws and I could see how long and sharp and curved their claws were for climbing trees and posts or any high obstacle. The sun glinted on them, showing the pointed hair, the little, oblong garnet eyes, the pale feet. It shone through their petalled ears turning them pink, showing the little blue and red veins. Their long cold tails slithered along as they darted about collecting the last crumbs, helping them to turn quickly.

As time went on I became part of their lives and they part of mine. We met at certain hours, fed together, felt together, talked together. There was an instinctive tie and they were so close some days they knew what I was thinking.

My two friends lived down a mine shaft which was in a field at the back of the factory. It was common for a shaft to be open even so near the town; the landscape was honeycombed with them. Often cattle were swallowed by them and sometimes a drunken man, falling to death in the dark bowels of the earth. In the evening I watched the two rats make their way to it over tufts of grass between clumps of spikey burdock and bits of broken machinery that littered the place, and disappear from sight. I thought of them making their way down galleries and pathways they had known for a long time, like the steep goat tracks on the cliffs, running over and along and through natural formations, descending to where they had their holes and most likely their families. Probably there was a complete city of tunnels and streets of their own. Last thing, the foreman often came down with the swill from the separators in a bucket and poured it down the shaft, using it as a refuse dump, but of course not thinking of feeding the rats. 'Or was he?' I asked myself.

When I was a boy I watched, out of the school dormitory window, rats taking eggs from the chicken run. One rat lay on its back with an egg between its forelegs and another rat pulled it along by its tail. Did these other rats, the ones I saw now, do such things, I wondered? If so how did they get the egg down the mine shaft? Unless the elaborate spiral roads and tunnels were more intricate than I thought. One of the masters at the school used to shoot the rats with an air gun. I remember the thud of the pellet hitting the soft body; the rat laying on its side working its legs slowly, blinking its eyes, bewildered. He must have hit the heart each time. It did seem man's hand was turned against them: probably because he had never forgotten they carried the plague – although these were brown rats on whom the plague flea would not live. But then these things, like so much else we fear, are unconscious. I felt no such animosity to these shadowy creatures who lived on the perimeter of my life and became close friends with whom I shared the wisdom of a sad Roman emperor.

War and destruction are always with us: it is the degree of shadow obscuring a planet that determines the degree of light. In this way we can assess the forces of evil. My rodent friends would seem to have been outside these things; unaffected by them. Are they only man's concern: this good, this evil? I wondered: still wonder!

The forces that had been unexpressed in individuals during the last twenty years, the dreams that had not been understood, the love that had been unfulfilled, now gathered in a dark sea of blood, as the wine had gathered, and surged towards the future. When war is upon us it is everywhere dark and ominous, as though under the shadow of eagles.

One morning the whole staff was called to the manager's office. The manager was a little man like a wooden doll whom I called Pinocchio. That name will do him for all time. He gave a short address to the workers, who were all local men save myself, and each was asked in turn to join the Local Defence Volunteers, which was father to the Home Guard. When it came to me I said 'NO!' just like that, and everyone was silent. Pinocchio turned red and wrote something down and, as I was

the last one, we were dismissed and returned to our jobs about the factory. In itself this seemed unimportant. There was some discussion by the butter churns and later in the drying plant, but I did not take part and they went silent when I passed. Otherwise everything went on as usual for a few days until Pinocchio caught me feeding the rats, which, in a milk factory, was very much against the rules; I was surprised he was not more angry.

'Have you nothing better to do?' he said.

'Yes, of course, Sir!' I answered, feeling awkward at being caught and in being so much taller than he was: it made me feel small, somehow.

'Filthy things!' he said, marching off.

The next day I was delegated to the milk platform where the churns came in from the surrounding countryside and I had to unload from the lorries and empty them. At first this was a harsh place and hard work, but I had learned the technique of handling heavy weights when I was a dancer so it was not long before I had the job in control. It was a new experience to have a liquid load and to spin the churns with one hand as I used to see the men doing on the railway platforms when I was a boy. Had I not spun a woman?

There were two vats: one large one for the milk, which six men served, and one small one for the cream which I took over after the first week and worked alone. It was not such heavy work because the churns were smaller and lighter to handle, but I found the rubber pipes covered with cream a source of repulsion and I was thankful when it was all pumped upstairs and I could scrub down the area in which I worked, take off the great yellow oilskin apron, and return to the boilerhouse with its quiet austerity and warmth. Being away so much, the balance of steam and heat was never so well poised as before and my brasses got dull, the automatic pump failed more often. There was no central control and what I had prided myself on being expertly done was now second rate through no fault of my own. In consequence the heat in the rollers in the dried milk plant was uneven – a lot of the skimmed milk that was running over them failed to reach the right state and was wasted under

the machine, which made me dissatisfied and brought com-
plaints. There was a growing restlessness among the men, a
growing unfriendliness. I kept more to myself. My short span
of happiness seemed to be over.

One morning after the platform was finished, I was in the
boilerhouse watching the two rats play in the sunshine when
I was aware of a door opening behind me and a man standing
there. I turned and faced him. Like all spokesmen of this kind
he was awkward and seemed afraid. Perhaps also, because we
had been friends in the first day of my coming there. Behind,
half in the shadows, were the rest of the men: sheepish as
individuals, angry as a crowd.

'Yes,' I said. 'Do you want me?'

'We do,' said the big man, looking grave.

'What for?'

'We are going to put ee on trial!' he answered.

'On trial? In what way?'

'For your life, brother!'

'*My life?*' I said astonished, going cold down the thighs.
'What on earth for? I don't understand!'

'Do en now!' shouted one of the men. 'Chuck the bugger
down the shaft now!' By which he meant the mine shaft. But
the big man moved his arm and shoulder, barring them from
coming forward with his vast hand. I was then marched off to
the canteen where a court had been set up with a table and three
chairs at one end for the Triumvirate. I was stood in the centre
of the room facing this, with tables all round. Big Man sat in
the centre chair with a vituperative, smaller man one side of
him and one with crossed eyes the other. He seemed enormous,
like Watteau's 'Clown'. He had that same solemnity and I felt
that perhaps in his soul he may have been protecting me against
the Devil. He asked my name and I replied.

'You are charged', he went on, 'with refusing to take arms
in defence of our community in time of war. If you can't give
we a satisfactory answer to this state of affairs and a good reason
for this attitude, the tribunal will order that you be thrown
down the mine shaft in Dan'll Widden's field, backalong. So

'elp me God!' The crowd shouted and banged the tables as Big Man sat down with his two triumvirs.

After this solemn introduction there was a lot of unpleasant heckling and requests that I should be executed on the spot. And there were shouts of 'Coward! Traitor! Bastard!'

The situation had grown up so suddenly it was like a dream for, although from their point of view it must have been going on for some days, I had only now become aware of it. Everything in me tightened, and as is often the case in the midst of unexpected danger I felt integrated and unafraid, with a cold sensation in cheeks and forearms; but helpless also. I knew I could only feel my way slowly. If I lost my temper all would be over, for although I was strong and could account for two or three of the men I could not expect to take on the whole factory: it would have been a bloody business if I had and I might not then have lived anyway, the latent violence was so great.

But how could I talk to these men of the Tao and of the Field of the Square Inch, the Square Without Corners, the Uncarved Block, the Inner Voice? Would they ever understand? It would sound pompous and highfalutin' because its meaning, though so simple in essence, was incommunicable in these circumstances. They were staunch Methodists for the most part and the fires of the Old Testament still burned in their primitive souls. This was a good thing in other ways because if I said anything unusual it would not seem so to them. The only thing I must not do was become intellectual. That is always death and it was for a death sentence I was being tried. God forbid that I should insult them in this way. These were simple honest men and like the crew of seamen who found Jonah on board their ship, they felt there was one among them who had the evil eye. If necessary they would throw me into the shaft as Jonah was thrown into the sea. I felt inarticulate and my mouth was dry, but in a little, when things started to go quiet, I heard myself speak. It all sounded terribly unreal. I quoted Robert Browning, hoping someone would remember him.

'In Queen Victoria's reign,' I began nervously, 'there was a

poet called Robert Browning.' Everyone stared in blank un-comprehending silence. 'Among other things he wrote some marvellous words which should apply to each of us.

> "There is an inmost centre in us all
> Where truth abides in fulness!"

'Now this centre contains a voice and it is to this voice I listen. It guides me through life, it advises me. You might call it the Voice of God: I call it the Inner Voice. It tells me to create and not to destroy. To love and not hate!'

'Animals destroy one another when they fight!' shouted someone.

'Evolution,' I answered, 'has given us a choice higher than the animals. We can choose for ourselves.'

'So you der believe in h'evolution?' said Big Man, looking self-conscious.

'I do!'

'But the Book der say,' broke in the triumvir with crossed eyes on the right, 'the Book der say this: that God made the world and did place Adam and Eve in the Garden.'

Here the left-hand triumvir, with a pointed nose, interjected.

'Ayse, and already rigged up with body and soul, my 'ansom; like the Creator hisself. In his AMAGE, you!'

Someone broke in with obscene remarks about the goings-on in the Garden of Eden, but I was glad of this because it leavened the situation with humour and gave me a chance to sense what might come next. No amount of argument would convince them, but there could be a moment when the silent communica-tion that takes place outside reason and words might happen.

'Adam didn't 'arf like 'is crumpet, you. Apple and all, mind. Cor she was 'ungry bitch too. 'Spect 'e were wore out 'arf the time and the other 'arf on the job: that's how the snake gotten.'

The men laughed and thumped their feet on the concrete floor. About this there was something terrible, perhaps because of the magic and poetry of Eden, but I had not learned to link things up: that the apple of consciousness had wrecked forever the everlasting peace. What hurt me now was the bite of the same snake by which I must be slowly cured. The worst thing

was the soullessness of the concrete room and the hopelessness of the unlit mind; I don't think they cared what was right. The only thing was to convince them of my sincerity. When silence returned I endeavoured to go on, treading carefully forward until I realised the only possible way was to find a common footing; but it must come from one of them. I paused again, sweating. Then almost as though Big Man had divined this, and wanted to give me a way out, he said:

'Do ee believe in God, Mister?' There was a dead silence. 'I do!'

As I spoke these words I felt the tension leave the room, and knew I was safe, because Big Man, in his simplicity, had found a clear focus by which each of us could see. In the face of this the uninspired went quiet. Had I said: 'No!' I would most certainly have been sentenced to death at that moment.

Big Man conferred with his triumvirs and after smashing his hand down on the table to command silence like an Old Testament God, he announced that the verdict of the court was that I had been reprieved and that I was free to go provided I did not hatch any evil against my fellow men.

Some dissenters still called for my execution down the shaft which made me wonder what they had intended to do to me before I was cast in. In some ways the whole episode was so much like Jacob with the coat of many colours being cast into the pit by his jealous brothers. Others taunted me with homosexual insults and jibes, but Big Man, who had tried me, shook my hand and to my astonishment said:

'Good luck to ee. I'd be a conscientious objector myself if I 'ad the guts.'

After this experience I felt shaken and spent a long time in the afternoon sunshine watching and talking to my rats.

> 'Take care that thou art not made into a Caesar,
> that thou art not dyed with his dye: for such
> things happen.'

Until the time came when they gambolled off through the rough grass and the rusty machinery and noble burdock to the shaft which was so near to being my grave. As usual the men

came with the pail full of swill from the drying machine and the separators and tipped it over the edge. As they came back through the boilerhouse one said to me:

'Good job you weren't down there, my beauty!'

'How come?' I said.

'Because the swill is not what it belong to be. It's dosed with carbolic acid and strychnine. Old man's orders!'

They went on their way laughing. I never saw my two friends again.

Feeling sick and sad I raked the furnace through, extracting the clinkers, and damped down with wet ashes and coal-dust for the night so that the fire was right up close to the fire door. I closed the damper. Then I returned to my empty cottage, for Greta had been taken to hospital already with early labour pains, which had subsequently stopped. My paintings on the wall, one of a pair of dancers, seemed remote and away from the world I now knew. I went to bed and read for a little.

> 'The dark power at first held so high a place
> that it could wound all who were on the side of
> good and of the light. But in the end it perishes
> of its own darkness, for evil must of itself fall
> at the very moment when it has wholly overcome the
> good, and thus consumed the energy to which it
> owed its duration.'

I fell asleep. Some time later I was wakened by a hammering on my cottage door and shouting as from a disturbed ghost who sought comfort by entering my home. But no: when I opened the door Pinocchio stood in the winter moonlight with Big Man.

'What's wrong?' I asked in dismay.

'Hurry, hurry!' shouted Pinocchio. 'The boiler. The steam is up over eighty degrees and the water is low!'

'What about the pump?'

'It's jammed!'

'The injector then?'

'No one can work it. Another fifteen minutes and the whole lot will go up – factory, village, everything.'

Pinocchio was waving his wooden arms above his wooden head in utter distress and Big Man rocked slowly from foot to foot like Frankenstein's monster. I slipped on some clothes and ran with them to the factory, which stood against the sky, intense and silent. All the lights were on and in the boilerhouse there were several workers discussing what to do, but no one doing anything though time was so short. I opened the fire-door to find a full hot furnace. How could this have happened a few hours after raking out and damping down? It seemed impossible. I suspected sabotage but there was no time to deal with the causes now. The pump was, indeed, jammed, never to work again. I had indented for a new one several times, but nothing had happened. Perhaps this would bring sense to things. The water was right down. I dared not rake the fire out for fear of the new air rushing in and combusting, increasing the heat. I shut the main damper down, which, to my dismay, was wide open; and closed the fire door.

'What are we to do?' whimpered Pinocchio, almost in tears. 'Work the injector,' I shouted. 'That's the only chance to get water into the boiler – and quickly. Otherwise we explode and everything goes with it. You had better tell the village,' I shouted, 'and the rest of the night staff!'

I climbed quietly but quickly up the hills of coal to where the injector was fitted on to the side of the boiler: as I did so every man silently left the building until I was left quite alone: there was no one else at all. But I was glad, because here was a gigantic force pent up and only quietness and absolute calm could conquer it.

At this distance in time I am not sure how the injector worked but I know that I had been shown by the foreman when I first came to the factory and had operated it successfully, but after great difficulty. I recall two pipes running up the side of the boiler and at the point where I was they turned horizontally with the mouth of each facing the other; a gap between. Each had a cock. I presume one ran down from a water tank at the top of the building and the other ran up to the top of the boiler where the steam chamber was. By operating the cocks the steam sucked the water across the gap and injected it upwards

and into the boiler on a syphonic principle. At first there was nothing but a frightful noise, a glut of cold water pouring over me and angry hot steam sucking the air. The boiler itself was tense with power, giving out an enormous heat; the steam had gone up to well over the red safety mark and the water gauge down to nil. The only comfort was to know that by now the fire was suffocating with the damper shut. I tried again and again to get the exact ratio between water and steam. My nerves were tense, my face burning against the hot plates.

Almost a prayer of concentration followed and, as I turned the left cock, I saw the water leap across the gap from one pipe to another and be sucked up. Then it broke, belched, spat, dribbled, vomited, discharged, egested, disgorged, spirited, squirted, spilt, slopped and finally stiffened into a silver rope, upwards into the womb of the boiler in a steady unbroken flow that sounded a single note of safety and triumph. In a little while the finger on the water gauge began to move upwards and the needle on the steam fell back till it was behind the red danger mark. The pressure grew less at every second and one could feel the atmosphere letting out its tension as it had in the canteen that afternoon.

Gradually the men, who were no longer afraid, came back into the boilerhouse. I climbed down from the hill of coals, black and wet and very tired, and walked through them, taking no notice of their remarks, into the milk-drying plant at the side, where the great machine with its wet rollers stood like an elephant that had been sick on the floor, amid the swill with which the rats had been poisoned.

Pinocchio was at my elbow with a sheaf of papers in his hand waving them at me and saying I must be more careful in future and be sure I damped everything down properly and maintained the pump. Through my carelessness I had nearly blown up the whole village.

I lifted him by the lapels and shook him.

'You stupid little bastard!' I said and dropped him in the stinking mess of milk and curd under the machine, then walked out.

The night was cold and starry, with a far-off silver moon

and just between the fold in a hill I could see, like a sleeping giant, the steel breastplate of the Atlantic.

At the corner of my lane leading to my cottage there was a kiosk. I called the hospital and they told me a son was born to Greta. A surge of wild delight cascaded through me. I ran under the stars waving my arms: the gorse bushes against the sky seemed to do the same with a silent spiky sort of laughter that pricked my heart and made me cry. I did an *entrechat* over the moon and a pirouette round Mars. I ran to Claudius Lantern's cottage because I had to tell someone of this marvellous event, but there was no one in, so I hammered on the door of a labourer's cottage nearby until he lit a lamp and came down.

'A son is born,' I shouted. 'I have a son!' He did not seem to comprehend. 'Aw ayse! Ayse! Aw ayse!' he said in his Cornish dialect and stood staring at me. Realising there was no way through I went home and made some cocoa and smoked a fag-end till the dawn came.

Twenty-five years later I heard by chance that Pinocchio had died of a rare liver disease only contracted from rats. I hoped it was true.

Petrified Forest

WAS it withdrawal from life that made the trees fall, I wondered? I leaned gently against one of them, there was a silent crack, a grunt and it toppled down the ravine to where the river tore the landscape open on its way to the sea. I pushed another with the butt of my hand, then another with my fingertips and they followed the first. It was as if a sudden power had been given me. I could fell mountains, take down suns, alter oceans; perhaps the strength of the forest had passed into me. And I felt tall, as if levitating over everything.

This went back into childhood. I remembered a dream in reverse to this when I had fallen through a magnifying glass and been terrorised by tunnel spiders and gigantic beetles as large as dinosaurs: the time a ladybird had saved my life. All these things, like a sculpture by Marino Marini of a man falling from a horse, are something more than paranoia: they are emblems of a falling world. I who could push a tree into the abyss had climbed from the abyss during that morning only to find a petrified forest, as though the devil had cast his spoor on it. The only true life was in the river racing below and in my strong body dancing through the forest like a demon pushing them over for fun, as in a symbolic part of some ballet. I ran laughing from one tree to the other till they crashed and splintered all around me and went hurtling downward to the valley. Voices echoed everywhere till they became one voice. I descended the slopes again to listen. It seemed to come from the water and then from the rock and then again from the air around me. On the bank was a girl with fair hair. She turned and looked for a moment with burning blue eyes and then walked away and dissolved into the trees. I was reminded of the day I had met Greta at Lyme in the early morning. At

certain times in life the spiritual image a man carries of a woman, it seems, is projected outside him; probably most vividly when pressures have been at their most intense. I shouted out but she didn't stop; only her song stayed but grew fainter.

> Come, my fair man
> To the rock in the water,
> Breaking the trees
> Your strength has all gone:
>
> Come my fine man
> I'm love's golden daughter,
> Be lover to me
> And child of the sun.
>
> Come, my fine man
> I promise to love thee,
> Broken the tree
> Your strength has all gone:
>
> Come my fair man
> My loving will prove thee,
> Be lover to me
> And child of the sun.

All day I walked in the petrified forest among the dead trees hoping to find her, and most of the time I could just hear her voice; at least I thought so, though sometimes it was indistinguishable from the breeze. Later in the afternoon I found the path to the little Devonshire town where I was staying in a big house with a community of pacifists.

The birth of my son had forced me to withdraw from the single-handed fight in the cottage in Cornwall. Trouble at the factory had decided the issue and I had no wish to return. That was over, although I knew I could have been exempt from military service by staying. Anyway, Big Man took over my job, so perhaps that explains why things went that way.

This situation precipitated my official appearance in front of a Tribunal, headed by a High Court Judge at Bristol. Although it was not so frightening as my trial for life at the

factory, it was in its own way more devastating. Standing in that high stone room at the university with tall windows recalled the workhouse at Carrington-Truth and the Board of Guardians. After reading my defence the judge said:

'Tell me: what gives you the prerogative of the chosen one that you will not fight with your fellow men to protect your King and Country?'

'I listen to my inner voices as Socrates listened to his and Joan of Arc listened to hers,' I replied.

'Yet,' snapped a professor who was at the right hand of the judge, 'both these people were soldiers. Joan is remembered because she fought for France – *her* France. Socrates for *his* Greece.'

'That is not true!' I replied. 'Both followed the inner voice and both obeyed their gods. Socrates was a good soldier but he was remembered for his teaching and because he died for his beliefs.'

'Are you willing to do that?' asked the judge.

'I am!' I replied. There was silence in court.

After conferring together the judge ordered that I should do agricultural work as the condition of my exemption from military service. I was not too troubled about painting because my rigorous self-discipline over the last three years had built into me the laws of drawing and something of the laws of colour and light. It was often good to lie fallow after an intense period. My innate single-mindedness would see to it that I did not give up. In any case I had learned that art could only be enriched by life if in its turn it was to be enriching. Everything was absorbed into the one purpose.

It was the condition that worried me. The farms in Cornwall were mostly family affairs and many sons returned home when war was declared so that they would not have to fight. There was no room for me. I dared not go to the Labour Exchange to draw the dole because the Agricultural Inspector would then know I was not working and was therefore breaking my condition. The penalty for this was prison. Perhaps going on hands and knees to Pinocchio would have got my job back, but being the sort of person I am I would not do that. With a

child it was no longer possible to face starvation and, although I now had stamps, I could not use them. The workhouse had threatened to send us back to London where the bombing had started, so the Poor Law did not function either. I had a triple problem: being an artist, being a pacifist, and being a father: I could not find an answer, until someone told me of a pacifists' community in Devonshire where we could live and work on the land till the war was over. We moved out of Cornwall into Devon where the round hills and red earth were warm and friendly even at the beginning of winter, and the people were broad in shoulder and heart, with the hardness, not of granite, but of limestone: in that way they had their truth, carrying in their innermost hearts images of earliest times, not without wisdom from the sea, so hated by intellectuals and scholars of our time.

I managed the last apple-picking and a little winter hoeing but that was not enough. The community I was with had bought a plot of land to cultivate but there were far too many of us for it to carry. I had to settle for a job in a coal yard: because they dealt also with sacks of corn that was legitimate; I was classed as an agricultural worker. The owner of the business was a nervous down-trodden little man with a fair moustache. He seemed to live in his office doing his books and insisted on calling me Paul because he could not pronounce my other name. His wife, on the other hand, a Cornishwoman, strode up and down the balcony overlooking the yard, shouting at the men to work harder and not to hang about smoking, to which there was an inaudible volley of obscene retorts.

My first job in the morning was to go to the station with a lorry and a mate and unload, by shovel, twenty-ton trucks of coal that were waiting there on a siding. This took several journeys back to the yard. Each time the wild Cornishwoman screamed from the balcony that we were taking too long, and if we paused to light a Woodbine she waved her hands in anger, shouting us on to work, to which we politely replied: 'Bollocks!' making her more mad than ever.

There was an exhilaration for me in the hard physical work, even though I was black as the Devil. It awakened the tiger

that had slept since my dancing years. And the warmth and humour of working with other men was something I always enjoyed, save at the factory: there I preferred rats.

After I had filled the yard it was my next job to fill a huge shovel-scales with a hundredweight of coal and tip it into a sack. The scale was high up and each time I tipped it I had to hold the sack off the ground to save spilling the coal. As I took the shock of the weight each time, the coal tore the side of each index finger till it was grinding the coal dust into the bleeding flesh. This slowed me down, increasing the complaints of the Cornishwoman. I was glad when the afternoons came and I went in the lorry to deliver to the big houses, save when it was raining and the coal dust ran down my neck in a black gritty stream of cold lava. Even then I found that, the more powerful and black I appeared, the more the kitchenmaids flashed their eyes; but they were wary with me, perhaps because I wore a beard. If I spoke they were even more uncertain. I never had a countryman's voice, only at one time Cockney veneered later with the Oxford voice because I thought it would help to find me a job in the early days of the twenties depression; it degenerated later to a Third Programme voice without knowing, for one is always silent to oneself. This was regrettable, not only because I frightened away the pretty kitchenmaids and I could not get them in the coal cellar, but also because the richness of a good voice grows out of its own earth and should not be imitated. At this point I could only imitate my origins, they were so far away.

This work went on until one day I was carrying a two-and-a-half hundredweight sack of corn up some stone steps to a barn. The sack was not set quite centrally down the length of my spine and slid sideways. The muscles I had injured so badly on the stage were torn again with agonising pain and I had to be helped home to lay on my back for three weeks. It did seem that I projected these situations so that the community would keep me and my family. It fell to the lot of these dozen pacifists to do so with extraordinary patience and generosity.

They were a kindly lot, but I always remember them quarrelling a good deal among themselves: where religious

tolerance was practised a wall of nervous tension and animosity was built up, for they were not skilled in the arts of meditation and poverty. There was a blindness to the destructive forces within themselves as well as to those in the outside world, because it was the world that was bleeding from the heart of each man. The result was that one was blessed and cursed in the same breath. Only one forthright preacher who was young, plain, transparently honest, seemed to hold a light within himself and walk with God. There were a pair of sophisticated and very kindly painters who lived together in one room. They took a womanly interest in everything that went on and interpreted it with piercing wit later in the pub: an attractive, fair woman who was a writer and belonged to the Bursar and a strange man – a poet – called Esau, who looked like the fawn in Piero di Cosimo's *Death of Porcis*. Upstairs in the attic lived a neurotic Christadelphian who played the violin to keep away the evil spirits.

I lived in a single room on the ground floor with Greta and the boy, so that one was involved in domestic disorders which would have been better avoided. I attempted to paint in bed but that was no good. When the Goddess becomes a housewife with children in bad conditions her spirit transmigrates to another shrine, and it is her man who projects her there: a sad truth but a solid one.

Outside it was snowing. Through the window I watched the people go up and down the street against an old red wall that carried a warm history in its bricks. The colour of their clothes stood out and seemed more luminous than in ordinary lights. Yellow of sulphur, blue of beatitudes, red of Spanish muleta, brown of hill and horse: Devil's black. A gay but quiet procession of people absorbed in themselves and in the uncanny silence of the snow. The black iron railing stood out against the white lawns of the church, like a sentence by Gogol. For some reason I was thinking of the girl I had come to call Lorel and thought I heard her strangely simple song. Upstairs I could hear the Christadelphian playing Mozart rather beautifully. Greta was feeding the baby; I could hear it suck and could smell the milk. Her position with her head hung forward and

her legs spread like columns supporting the child, was monu-
mental and ancient: an archetypal image that I would one day
carve in stone. It was out of this dark struggle that the art
was coming. I did some drawings of her.

The interpenetration of images and of experiences resolved
themselves into a complex aggregate which can only be seen
as a complete single image at a certain moment just outside
time – it is the image you create as you draw, crystallised for-
ever, such as it was with Greta brooding over her child, her
hair falling forward in the shadow and her once beautiful hands
guarding its frail being. The dancer transformed into a mother
in stone. I carved this years later.

Perhaps this was the emergence of the sculptor's vision as
distinct from the painter's or the writer's: I was seeing form
for the first time consciously in a physical mass outside myself
– in stone. Coming as it had in a direct line from the dancing
world where one is a living sculpture in space, through the
physical experience of working in the fields, the factory and
coal-heaving, pushing down trees, touched by the poetry of the
Lorelei, I felt strangely stirred to work in this way: to use my
hands cutting the image I had created from the physical world
and so adding to its phenomena a new image: this, it seemed to
me, was art.

While I was still working the door opened and the thin
haunted figure of the Bursar came in to ask how I was and to
tell me there was a job going in a girls' school at the other end
of the town – as gardener. He said it would fill the official
requirement because there was a kitchen garden which supplied
the whole school and the gardener would have to look after it.
I knew very little about gardening but it seemed to me a
reasonable way to earn a living with a certain amount of
freedom, besides which I was anxious not to be too heavy a
burden on the little community. My back was a good deal
better after three weeks' rest and it would be good to get away
from the noisy house during the day.

At that moment the preacher went past the door shouting
and smiling at the same time, all teeth and glasses:

'Christ is here. Let us rejoice in the Lord. God be with you!'

The two artists in the background, playing chess in the far room, smiled knowingly to one another. The Christadelphian went on playing the violin, and a visitor, who often came up from Cornwall, wearing as always a strong tweed suit, a collar and tie and a pair of good stout brogues, short hair, was listening. It was all rather like a hurdy-gurdy starting up with its grotesque revolving images and supporting music. I had the strange feeling I did not belong in this place where a few members of the immature had gathered. None of these people had touched the harder edge of life. Somehow there was a good deal of violence locked up here. I felt this particularly when I heard Esau shout upstairs at the Christadelphian to stop that bloody awful noise, and the good lady scream back like a macaw that she would do nothing of the kind.

'And I'm trying to finish a bloody chapter of my book, you noisy bastards!' shouted the fair wife of the Bursar, leaning out of her door and lifting back her short heavy fair hair with her hand, giving me a quick smile. 'I can't hear a word!'

'Peace. Peace be with you, Children of God! Peace be upon you!' shouted the preacher.

'Balls!' said Esau, laughing to himself. 'Go an' get stuffed!'

Then my son started to scream his head off which ended with loud farting and a warm brown smell, upsetting Greta who had just changed him. In a moment it seemed the whole house was in an uproar. Looking up I saw Esau sitting on the back of an armchair like a gnome, smiling to himself; he had set it all going and no one knew how or why. It was his private hobby. He lit the spare emotions and waste gases of each human being when they were gathered in one place. He was a catalyst.

At the school where I went to work as gardener there was an Elizabethan walled garden in which I planted some purple-sprouting broccoli among the artichokes and, as the season matured, other miracles of growth, all by reading the instructions on the seed packet or asking the person who sold the plant and so on, beside a little experience from when I was working with Bert. Here, above all things, was a medieval peace which I shared with the roses and the trenched earth where I attempted asparagus. My tempo settled to a slow pace of contentment and

I could not think of anything better for the duration of the war. Nor could I think of any possible event that could dislodge me. As the cycle of the seasons came into control it was without apprehension that I conducted my lonely life under the juniper tree while the quiet intoxicating afternoons turned to evening and the shepherds left their rose light in the sky. It did seem that I had found a harbour for a time. This gave me time to meditate on my situation and assess what I had done since I gave up dancing and left London. At least to some extent – more than I realised at the time – I had gained my skills and mastered them.

It seemed to me on reflection that I had become a pacifist by chance, not so much because I disbelieved in killing but because I found myself involved in a war which had no real meaning for me, as a man might travelling in a foreign country. On the spiritual quest I was at the opposite pole to the economic one. I knew nothing of the horrors of Germany, for evil wears its own cloak. Yet the conflicts I had been facing were as much a universal pattern as a personal one: that is why I could not escape, even though I was a creative man with as high a respect for the construction of a dragonfly or a spider in his web at morning light across the apple tree, as I had for a man – though the insects were not perhaps so Luciferian. I wanted to make something beautiful in this way – one thing – for all time. That was my answer to death and destruction. But I was to see that in this truth was hidden the one way to bomb my own city, that I would have to be a whole civilisation unto myself to achieve this end. This, in the flux of time and eternity, was only possible by itself unless I could reach the spiritual heights, which I had proved I could not. To be a painter I had to be a complete man and touch evil before I could conquer or understand it: otherwise I would be destroyed. This was the other face of God. Thus far I progressed in my meditations.

The garden progressed also. On the wet days, while it grew, I sat in the gardener's hut cutting 'Nickey Wood' for the school: so called because it was originally used to light fires to keep away the Devil – and he was abroad to-day. It was a good occupation while I was thinking things out or just

training myself not to think at all, which was far more valuable.
The spears of rain fell outside, imprisoning the still trees and
lawns and the dripping roses: but it did not keep destiny away.
Far from it.

One morning a shadow fell across the pile of wood in the
centre of the floor where I was chopping. Lifting my eyes I saw
someone leaning against the jamb of the door looking down
at me, her fair hair falling forward.

'*You!*' I said, almost without breath.

'Yes, me,' she said simply. 'I've been several times to find
you but you have always been out.'

'I saw you in the wood – the petrified forest where the trees
fall over. You were singing a song; a strange song it was. It
has haunted me ever since, only I have no musical memory and
I could not repeat it. I am the Silent Man. Do you remember?'

She started to sing, very gently – almost a whisper, almost
as though she was a projection of my mind after all; almost as
if it were the breeze.

> Come, my fine man
> To the rock in the water,
> Felling the trees
> Your strength has all gone:
>
> Come my fine man
> I'm love's golden daughter
> Be lover to me
> And child of the sun.

Her voice trailed off as the school bell rang and she was gone.
That was it; a schoolgirl of seventeen; a woman for all that.
After that she got to know my times and visited me often.
She did not seem able to stay away and when I asked her not to
come any more because I was falling in love with her, she
simply smiled in my face with those marvellous blue eyes and
kissed me till I was silent.

This went on for several weeks until I became troubled even
while I longed to see her. One learns later that when love's
poetry enters unbidden it should be treated as a gift from the
gods and taken with both hands, as a Gypsy friend of mine

once said. For some reason the loyalty to family was always strong enough for me to hesitate about this advice and with a ponderous self-righteousness that often goes with truthful behaviour, I went to the headmaster and told him I must leave. Apart from this the community with whom I lived got to know and it was uncomfortable.

The headmaster was a garrulous old man with steel-rimmed glasses and a secret but not unworldly sense of humour. He wore the glasses on top of his bald head and a green waistcoat covered with stains under a long countryman's coat with large pockets.

'Leave? Leave, man? You're mad. You can't leave. I won't let you. Just as everything is all right and the garden is going well. I won't hear of it. I thought you were happy here. What on earth has made you change? And how am I going to replace you in wartime?'

'My health is not too good,' I said rather lamely.

'Nonsense. Never seen anyone look better. I am an experienced man,' he added, quizzing at me over his glasses as they fell down from his bald head. 'You are hiding something, aren't you?'

His gaze was keen and I felt like a transparent schoolboy again. I made more excuses and in the end I could see no point in holding it from him. I told him about the visits of Lorel, which is the name I had given her, and how I had grown to love her in spite of the fact that I had a wife and child at home at the other end of the town. I could not help myself. It was necessary for me to go away.

The old man became silent and quite serious for a time with one long finger resting down the side of his nose.

'Oh!' he said after a time, 'I didn't know that. I don't blame you. But I do understand how difficult it must be; how you must feel. I will talk with the girl. No. Don't worry. She will come to no harm. I will not punish her. You don't punish young people for things of the heart, young man: that would be quite wrong. You help them with as little pain as possible. It is good of you to come and see me. Er – nothing has happened?'

'No,' I said. 'Not yet.'

'It will though?'

'Yes. Of course!'

He puckered his brow. 'Don't worry. That will be all right. I will see her after supper this evening – but only on condition you go on working.'

I consented to do my work in the garden but when it came to it the days were long and arduous and I fell into a depression. She came no more to sing and talk to me.

> O what can ail thee, knight-at-arms,
> Alone and palely loitering?
> The sedge has withered from the lake
> And no birds sing.

This was indeed *La Belle Dame Sans Merci*, who had left me to eat out my heart: the image of all northern love and when she appears in Greece or Syria or Spain she is of divine status – half goddess, like Helen who was daughter of Zeus. She was the Ice Maiden, Queen of the Snows. Oh, and the fateful Lorelei. How could I compete with the golden images of history come into one form, merged also with my father's secretary, Ethel the domestic help at home, Greta as a young girl dancing in the lights of London and Wigan and the lovely fishergirl I met in later years. What a mystery the soul of man is! Only a key like this can unlock it, for this was love.

Back at the community things went on much the same with frequent meetings to state views on the war and to organise the community as a whole, but these usually ended in a row. Life seemed to me to be cut off from reality: it was words, theories, ideas strung together with suppressed hatred and other emotions incompatible with brotherly love. Painting, which had been the original purpose of my running into all these difficulties, had now taken a back seat for the time, but was not lost sight of.

The lady in the tweed suit who used to visit us was indeed Lady Crankshaft from the Towers College which had been evacuated to Cornwall, and she quite unexpectedly offered us a post to teach dancing and painting at her establishment, doing a little in the garden to fill in the condition of exemption from

the Army, in return for our keep and a pound or two a week. We discussed this and agreed. I saw a way of getting on with my work I had given up so much for, and of solving, however painfully, the secret affair with Lorel, who was identical with my anima, therefore of supreme power. I arranged to hitch down to Cornwall on my own to see the school and meet the staff.

That evening I climbed the hill above the town and stopped where I could lean on the gate and overlook the petrified forest and the river. It seemed a long time since I had come here alone that day and found I could push the trees over, send them crashing down the valley side. It was spring again, but they had no seasons. In them there was no longer any sap, here creation had withdrawn and they had died. The river roared timelessly and far below I could see a little roe deer come out to drink from a pool. And then the voice again that so haunted my inner mind, singing the tune I could not hum. For a time, as on the first occasion, I did not know if it was a vision or not, until all at once Lorel was at my side in a simple dress; she was so beautiful in the evening light I could not tell how the hillside glowed. We stayed together for a long time. We talked of the child we would have if we were together always – a child of the sun – and call him Soleil. Her mouth and her hair were like moth wing, her body like water in which the moon was hooked when a meteor had fallen.

Quite late we could hear distant explosions. Looking to the west there was the flash of guns and bombs and the glow of fire lighting the sky. The Germans were bombing Plymouth.

Early next morning I was on the road to Cornwall. When I got to Plymouth it was still smoking: a mass of concrete and twisted girders: a petrified forest. Standing among the ruins where they were still pulling out the dead I could hear Lorel's last words:

'You must go to war, darling. You must go to war!'

Hateful Sunset

THE project at the college to teach dancing and painting was not successful and we could not stand the narrowness of school life. Greta got pregnant again and we were asked to go. We beat a rearguard action into the moors above the sea where we rented a cottage. I stood on the hill at night watching the flash of bombs and guns garotte the darkness out to sea where a convoy was being attacked. I stood cold. And so came the hateful sunset. Hateful because whatever was wrong with the world it was the end of sweet fortuity; of the natural acknowledgment of warmth of feeling from the heart; of deep humour that welds love together, and love itself that is touched by trust and lit by a truthful candle; of painting that contained these things in a net of skill and a shrine of beauty; earthiness and character, suffering for a purpose, belief in God, laughter that was not sick, smiles that were not bitter. A dry crust and puddle water for the sake of what was beautiful and enduring. This was the end of the time of hands, of simplicity, sentiment, animals, graciousness and the belief in the shadows and the rich colour of the shadows: a knowledge of candlelight and time and of old eyes wherein wisdom took up residence for the lost years of age and the exultant moments of youth. Without wisdom God was dead: without God there was only the intellect and the devils which no one – no one – could cast out, for they had their being in the darkness behind the towers of light and the cubes in azimuth, laughing in their diabolic strength because they could no longer be exorcised. No longer was it the interpretation of life that was the purpose, but its substitution: not a dream interpreting experience but a scheme to take it over in a controlled madness, a precise and devilish liquidation. A darkness was upon the face of the earth and in the teeth of this creation was not possible. I was excited with the

intrusion of war. I stood for an hour on the hill watching the stars in their constellations and the lighthouse garotte the darkness. I stood cold and corseted in salt air from the ocean. Everywhere there was the negative sound of silence, where the stars danced in their courses as I had danced, where the sunset had painted the sky as I had painted, where the morning wrote a word in the waters as I had written and the heart leapt in the waves as mine had leapt.

When I went down to the cottage again Greta was sleeping with an oil lamp burning in the window, her hair fallen across the pillow, her lips full, her face pale. Under the blanket the soft curve of the unborn child was just perceptible, breathing in the hill of time. Over in the cot my son burrowed in the pillow as though he would go back into that hill.

The tin clock said four a.m. I had a job at a smallholding five miles away from the cottage and before I left for the day there was water to draw from the well, wood to saw for the day's fires, faggots to collect for Greta to make the fires, so that she could cook and be warm: these jobs could not be hers in pregnancy.

In an outhouse there was a huge collection of driftwood from the sea, some of which I sawed up each day. It was a source of great distress when I found out later that the two craftsmen who owned the cottage had saved this wood for years to use in their work. As I sawed innocently through each section of teak I enjoyed its smell in the lamplight, wondering into which ship it had been built, to which parts of the world it had travelled, what disaster had brought it to our shores to help in our survival. Here was the thrill of existence.

Strong orange tea with tinned milk, bacon and fried bread eaten before dawn by oil lamp is recommended for those who meditate early, and is never to be understood by those who sleep late: especially beautiful if wood smoke has burnt the inside of the nostril.

Without waking Greta but kissing her gently in sleep, I went outside and on my way, after taking my bicycle from the stone hut. The little pathways were quite perilous with sharp rocks jutting out and in the deep moon shadows it was not easy to see

just where I was going, as though I was walking under the sea and a great fish might glide from a crevice and take my ankle. A sheet hanging by a farm cottage moved like a plaice: the stars were pilot fish escorting the whaleshark night on her un-fathomable way. As I climbed the slope on the other side of the valley I seemed to surface and feel the cold air again and the round hills rolling like dolphins in the moonlight. Ahead of me was a ploughed field which I must cross before I came to the road and could ride my bike. The field was shining like machined metal. I carried my bike on my shoulder, stumbling a little over the rough earth and anxious to get to the road. I had been doing this for some time every morning, but I had not met anyone before; from half-way across the field I could see the forms moving and could hear the voices of men calling to one another. There were figures moving on the road. My heart jumped. How good to have company on the road: it would make my five mile journey seem far shorter.

As I approached the far side of the field I saw that my company was not only men but animals also. Two old-fashioned hay carts were moving slowly up the incline, the great horses – two to each wain – strained steadily at the traces, their heads down, the hames and brasses shining in the moonlight. I could hear the jangle of the chains and the clank of swiveltrees, the crack of felspar spitting on the road, the soft ffrou-ffrou of suede nostrils, the clip of each battering steel foot winged with sparks. On the right-hand shaft of each wain sat a man loosely holding the reins. Others sat on top of the loads of hay smoking and talking.

I became very excited by all this and ran towards the strange procession, already catching the warm smell of the horses and the squeaking leather, the little bells jingling on the back pad and head collar. They seemed to make slow progress but when I got to the stone hedge which divided me from them they were already some way on. I lifted my bicycle like a praying mantis against the moon and cycled after them. As I approached, the last waggon seemed to grow thin, to dissolve before my eyes. In a moment I was entering it, going through it, until I realised I had cycled through the entire cortège: there was

nothing there. I stopped, feeling very much part of the dolphin-diving moonlight, the gorse and the granite. They no longer withheld their secret but whispered instead for me to keep mine, which would be the same in the telling if it could be spoken. I bent down and picked up a whisp of hay from the road: it smelt like tobacco.

'Whoever heard of harvest in November?' I said to myself.

This strange experience stayed with me all day, carrying some meaning of which I was not fully aware. But in its simplest explanation it was a promise of life and perpetuity, which is what I most needed at that time.

When I got to the smallholding where I worked, the farmer was undoing the top vertebrae of a rabbit: the animal squirmed in his hands and became still, its eye glazing with death.

> 'It was the reply of Zeus that he
> should leave with the rest!'

These words of Xenophon were released from memory perhaps by the death of the rabbit or the vision on the road: who can tell? But they came up and I had the feeling the connecting link for which I had been looking had now been found. I felt as I had felt that night when I had left Lorel and she had said to me: 'Go to war, darling. You must go to war!' after we had stood on the hill and watched England burn, as the Crystal Palace had burned and with it childhood had burned into youth. I was like Pierre in Tolstoy's *War and Peace*, caught in a war which I did not understand or believe in. The net was closing: I knew there was no escape.

The winter was hard. Snow prevented me working. There was no money, little to eat; only the ubiquitous Agricultural Inspector who bobbed up here and there from behind hedges to see if I was working. I hid behind a rock or bush of gorse on my way to steal roots from the fields and milk from the farm churns: eggs if possible for Greta and the baby. I knew our only hope of survival was to get into the little town and by early summer we were living in a studio in one of the back streets after I had sold a sackful of paintings to a Czecho-slovakian refugee.

It was here that one day Icarus appeared, splendid in Wing-Commander's uniform: he was commanding an airfield nearby on the Atlantic cliffs. We felt shabby and outcast. He brought us some strawberries and went away.

One day when there was no food I went to a little shop called the Dolls' Hospital run by a strange man named Jonathan Lovelace, who had an articulatory disease which made him leap about like a marionette on a string. I sold him my paint box and palette for seven shillings and sixpence. The next day I signed on as a soldier.

In doing this I had turned voluntarily towards Death, whom I wished to know and to understand. This seemed the only cure to life's illness. I could not live as I felt inspired and, with one greater, I had said: 'I owe a cock to Aesculapius: see that the debt is paid!' In this measure I paid my debt to the Gods. Life had begun again in learning a new art – the art of death.

When I first heard the guns, when I first saw the flame-throwers belch fire over those screaming men, it was as if I had been touched by the hot breath of the Minotaur to whom all these youths with their golden swords had once danced and now had once more to be sacrificed to history in the dark labyrinth of war. It was the doom of which I had first become aware in the surging ballet, *Les Presages*, and in the faces of the men to whom I had danced in Surbiton and, in obverse manner, in the heartbreaking art of Anna Pavlova. Now it was here, spewing cordite and napalm over the generations, and the seed of life was burnt in the ground. It was the horror that was the other face of beauty. I wrote in my journal:

'O, ye prophets of Heaven and Hell, the war was painted and fought and danced years before it becomes now to me apparent. Electric light bulbs and cows' faces rinsed with terror. In the warm foetid air, golden and grey with dust, I am caught in a daylight Walpurgis. Beauty moves in a strange place, walking with a wild song, with engine-intestines; her breath smells of anti-vermin powder: vermin eat her liver. Take down her rubber face, put out her perspex eyes, mark out her journey with a chinagraph pencil and let it be recorded, for

this is the meeting of opposites which the world vomits from its bed of spunk and dead men.'

I knew this to be the other side of creation and why violence awakened all around me during the years. Who gave me the thread that led me through it, I don't know, for often, like others, I was blind and bewildered. And when it was over Greta died.

I became entrenched in another stage of life with the dim memory of having once been a dancing man, of having played on the same stage as Harry Tate, Alexander Zass and Max Miller: of watching Massine at his alchemy of creation, spreading his genius like the tail of the peacock. I had bitten into the black root that heals the soul of man and found the full arc of creation was now possible at last. It is a lonely and difficult task, only worth doing to the glory of God, the love of Mankind and the damnation of Philistines, for the burning man is the price of resurrection. Farewell, O dancer from the Capitol: it is time to say farewell! Farewell Ariadne!